Byzantium

709.0214 M425b Mathews, Thomas F. Byzantium

109,0214 109,0256

Acknowledgments

I am indebted to Philippe de Montebello, Director of the Metropolitan Museum of Art, and Marian Burleigh-Motley, Co-Chairman of the Grants Committee, for the J. Clawson Mills Fellowship which gave me the opportunity to write this book in the museum's Thomas J. Watson Library. I would like to thank as well William D. Wixom, Chairman of the Medieval Department and the Cloisters, and Helen C. Evans, Curator of Byzantine Art, for their help and hospitality, while they were busy with "The Glory of Byzantium" exhibition. To my wife Annie-Christine Daskalakis, my critic and muse, I dedicate the volume.

Frontispiece Springtime Activities in the Countryside, page 88 (detail)

Series Consultant Tim Barringer (University of Birmingham)
Series Manager, Harry N. Abrams, Inc. Eve Sinaiko
Senior Editor Kara Hattersley-Smith
Designer Karen Stafford
Cover Designer Judith Hudson
Picture Editor Susan Bolsom-Morris

Library of Congress Cataloging-in-Publication Data

Mathews, Thomas F.

Byzantium: from antiquity to the Renaissance / Thomas F. Mathews.
p. cm. — (Perspectives)
Includes bibliographical references and index.

ISBN 0-8109-2700-4 (paperback)
1. Art, Byzantine. I. Title. II. Series: Perspectives

(Harry N. Abrams, Inc.) N6250.M33 1998 709′.02'14— DC21

97-42413

Copyright © 1998 Calmann & King Ltd Published in 1998 by Harry N. Abrams, Incorporated, New York

All rights reserved. No part of the contents of this book may be reproduced without the written permission of the publisher

This book was produced by Calmann & King Ltd, London Printed in Hong Kong / China

Harry N. Abrams, Inc. 100 Fifth Avenue New York, N.Y. 10011

www.abramsbooks.com

Contents

Maps: The Byzantine Empire 10-11

EARLY BYZANTINE AND MEDIEVAL CONSTANTINOPLE 19

INTRODUCTION 7

Three Phases 9

ONE The Imperial City of Constantinople 17

Constantine's City 17 The Classical Heritage of the City 24 Justinian's City 29 The Period of Crisis 32 Medieval Constantinople 33 The Decline of Constantinople 40

TWO Icons 43

Pagan Origins 43 Sixth-century Icons 47 Icons in Church 52 Iconoclasm and the Theology of Icons 55 The Restoration of Icons 57 Icons in Public 65 The Mother of God 70

THREE The Secular Domestic World 73

The Palaces of Constantinople 73 The Fashions of Palace Life 79 Country Life 87

FOUR A Temple of Transformation 97

Early Byzantine Churches 99 Medieval Byzantine Church Design 106 The Medieval Decorative System 111 Christ in the Dome 117 The Selected Narrative 118 The Sanctuary 127 The Narthex 133

FIVE A Cosmopolitan Art 137

Art and Diplomacy 137 Italy 143 Palaiologan Art 151 The Renaissance 157

Timeline 164
Bibliography 166
Picture Credits 170

INDEX 172

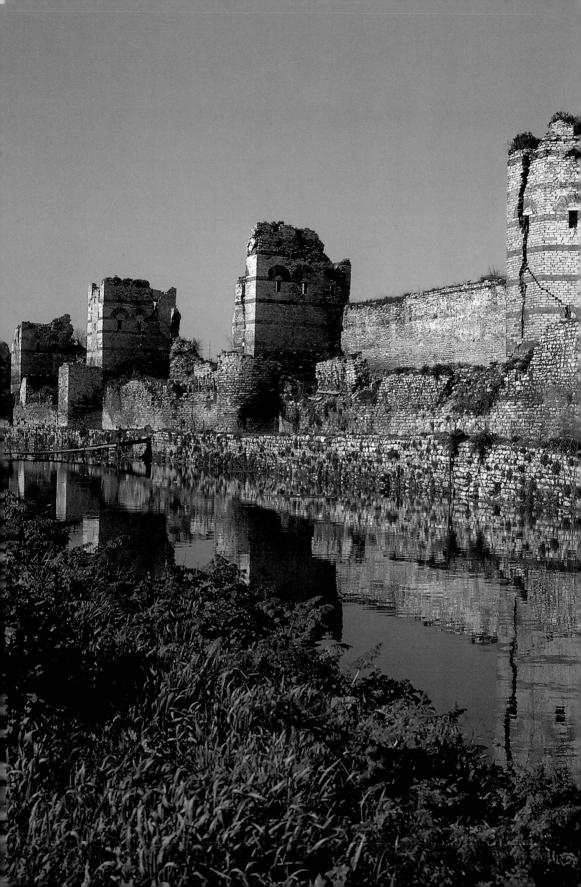

Introduction

hen the Turks breached the walls of Constantinople on 29 May 1453, they extinguished the longest-lived political entity of Europe, the Byzantine state (FIG. 1). The disappearance of this ancient Christian polity from the living family of nations reduced its civilization to a study for historians and archaeologists. Even the name of the state was quickly forgotten and scholars began calling it Byzantium, which had been the original name of its capital city, Constantinople. The "Byzantines" themselves had called their state the "Roman empire," or in common parlance "Romaneia," since it was in fact a continuation of the Roman empire in its fiscal, legal, and administrative systems – even though it had evolved into a Christian and primarily Greek-speaking state and the city of Rome itself had ceased to be part of the empire by the ninth century.

The disappearance of Byzantium has given it an aura of mystery and remoteness to the modern observer, and the distance is compounded by the barriers created by the Greek language and by an unfamiliar theological frame of mind. Yet Byzantium constitutes a major piece of the puzzle of European history, and indeed of the history of the entire Mediterranean basin as well, which we dismiss only at a risk of substantial incompleteness. As heir of the legal systems of Rome it supplied the model for the medieval state; as heir of the learning of Greece it served as elder mentor of Europe. Its military sealed the eastern borders of Europe from the expansion of Islam, while its economy linked Europe with the Near and Far East.

Byzantine art recommends itself as the most accessible manifestation of Byzantine culture and at the same time the key to its most intimate soul. Other accomplishments of Byzantine civilization are more exclusive. For example, the diversity and richness of Byzantine literature, including romance, are now widely recognized, but an appreciation of that literature is inevitably linked to an understanding of the stylistic subtleties of the Greek language. Similarly, Byzantine contributions to law and theology,

1. Land Walls of Constantinople, built by Theodosios II, 412–3.

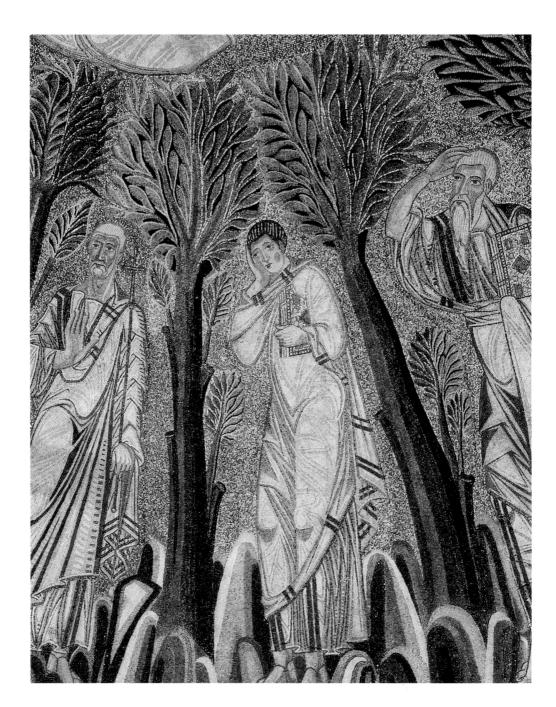

2. Apostles, detail from the *Ascension*, 885. Mosaic in the dome of Hagia Sophia, Thessaloniki, Greece.

Mosaics were very labor-intensive, requiring the setting of thousands of cubes (*tesserae*) of colored stone, ceramic, and glass in a bed of plaster, but the result was an unfading brilliance of color.

basic as they are to Western developments, are hardly understood except by specialists. The refined humanism of the art of Byzantium, however, speaks directly and powerfully to the modern viewer.

In the Middle Ages, moreover, Byzantine art leaped large gulfs, linguistic, ethnic, and cultural. Its ivories and manuscripts circulated freely in the world of Islam, its enamels and silks were treasured in Paris, its icons were well known in Italy and Russia. Byzantium's role in the conversion of the Balkans and eastern Europe to Christianity gave its art an unparalleled authority in those lands.

Most important was its role in developing the Greco-Roman heritage of painting the human figure. In contrast to Islam's fascination with calligraphy and geometry, or China's concern with the landscape environment of human life, Byzantine art took the human figure, in all its moods and poses, as its almost exclusive vehicle of expression, and in this it constitutes the essential bridge between antiquity and the Renaissance. When western Europe lost the human figure in a maze of animal interlace, Byzantine artists were taking figure painting beyond its classical roles by employing it in daring proportions. In the thirty-six-foot (11 m) dome of Hagia Sophia in Thessaloniki, Greece, we are confronting apostles over twice life-size (FIG. 2). Dressed the way Roman authors or philosophers would have dressed, in full-length, striped tunics with loose mantles, their gestures convey a mixture of amazement and sorrow as they watch their Lord departing into heaven in his Ascension. To carry such a message the artists developed a medium of indestructible beauty, the mosaic, which in Roman art had wide use only on floors. Byzantine artists used it as a true painting medium, with a rich palette of blues, greens, and gold visible from great distances. In managing such powerful themes on so grand a scale Byzantine art set a standard that would challenge artists into the Renaissance.

Three Phases

Byzantine art may be defined as the art of Constantinople and its empire, and of those who came under its immediate sway, over the eleven hundred years of its history (324–1453). The subject falls into three phases, corresponding to the political fortunes of the state (FIG. 3). In the Early Byzantine phase, the mid-fourth century to the mid-sixth, the state embraced most of the territory of the former Roman empire around the Mediterranean basin, with the exception of territories north of the Alps. Its art in this phase presents a gradual transformation of classical art as a new aesthetic and a new ideology are imposed on the forms.

Overleaf

3. The Byzantine empire

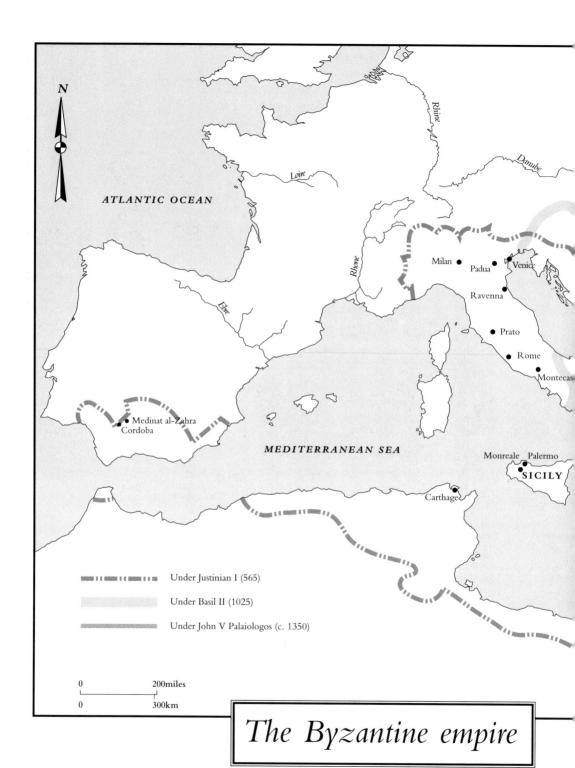

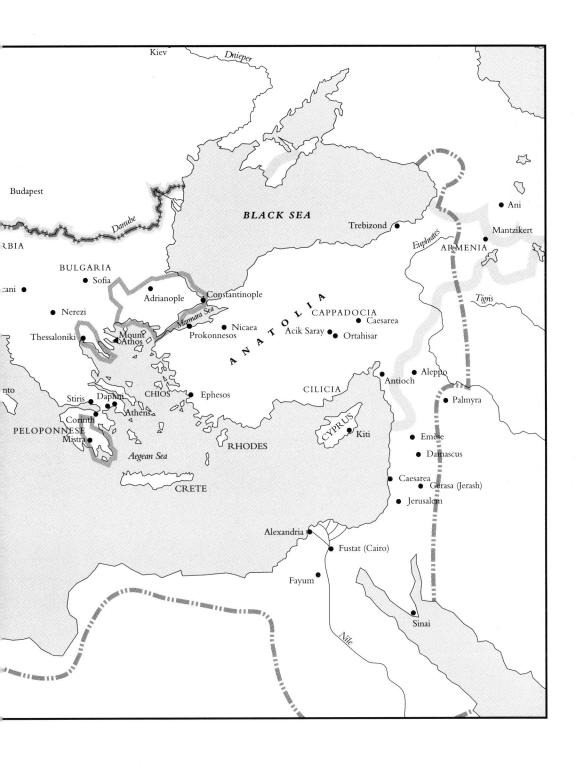

This phase was followed by an interlude of reversals and crises caused by the arrival of new peoples in Europe and the success of Islam in the Near East. While in its first phase Byzantium was a superpower, in its second or middle phase, starting in the ninth century, it was a state of only moderate size, restricted to present-day Turkey and the Balkans, and in some respects a satellite to the Arab superpower. Its prosperity, however, and its position in Christendom gave Middle Byzantium an importance far beyond the limits of its borders. In this medieval phase it enjoyed a much greater coherence, under a rigidly autocratic government; its society was well educated by contemporary standards, and wealthy. Its art, whether worldly or sacred, is courtly and sophisticated, expressing with brilliant clarity the spiritual-centeredness of the Byzantine outlook on the universe.

The conquest of Constantinople by the armies of the Fourth Crusade in 1204 dismembered the empire, and prepared it for its final dissolution. Yet the Byzantines were able to overthrow their Western lords in 1261 and re-establish a much diminished empire. In this third or Late Byzantine phase, art found a new humanism that appealed strongly to surrounding countries and influenced profoundly the Italian Renaissance.

The present study makes no attempt to discuss the entire range of Byzantine art. The challenge rather is to reconstruct the context, whether that be seen as the palpable physical context of the environment of city, home, and monastery, which has now largely been destroyed, or the more intangible context which was the web of beliefs and practices that surrounded the images they used. Within such a setting, moreover, it has seemed important to select those manifestations that are peculiar to Byzantine art and to define its special contribution to world art rather than try to treat everything with even hand.

For this reason a topical approach has been adopted in the hope that long lines of continuity will emerge better than if objects were parceled out, museum-style, into decades by rulers. A series of themes will be followed across the artistic landscape. Looking in turn at public and private realms, secular and sacred, the study will attempt to present some of the essential dimensions of the subject without pretending to completeness.

Architecture has been consciously slighted, being introduced only in so far as it supplies the setting for Byzantine art. The focus rather is on the human subject – which was the single-minded preoccupation of Byzantine art, whether in individual figures, complex programs, or heroic narratives – and on the human viewer or participant, for Byzantine art was very involving.

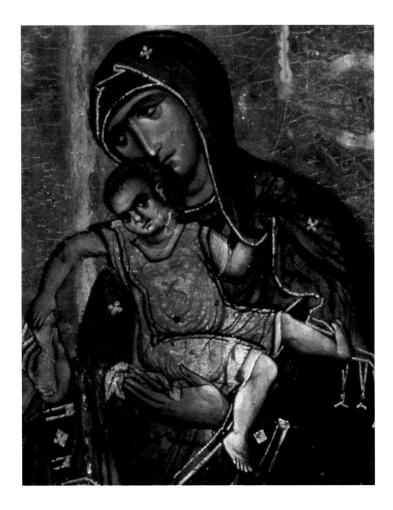

4. Mother and Child, detail from Enthroned Mother of God with Prophets and Saints, c. 1100. Tempera on board, 19% x 16¼" (48.5 x 41.2 cm). Monastery of St Catherine, Mount Sinai.

Byzantine art, it is argued, is surprisingly unlike the abstract and rigid stereotype in which it has sometimes been cast. It is personal and, in a sense, deeply subjective. Although we can rarely identify the artists personally responsible for individual works, and even patrons are poorly documented, contemporary sources do bear vivid witness to the emotional power of the images. The system of imperial government allowed little freedom of expression in the public sphere, but in the private sphere, and in the religious, the Byzantines developed an art full of pathos and ecstasy, capable of warmth and intimacy. In the icon of the Enthroned Mother of God with Prophets and Saints on Mount Sinai, which introduced one of the most popular ways of interpreting the subject, the child struggles energetically with his mother; with one hand he tugs playfully at her veil as if he would hide in it, while with the other he grasps for a scroll she holds (FIG. 4). Such direct human observation is not what we have been told to expect

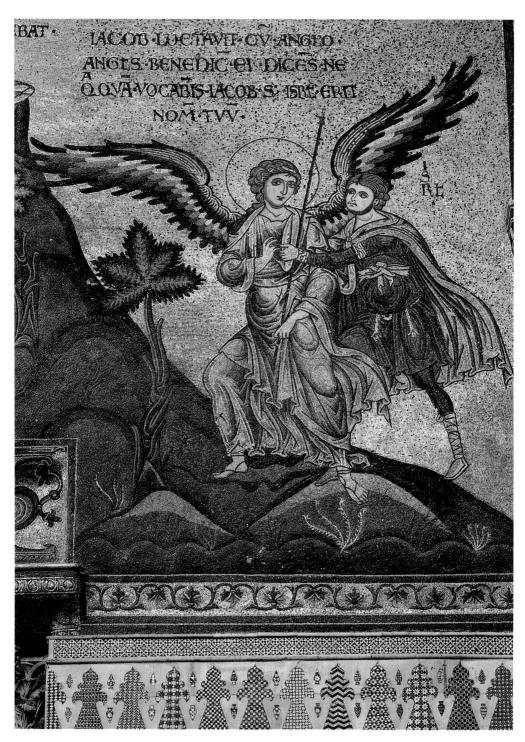

5. Jacob Wrestling with the Angel, 1176–86. Nave wall mosaic, Monreale Cathedral, Sicily.

from Byzantine art. But Byzantine art was a complete vehicle with ample room for all of human experience, from the tenderest to the most solemn, and from the pompous to the prosaic.

Painting was central. Sculpture in the round, the pre-eminent medium of Greek and Roman art, was abandoned, and large-scale relief sculpture became rare. While the imagery of the ancient gods was largely discarded, in painting a whole new language of imagery was developed to carry a new, deeply Christian, world view. Christ was made the fulcrum on which all human history turned, and his body figured as the magic vehicle for transforming the lives of all his followers.

On this lofty and diversified accomplishment, the art of Europe leaned heavily, not only in its imagery and image use, but also in its technical heritage, whether one looks at panel painting. mosaics, and murals, or at work in gold and enamel. Throughout the Middle Ages authentic Byzantine works were either exported to Europe or executed directly by itinerant Byzantine artists on European soil. When William II, the Norman king of Sicily, wanted to decorate the vast naves of the monastery of Monreale he sent for artists from Constantinople. They arrived with their sketchbooks, tools, and materials and executed the largest surviving mosaic program in the world (FIG. 5). Byzantine art is the backbone of medieval art, from the easternmost kingdom of Christendom, that of the Armenians in the Transcaucasus, to the Slavs of the Gulf of Finland around modern St Petersburg, to the medieval states of Europe, and this cosmopolitan dimension enhances its place in the study of art history.

ONE

The Imperial City of Constantinople

Constantine's City

Byzantine art is coterminous with the lifespan of Constantinople, the capital city, from its founding to its fall to the Turks. Seat of government, hub of trade, source of patronage, and center of learning, Constantinople – one of the largest cities of Europe before 1204 – played a preponderant role in the empire's art production, which flourished and faded with the prosperity and reverses of the city. Moreover, the city in its public dimension offered the emperor a unique arena for the expression of his autocratic claims on Byzantine life.

Constantine the Great, fresh from the Battle of Chrysopolis on the Bosporos, in which he defeated his co-emperor Licinius and so reunified the Roman empire under his sole rule (324–37), made the strategic choice of an insignificant city called Byzantium as his new base, renaming it after himself "Constantinople." It was a fateful decision. Having spent the preceding eight years in the Balkans staving off the Germanic invasions along the Danube border of the empire, Constantine realized the impossibility of managing the empire's crises from distant Rome. Byzantium, a harbor city on the Bosporos, the strait that links the Black Sea with the Aegean, lay midway between the threatened Balkans and the empire's great reservoir of wealth and manpower in Asia Minor. The peninsular site of the city made it eminently defensible. The Roman empire was saved at the expense of Rome itself.

Constantine commemorated the founding of his city with a gold medallion of himself which introduces a new imperial portrait type (FIG. 7). While his immediate predecessors chose to be represented as rugged generals, staring full-face at the viewer, with short, stubby beards, Constantine is clean-shaven and gazes

6. Triumph of Justinian, the "Barberini Ivory," second quarter of the sixth century. Ivory, 13% x 10%" (34.2 x 26.8 cm). Musée du Louvre, Paris.

7. Medallion of Constantine, 324–6. Gold, diameter 1%" (3.6 cm). Byzantine Collection, Dumbarton Oaks, Washington, D.C.

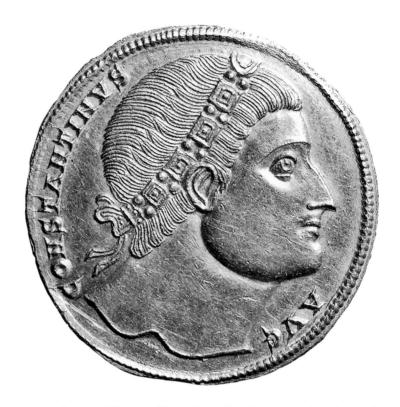

upward toward heaven like Alexander the Great, the idealized ruler and greatest general of antiquity. Further, unlike previous Roman emperors, who espoused puritan *mores*, he wears an extravagant diadem of gold-set gems and pearls, setting a fashion for his successors in Byzantium.

Although the modern visitor finds that the Turkish city of Istanbul has effectively blanketed Constantinople, archaeology has deciphered the main lines of Constantine's city. Its plan reveals the emperor's grand intentions. In the first place he enlarged the city's area four- or fivefold, throwing up a new wall from the Marmara to the Golden Horn (FIG. 8). To fill up the new city, various practical measures were undertaken to attract residents: Rome's Egyptian grain shipments were diverted to Constantinople to assure free bread for the populace, and contractors building in the city were given tax remissions. So attractive did the city prove that in 412 Theodosios II (408–50) would be obliged to erect another wall doubling the size yet again (see FIG. 1). Within a century the population, perhaps half a million, had outstripped even that of Rome.

Meanwhile, Constantine enlarged the hippodrome to match the size of the Circus Maximus in Rome, providing a grand center of public entertainment and a theater of imperial appear-

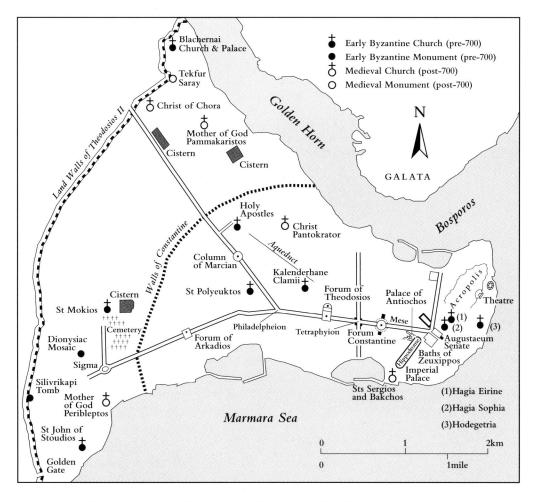

ances; alongside, as in Rome, he constructed an imperial palace, called the Daphne, which formed the nucleus of what later became the Great Palace and which communicated directly with the emperor's loge in the hippodrome (FIG. 9). Before the palace lay a great square which he named the Augustaeum in honor of his mother, Helena Augusta; her statue presided atop a porphyry column. Facing the statue he erected a basilica for the senate. Although as a body the senate's role under the empire was largely ceremonial, as a class it represented the wealthy elite from which high government offices were filled, and Constantine actively recruited both the nouveaux riches and old Roman families to fill these ranks in his new city. It is clear that from the outset Constantine had the revolutionary idea of founding not just a temporary base of military operations but a true second Rome that would replace the first as the heart of the empire's life and administration.

8. Early Byzantine and Medieval Constantinople.

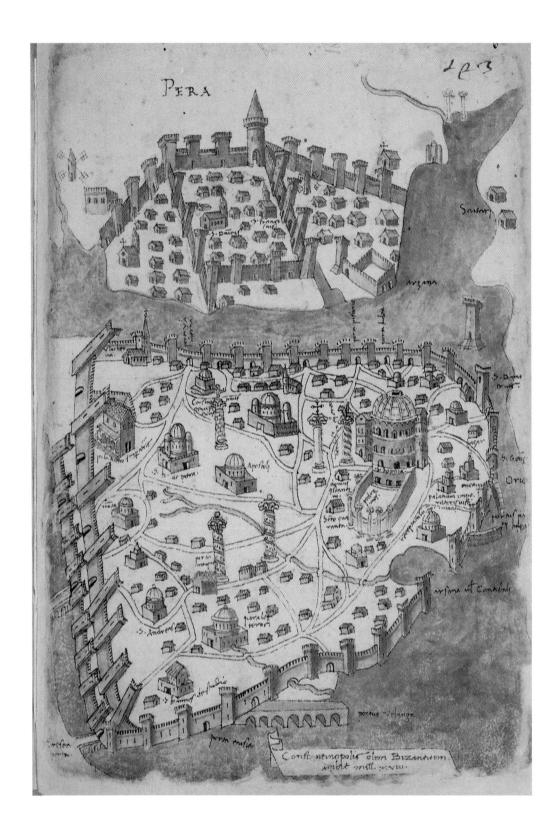

The city Constantine laid out, however, was hardly a copy of Rome. Apart from the peninsular site, which gave Constantinople an entirely different topography from land-locked Rome, the fabric of the city had rather a different feel. While Constantine's personal commitment to Christianity is difficult to assess, it is hard to deny that he gave the city a special Christian character from the outset. In Rome the churches Constantine had founded were placed in the cemeteries peripheral to the city; in Constantinople he placed the church at the heart of the city. The original cathedral of the city he erected a short distance from the Augustaeum. Referred to in sources as the "Old Church," it was dedicated to Christ under the title of Hagia Eirene, "Holy Peace." Alongside it his son Constantius II (337-61) dedicated a second cathedral, Hagia Sophia ("Holy Wisdom"), in 360; but its site on prize real estate on the north side of the Augustaeum must have been designated for ecclesiastical use right from the start. The cathedral complex and the residence of the bishop were at the heart of the city, across the Augustaeum from the imperial palace. This novel planning unit of imperial palace, plaza, and church symbolized the twofold foundation of the Byzantine state. As Byzantine law eventually formulated it, sacerdotium (priesthood) and basileia (imperial power) were expected to be equal partners in promoting Orthodoxy and in regulating human affairs. This planning unit was to be adopted in important new cities of the Middle Ages, such as Ravenna, Venice, or Moscow.

Constantine's other Christian foundations in Constantinople included churches to the local martyrs Sts Mokios and Akakios, and his own mausoleum-church of the Holy Apostles on the highest hill in the city, all basilicas in structure. Centers of Christian worship marked important axes in the city and by the end of the fourth century religious processions traced these axes with a developed public liturgy. Churches and monasteries proliferated, over a hundred being mentioned by the sixth century.

Beyond its ever-developing Christian character, Constantinople also had an "oriental" flavor that distinguished it from the old Rome. While Rome had grown by a gradual additive process, in his new city Constantine was free to lay out a bold armature of grand avenues lined with stoas or porticoes on either side, separating wheeled traffic from pedestrian and providing comfortable shade for shops. Such colonnaded avenues were a feature borrowed from the luxurious Hellenistic cities of the East – Alexandria, Antioch, Palmyra. The nearby quarries of Prokonnesos Island in the Marmara Sea furnished abundant bluish crystalline marble with which to build the porticoes.

9. CRISTOFORO
BUONDELMONTI
Map of Constantinople,
1420. Ink on parchment.
Biblioteca Marciana, Venice
(Cod. Marc. lat. xiv,
45 (=4595), p. 123).

The earliest useful map of Constantinople, by the Italian cartographer Buondelmonti, shows the principal features with great clarity: the doubled wall with moat on the landward side (left); the honorific imperial columns, including Justinian's equestrian column alongside Hagia Sophia; and the hippodrome.

10. Column of Constantine, 325–30. Porphyry, 120' (37 m). Istanbul.

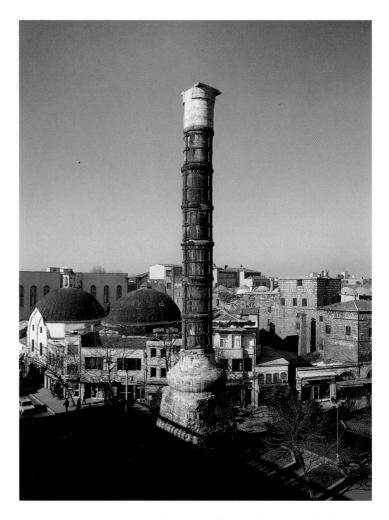

As the main avenue, called *Mese* ("center") street, climbed the hill from the Augustaeum it passed under an arch into the splendid circular Forum of Constantine. An early chronicle, the *Chronicon Paschale*, recounts how the emperor "constructed a big and very beautiful forum and set up in the center of it a tall column of purple Theban stone worthy of admiration. At the top of this column he set up a big statue of himself with rays on his head, which bronze statue he had brought from Phrygia." A second chronicler, Zosimos, explains in his *New History* that the forum was circular, "with porticoes two stories high, and two very large arches of Prokonnesos marble facing one another." The column still stands (FIG. 10). The circular forum was also without precedent in Rome. Constantine's father had sponsored a smaller circular plaza at the meeting of the main streets in Gerasa in Arabia (modern Jordan), but Constantine made his circular

forum into a grand explicit symbol of the world which he, as sole autocrat, now ruled from his lofty column under the guise of Helios, the sun god.

The idea of punctuating the city with a series of honorific statuebearing columns also came from the Hellenistic cities of the east, and Constantine used it to special effect for imperial propaganda. At every major turning in his new city he erected lofty porphyry columns of his dynasty, placing his mother in the Augustaeum, himself in the forum, and at the Philadelpheion, the point where the center street divided, a grand composition of three columns. One column bore a golden replica of the cross that Constantine claimed to have seen in his conversion vision (312) on the eve of his conquest of Rome; the other two carried statues of himself and Helena Augusta on top, and half-way up, on consoles, his four prospective heirs his three sons and their step-cousin Delmatius. Constantine raised the

four to the rank of Caesars and entrusted them with various segments of the empire. These figures, ardently embracing one another in pledge of harmonious rule, have survived, having been carried off as spoils by the Venetians after their sack of Constantinople in 1204 (FIG. 11). Craning his head to view these columnar figures from the street below, the city-dweller would have been more struck by their unmistakable gestures and military regalia than by individualized portrait qualities. Imperial portraiture in Byzantium absorbs the person into the office. The four Caesars convey an impression of indomitable strength. Each of them wears a short tunic, a heavy cuirass or vest of leather, and a *chlamys* or heavy military cloak, and they all clutch firmly the eagle-head hilts of their swords. Although his sons' harmony did not last beyond his own lifetime and his family dynasty did not last beyond the reign of Julian (361–3), a step-nephew, Constantine intended his

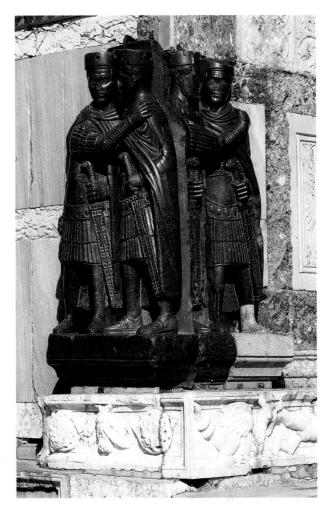

11. Constantine's Four Sons, 325–30. Porphyry. Formerly in the Philadelpheion of Constantinople, now in the Piazzetta S. Marco, Venice.

Porphyry, a rare, hard purple stone quarried in Egypt, was reserved for imperial use. city as residence of a new imperial dynasty that would manage a reorganized Roman empire. His imperial stamp on the city would remain.

The Classical Heritage of the City

Constantine created a city of grand public spaces; he was no less ambitious about its decoration. St Jerome complained that the emperor had stripped the entire world to ornament his new city. Ancient cities commonly displayed their history in statuary; but the new Constantinople, having an undistinguished past, had a "museum" look in its statuary, displaying a disparate assortment of sculpture of all periods from the fifth century BC down to contemporary times – pieces stolen from their original context. Of this vast collection only a single group survives, the famous gilt-bronze Horses of S. Marco that ornamented Constantine's hippodrome, also taken to Venice by the Crusaders in 1204 (FIG. 12).

In some situations coherent statuary groups were assembled, such as a set of twenty-nine mythological figures from the legend of the fall of Troy, displayed in the baths of Zeuxippos, adjacent to the hippodrome. Homer was the most widely read

12. The Horses of S. Marco, Greek or Roman. Gilt-bronze. Formerly in the hippodrome of Constantinople, now in S. Marco, Venice.

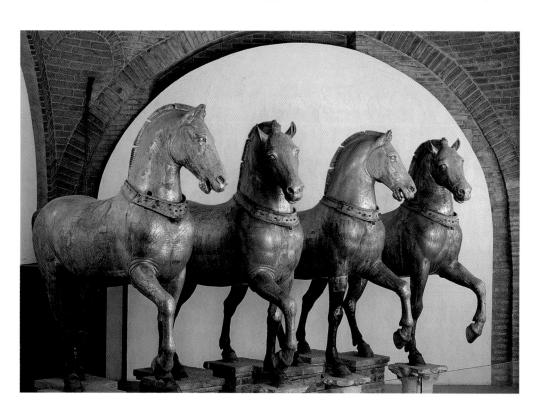

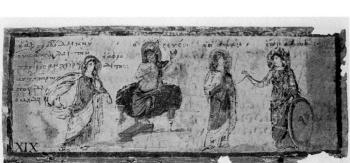

13. Hector Meeting Hecuba, from the Ilias Ambrosiana, fifth century. Tempera on parchment, 5% x 8½" (13.5 x 22 cm). Biblioteca Ambrosiana, Milan (Cod. Ambros., fol. 205 Inf., sheet xxiv).

The inscriptions of names and notes, entered on the miniature in red and black ink in the eleventh century, testify to the continued use of the manuscript through the Middle Ages.

14. Aphrodite
Complaining to Zeus of her
Wounded Hand, while
Hera and Athena Laugh at
Her, from the Ilias
Ambrosiana, fifth century.
Tempera on parchment, 3%
x 8½" (8.5 x 21.5 cm).
Biblioteca Ambrosiana,
Milan (Cod. Ambros., fol.
205 Inf., sheet xix).

ancient author throughout Byzantine history; the *Iliad* was the basic school text and students memorized lengthy passages of the epic. The earliest illustrated codex, a fifth-century manuscript of the *Iliad* from Constantinople, documents this interest in classical antiquity. In his depiction of *Hector Meeting Hecuba* the artist has situated his heroic figures as if on a stage, before a cityscape like those known from Roman wall painting in Pompeii (FIG. 13). In another miniature he illustrates a conversation among the gods without any background (FIG. 14). The figures come as close as we can get to picturing the bronze figures of the pagan gods that were distributed around Constantinople, in mixed company with classical authors and Roman emperors.

In so displaying the pagan gods, according to his Christian biographer Eusebios of Caesarea (c. 270–c. 340), Constantine "held these up as playthings to be the ridicule and sport of all beholders." Unlikely as this explanation may be, the removal of the pagan figures from their temple contexts did represent a distinct desacralization of the figures characteristic of the new Byzantine atti-

tude toward its classical heritage in general. The establishment of Christianity was a gradual process: temple sacrifices were banned by Constantine and temples themselves were closed by Theodosios I (379-95); but one of the by-products of the new religion was a growing appreciation of classical art as art, rather than as cult. Basil the Great of Caesarea (c. 329-79), the most prominent theologian of the early Byzantine church, defined the fundamental position. Having studied the classics in Constantinople and Athens in the 340s, he fell in love with the ancient authors and believed a good Christian could read them without subscribing to paganism. He urged students to make prudent and eclectic use of the classics; Homer could be literature without being theology. It is this liberal attitude which accounts for the preservation of much of the corpus of ancient Greek literature, which survived until modern times through manuscripts copied in Byzantium in the Middle Ages.

Basil's appreciative eclecticism defines the Byzantine attitude toward Hellenistic art. The artists of Constantinople regarded the Greco-Roman heritage of human figures as their own, to build on and develop as they pleased. Authentic classical figures appear everywhere in Byzantine art, whether the subject be sacred or secular, and excerpts from classical stories are frequent. The fragmentary remains from early Constantinople give us some notion of the Hellenistic beginnings of Byzantine art.

As late as the seventh century, emperors followed Constantine's example in establishing honorific columns, and in the fifteenth century this still impressed the Italian geographer Cristoforo Buondelmonti (c. 1385-after 1420) as one of the most dramatic features of the city (see FIG. 9). Constantine's immediate successors spent little time in Constantinople, occupied as they were with unmanageable wars on the German and Persian frontiers. But Theodosios I, who brought new stability to the empire by accepting large numbers of Goths into the empire as feoderati ("allies") and promoting them to positions of authority in the army, gave a new impetus to the expansion of Constantinople and imposed his own dynastic imagery. To commemorate his victory over the usurper Maximus, he erected in 390 an Egyptian obelisk in the hippodrome. On the base he had himself represented as ruler of the barbarians (FIG. 15). Persian captives, with characteristic felt hats, are shown offering gifts on the lower register on the left. On the right the elders of the Goths, with fur coats and long hair, kneel in submission; their vigorous sons, however, have been incorporated into the emperor's service and they stand guard on either side of his box, wearing Gothic torques around their

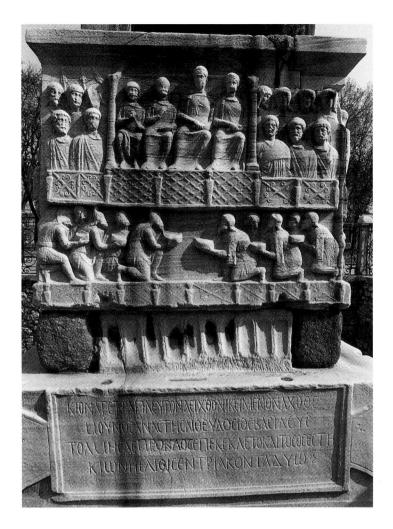

15. Barbarians Paying Homage to Theodosios I, base of the Obelisk of Theodosios, northwest face, 390. Marble, Istanbul.

necks along with their Roman military garb. In the imperial loge sits the emperor, with Valentinian II, co-emperor for the West, on his right. The ruling sovereigns are flanked with their destined successors, Theodosios' sons Arkadios and Honorius, diademed and undifferentiated except in size. Among the government officials that flank them one may identify the consul Rufinus, first on the right, with the *loros* or scarf, last vestige of the Roman toga, that distinguished his office. Imperial portraiture neglects individuating features in favor of ranking figures in hierarchy, mirroring the order of the imperial court.

Theodosios' claims for a family dynasty were articulated even more forcefully in a grand rectangular forum, dedicated in 393, rivaling that of Constantine. His own statue in the center carried the inscription: "Easily reining in your impetuous steed,

16. Troops of Maximus Laying Down their Arms before Theodosios I, fragment of the Column of Theodosios, 386–93. Marble. Istanbul.

you arise like another sun out of the East, flashing rays on mortals, O merciful Theodosios," while at either end of the forum arose grand triumphal arches, the eastern one carrying a statue of Arkadios, the western one (partly discovered) that of Honorius. However, the most splendid monument of the forum was a huge spiral column in imitation of Trajan's column in Rome, but larger: 164 feet (50 m) against 131 (40 m). The column was torn down in 1517, but some twenty fragments survive narrating Theodosios' campaigns against Maximus (FIG. 16). In contrast with the static, hieratic style of the obelisk base, the figures here move with vigor and turn in three dimensions, testifying to the survival of the impressionistic and atmospheric values of Roman relief sculpture.

The Theodosian dynasty lasted three generations and it substantially reshaped the public sector of the city. Arkadios (395–408) added yet another forum and another huge spiral column, and his son Theodosios II (408–50) gave the city its moat and double walls, an innovative system that would defend it effectively down the development of modern canons in the fifteenth century. A monumental running Victory figure from the northern gate of this wall marks a climax in early Byzantine sculpture (FIG. 17). She holds a palm branch in her left hand and must have held out a crown

in her missing right, which would account for her arrested movement. The fluidity of her finely pleated peplos, the garment of Greek goddesses, and the strength of her head, sadly mutilated but piled with bouffant waves of hair, demonstrate a mastery and a sureness in the sculptor's art that Rome itself had long lost. Even a century earlier, the Victories on Constantine's arch in Rome struggle helplessly in the spaghetti of their garments. The monumental reliefs of Constantinople, however, exhibit strong, well-understood figures. Victory remained an important element of imperial iconography, repeated frequently on coinage, though transformed, in the sixth century, into an angel.

Justinian's City

Constantinople's rivalry with Rome took a decisive turn in the course of the fifth century as successive Germanic invaders reached Italy. First the Visigoths (410), then the Vandals (455) plundered the city, and the latter then proceeded to seize Rome's grain supply in North Africa; in 476 Odoacer established a Gothic kingdom in Italy which he governed out of Ravenna. His successor, Theodoric the Great (497-526), ruled with the recognition of the emperor Anastasios I (491–518), but Justinian I (527-65) sought to re-establish the direct rule of Constantinople. Possessed by the ideal of a universal empire embracing the whole Mediterranean, he embarked on a

heroic campaign, retaking first North Africa (534) and then, after a devastating twenty-year war, Italy (555).

Disastrous riots in Constantinople in 532 ruined large portions of the city's center, and Justinian turned this into an opportunity to impose a new iconography of rulership over the city. While his predecessors left their mark in grand open forums, Justinian's principal contribution to the city was a building that might

17. Victory figure, from the Land Walls of Theodosios II, 412–3. 8'9½" x 4'11" (2.68 x 1.5 m). Istanbul Archaeological Museum.

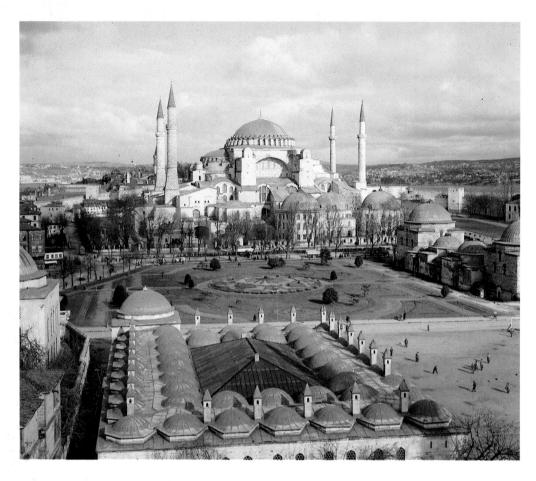

18. Hagia Sophia, Istanbul, 532–7. View from the south.

The Baths of Zeuxippos stood in the foreground where the mosque school now stands; in the garden beyond lay the Augustaeum square; the Chalke, or bronze, entry to the Great Palace was located on the right.

Opposite

19. Hagia Sophia, Istanbul, 532–7. Interior view, looking east.

The furniture and Arabic inscriptions belong to the Ottoman use of the building as a mosque.

be described as a closed forum, the new Hagia Sophia (FIGS 18 and 19). With its hundred-foot (30.5 m) dome soaring to 180 feet (55 m) above the floor, it encloses the largest vaulted space of the ancient and medieval world. The court poet Paul the Silentiary, in his encomium of the building, describes it in terms of Constantinople's ascendancy over Rome, the daughter excelling her mother. He bids Constantinople, "crown your savior king [Justinian], not because he has put your yoke on all the nations of the earth, nor because he has extended your boundaries beyond the most remote borders and shores of the ocean, but because here in your arms he erected this enormous church, making you more brilliant than your parent on the banks of the Tiber."

Before the church, that is at its entrance from the Augustaeum, Justinian erected in 543–4 an honorific column of his own. Standing on a base seven steps high, the column was constructed, like Hagia Sophia, of brick with bands of stone, but it was covered with bronze and wreathed about with garlands like the

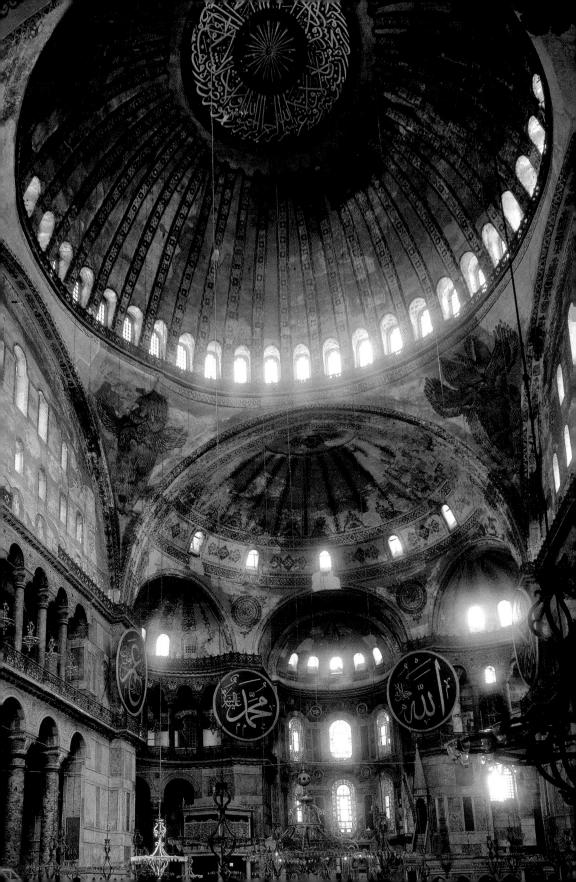

column of Constantine. It was still visible when Buondelmonti made his drawing of the city in the fifteenth century. At the top, Justinian, wearing a plumed parade headdress and holding a cross-surmounted globe, sat astride an enormous horse. He faced east and raised his right hand, according to the contemporary historian Prokopios, to command the "barbarian" Persians to stay within their borders. The triumphal iconography of the Roman emperor, traditional since the second century, now takes on Christian content. The domed cathedral was Justinian's way of commemorating his restoration of the Roman empire.

An ivory now in the Louvre, reliably attributed to Justinian, spells out his divine role (see FIG. 6). In the central panel, in deeper relief than the others, the emperor's horse rears up over a female personification of the bountiful earth, a Victory reaches out to crown him, and an Asiatic prisoner follows behind. Other barbarians offer tribute in the lower panel, while a pair of generals carry miniature figures of Victory in the side panels (one now missing). Overhead, however, where Roman imperial iconography might exhibit personifications of Constantinople, a youthful Christ now rules in the heavenly sphere of sun, moon, and stars. On either side of Christ the traditional female winged Victories have been transformed into male angels.

The Period of Crisis

The image of universal Roman rule that Justinian raised in the heart of the city represented a perennial ideal in Byzantium; when Charlemagne assumed the title imperator Romanorum, ("emperor of the Romans") upon his coronation in 800, the Byzantine court objected that he was no more than a "king of the Franks." But in fact Justinian's military gains in Italy were rapidly undone by the Lombard invasion of 568; the Danube border could not withhold the Avars and Slavs who by the end of the century had overrun the Balkans, where the Slavs settled permanently: and on the Persian border Justinian's successors fought tirelessly for the rest of the century before the Persian victories of 605. Herakleios (610-41) managed to reverse this for a period, but the rise of Islam in the Arab world permanently ended Byzantine sway in the eastern Mediterranean. Syria, Palestine, Egypt, Cyprus, and Rhodes were all in Arab hands by 654. Not until they encountered the walls of Constantinople itself in 678 was the Arab advance stopped in a decisive Byzantine victory.

The seventh and eighth centuries were a dark period for Byzantium. The population was sharply reduced by outbreaks of the

bubonic plague, and the Arab conquest of Egypt cut off the grain supply. While the Arabs continued to raid Asia Minor, the problem of icon worship (see Chapter Two below) divided the empire into bitter factions. Apart from repairs to the defenses, all civil construction in Constantinople ceased until around 800. Three factors guaranteed the survival of Byzantium: first, the impregnable defense system of the Theodosian walls around Constantinople itself and a professional military with proud regimental traditions; second, the survival of the fiscal system of land-based taxation, which disappeared in the West in the face of the Germanic invasions; and third, a sense of popular loyalty to the empire, reinforced by a common religious identity. All of these factors contributed to a medieval state that was more cohesive than the early Byzantine empire and more focused on Constantinople and the imperial court.

Medieval Constantinople

The city that emerged from these straitened times around 800 was a very different Constantinople. While the hippodrome continued in use for games and imperial display, many of the public spaces of the Early Byzantine city proved too grand for the city to maintain. The forums were gradually transformed into markets, and the stoas of the colonnaded avenues were partitioned for private use for shops and dwellings. The great Baths of Zeuxippos, which Constantine had decorated with statuary and Justinian had restored, no longer functioned as baths after the eighth century; one part was used as a prison, another as a silk factory. The decline of the public bath is an important signal of the abandonment of a whole way of life, in which the traditional Greco-Roman cult of athletics and of nudity had played a large role. Antique-style nudes occasionally re-emerge in Byzantine art, as we will see, but the most important use of the nude has nothing to do with games and athletes but rather with the solemn narrative of the Passion of Christ.

Much of the city's heritage of ancient statuary was lost in the interval, and by the tenth century the identity of many surviving pieces had been forgotten. Statues of pagan philosophers were reidentified as Christian saints; other sculptures were thought to possess spirits and were used for magic and fortune-telling. The narratives encircling the columns of Theodosios and Arkadios were reinterpreted as prophetic, containing in cryptic form the future history of the world down to the end of time. The city not only had a different shape, it had a different mentality. The new shape had much to do with Constantinople's rise as an international center of commerce; vast emporiums lined the wharves on either bank of the Golden Horn. Only Baghdad and Cordoba, both Islamic cities, could compare in volume of trade. A Jewish merchant from the latter, Benjamin of Tudela, recorded his impression of the city in the 1160s:

All kinds of merchants come from Babylon and Shin'ar, from Persia and Medea, from all the kingdoms of Egypt, from the land of Canaan, from the kingdom of Russia, from Hungary, from the land of the Petchnegs [Rumania], from Kazaria [the Caucasus], from Lombardy [Italy] and from Spain. It is a tumultuous city; men come to trade there from all countries by land and by sea. There is none like it in all the world except for Baghdad. ... They say that the city's daily income, what with the rent from shops and markets and what with the customs levied on merchants coming by sea and by land, reaches twenty thousand gold pieces.

Grand imperially founded monasteries were a second important factor shaping the medieval city. Instead of erecting public forums, medieval emperors founded monasteries that constituted small

20. Triple church of the Monastery of Christ Pantokrator, Istanbul, 1118–36. View from the west.

The church on the right was the *katholikon* or principal church of the monastery, while that on the left was the public church of the Mother of God; between them stood St Michael's, the burial church of the Komnenian dynasty.

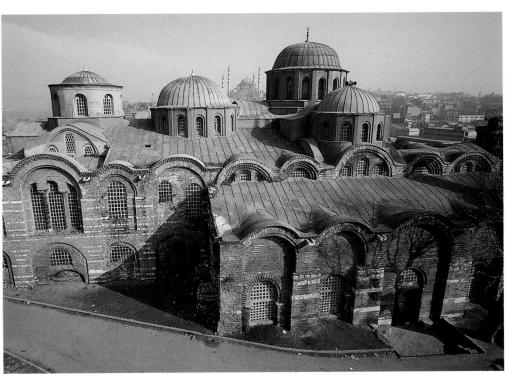

cities within the city. Starting with the foundation in 1030 by Romanos III (1028-34) of the Peribleptos Monastery in the south-west sector, these super-monasteries became the chief vehicles of imperial philanthropy. While rural monasteries functioned as agricultural "communes," subsisting on the land, urban monasteries served important public and social functions, running schools, hospitals, orphanages, and homes for the aged. Of these super-monasteries only the triple church of the Monastery of Christ Pantokrator survives, high on the ridge above the Golden Horn (FIG. 20). The monastery, founded in 1136 by John II Komnenos (1118-43), included an old men's home and a fifty-bed hospital divided into ten wards for different diseases, the women's ward having a female medical staff. The monks' church, the katholikon, was prohibited to the public, but to the north (left) was provided a public church of the Mother of God, which was serviced by secular clergy and was the goal of a weekly procession of icons. Between the two stood the imperial mausoleum of the Komnenian dynasty.

Medieval Constantinople was also graced with the lofty palaces of the rich, many of which clustered along the Marmara shore, where they aped the Great Palace of the emperor. The

emperor's central position in society was certainly felt throughout the medieval city, but it was asserted not in the monumental iconography of the Early Byzantine period but in the drama of ceremonial now lost to view. Our best documentation of the new ideology of kingship is sometimes found in small-scale works in ivory or in manuscripts. While these are clearly intended for more limited circulation, they often reflect the public ceremonies of coronation and triumph that the city witnessed in the hippodrome and cathedral.

In his coronation portrait of 945, the emperor Constantine VII Porphyrogennetos had himself represented as personally crowned by Christ (FIG. 21). While in Justinian's ivory Christ blessed the emperor from the celestial realm above (see FIG. 6), here Christ descends into the emperor's own space to confer the crown on him. This is an important innovation. Ancient Roman iconography had shown the emperor in the presence of the pagan gods

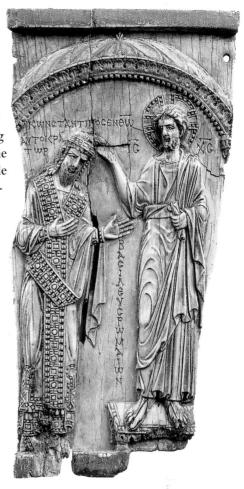

21. The Crowning of Constantine VII Porphyrogennetos, 945. Ivory, 7% x 3%" (18.6 x 9.5 cm). State Pushkin Museum of Fine Arts, Moscow.

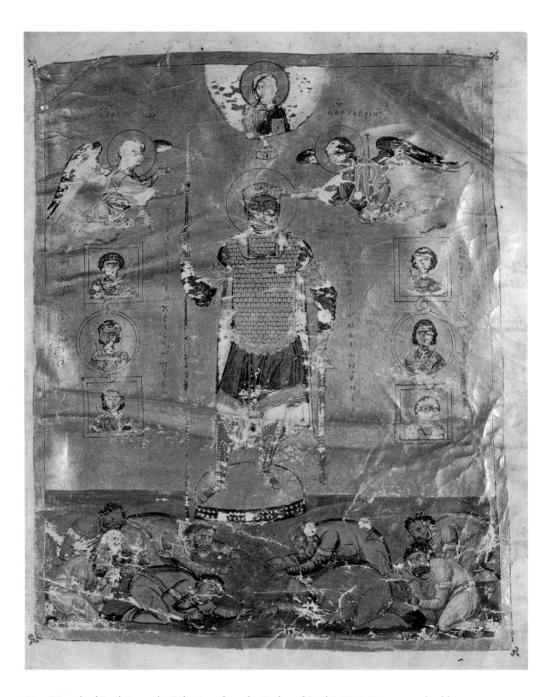

22. Triumph of Basil II over the Bulgarians, from the Psalter of Basil II, 1017. Tempera and gold on parchment, $15\% \times 12''$ (39.5 x 30.5 cm). Biblioteca Marciana, Venice (Cod. Gr. Z, 17, fol. 111).

The triumphant emperor Basil is flanked by heavenly warriors: on the left is Archangel Michael above icon-like images of the soldier saints; on the right is Archangel Gabriel above images of three more soldier saints. The miniature has suffered considerable flaking.

but always as the gods' suppliant or priest, making offerings to them. Now the tables are turned. The divinity serves the emperor, making him his rightful delegate on earth. The change reflects the general sacralization of the imperial coronation ceremony itself. While in early Byzantium it was the army that crowned the emperor before the public in the hippodrome, in medieval Byzantium the patriarch crowned the emperor in the ambo or pulpit of Hagia Sophia. The ivory, however, represents not the historic patriarchal crowning, but the personal intimacy the emperor is imagined to enjoy with Christ. The inscription proclaims "Constantine through God the autokrator and the basileus of the Romans;" autokrator is the ancient title of the Roman emperor, but basileus ("king") is a new title assumed in the seventh century through analogy with biblical kings and with Christ himself, often addressed as basileus in prayers. The emperor wanted to situate himself in a line stretching back to King David. This ivory panel would have been offered to announce the emperor's coronation to an ambassador or important ally, and the imagery had additional popular circulation on coins.

A purposeful identification with King David lies behind the illustration of the Triumph of Basil II over the Bulgarians, for the miniature stands as frontispiece to a psalter and it is followed by six scenes of the exploits of David (FIG. 22). The longestreigning Byzantine emperor, Basil II (976-1025), incorporated Georgia, Armenia, and Bulgaria into the empire with unprecedented ruthlessness, relocating populations and blinding prisoners of war. The astute eleventh-century historian Michael Psellos said his rule was founded on terror rather than loyalty. Concerning his conduct of war, he recounts, "Basil did not follow the customary procedure of other emperors, setting out at the middle of spring and returning home at the end of summer. For him the time to return was when the task in hand was accomplished." When he returned from his campaign against the Bulgarians in 1019 he celebrated a formal triumph, entering through the Golden Gate and driving his Bulgarian captives before him, including the archbishop David and the wife of the Bulgarian tsar, who had died in combat. The Bulgarian lords who grovel at his feet may reflect the actual ceremonies of triumph as conducted in the hippodrome before the jeering crowd. But the rest of the image is symbolic, presenting its ideological message in symmetrical order against a ground of gold. Basil is surrounded by a celestial hierarchy. In heaven above, Christ holds the crown that will be Basil's ultimate reward; from either side the archangels fly to his assistance, Gabriel presenting him with a spear while Michael bestows his earthly

crown; Basil's military patron saints flank him on either side: the two Sts Theodore, Demetrios, George, Prokopios, and Merkurios. According to the accompanying inscription, they "fight beside him as with a friend, laying low the enemies prone at his feet." Basil himself, in larger scale than the figures around him, is doubly armed, holding a sword as well as a spear; he wears high red boots, a cuirass of mail, and a purple tunic with Islamicstyle arm bands including pseudo-Arabic inscriptions (tiraz), to demonstrate his authority to the whole Near East. He is the personification of God's righteousness.

The Triumph of Basil II stands in a direct line of descent from the Triumph of Theodosios I on his obelisk base in the hippodrome. The distance between the two images is the religious canonization of the emperor in the latter. Whatever the behavior of their sovereigns and however devious their route to the throne, their divine appointment was an unquestioned premise in the ideology of Byzantium. Throughout Byzantine history the propaganda of imperial images announced the severity and absolutism of the autocracy.

Because Byzantine law lacked regular provision for imperial succession, family dynasties became all important, the longestlived being the Macedonian dynasty (867-1056) and the Komnenian (1081-1185). The mechanism for guaranteeing succession

consisted in making one's heir co-emperor during one's

lifetime. This was the motivation behind the relief of John II Komnenos, founder of the Monastery of Christ Pantokrator (FIG.

> 23). Judging from its size and marble manufacture, it was intended for exterior display, along with

an identical relief of his father, Alexios I (1081–1118), now in Venice. The two emperors, distinguished only by the longer beard of the elder, are laden with their attributes of power. By exception they wear not only a gem-studded loros, or scarf of festive occasions, but also the more usual gem-studded sagion (mantle), or

They wear crowns and carry scepters and cross-surmounted globes, symbols of world

23. Emperor John II Komnenos, 1110-18, Marble relief tondo, diameter 351/2" (90 cm). Byzantine Collection, Dumbarton Oaks, Washington, D.C.

John II Komnenos ruled 1092-1143 and was coemperor with his father Alexios I Komnenos 1092-1118.

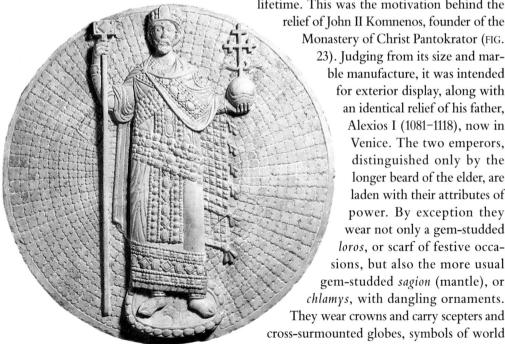

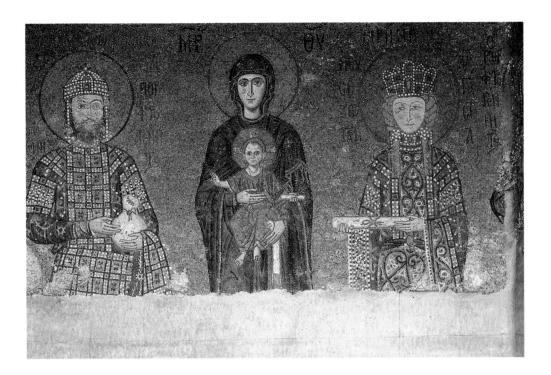

dominion. They were co-emperors 1092–1118, and they stand against a sunburst decoration, a popular symbol of the ruler's brilliance.

John II, the most successful of the Komnenian emperors, led Byzantine troops to victory on all sides, from Antioch to Serbia. When he in turn sought to ensure the succession of his eldest son, Alexios, he named him co-emperor in 1122 and included him in his mosaic portrait in the gallery of Hagia Sophia (FIG. 24). John and his wife, Irene, flank the Mother of God, and the emperor shows his philanthropy by offering a sack of gold, his usual gift on visiting the cathedral. The imperial family stand in the immediate presence of the Mother of God, whose throne was only slightly elevated on a pedestal. The contrast between the divine and human figures is significant, for the shadowing and modeling actually give Mary and her Child a

greater reality status than the imperial family. The imperial couple appear fragile and linear, their opulent dress and regalia being more important than their persons. The inscriptions emphasize that Alexios, like his father, is *porphyrogennetos*, that is, "born in the purple" chamber of the palace as legitimate offspring of the emperor. In the event, Alexios predeceased his father and a younger brother, Manuel I, succeeded to the throne (1143–80).

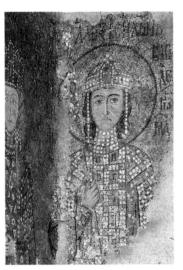

24. Virgin and Child between John II Komnenos and Irene (top), 1118, with their son Alexios (above), added c. 1122 to the right of Irene. Mosaic panels. South gallery, Ayasofya Museum, Istanbul.

The Decline of Constantinople

Indomitable as the empire appeared in the time of Basil II, or even of John II Komnenos, larger forces were at work with which Byzantium eventually proved unable to cope. One was the mounting pressure of the migration from Asia of the Turks - initially the Seljuk Turks and later the Ottomans. The other was the increased involvement of Europe in the eastern Mediterranean - both in the aggressive expansion of their commerce and in the political expansion of the states established by the Crusades. The two developments were intertwined. With their victory in Mantzikert in 1071 the Turks made their first major invasion into Anatolia, and Alexios I Komnenos sought the help of western Europe and the papacy to counteract the Muslim advances. It was partly in response to this plea that the papacy promoted the first Crusade. The first Crusade did in fact give Constantinople some reprieve, driving the Turks out of western Anatolia, but it also established a string of Crusader states from Antioch to Jerusalem (lasting 1099-1291), which decisively established Western hegemony in the Mediterranean. French, Norman, and Italian trading interests expanded at the expense of Byzantine.

It was the commercial interests of Venice that diverted the Fourth Crusade from its goal in the Holy Land to an assault on Constantinople, ending in the disastrous sack of the city in 1204. "The booty gained was so great that none could tell you the

25. Late Byzantine extension of the Blachernai Palace, now called the Tekfur Saray, fourteenth century. Istanbul.

end of it," wrote the French chronicler Geoffrey of Villehardouin. "Gold and silver, and vessels and precious stones, and samite and cloth of silk, and robes vair and grey, and ermine, and every choicest thing found upon earth. Never since the world was created, had so much booty been won in any city." Churches were sacked, relics and sacred vessels were eagerly carried off. Bronze statues that survived from the founding of the city were melted down—the Byzantine historian Nichetas Choniates mentions statues of Hera, Paris, and Aphrodite from the Forum of Constantine and a giant Herakles from the hippodrome. Large portions of the city were consumed in the fires that accompanied the hostilities.

Constantinople became seat of a Latin kingdom (1204-61) under Venetian and papal sponsorship. The Byzantine empire was dismembered, only fragments remaining in Greek hands. When Michael VIII Palaiologos (1259-82) drove the Latins from Constantinople in 1261, he took up residence in the Blachernai Palace in the northern corner of the city, the preferred residence of the Komnenian emperors. The latest extension of that palace, a fourteenth-century addition which is now called the Tekfur Saray, still looms over the city at the highest point in its topography (FIG. 25). The palace's location on the walls gave it a strategic importance, allowing the imperial guard to double as defenders of the city. In the early fourteenth century wealthy aristocracy established churches of great elegance nearby along the high ridge of the city, and Constantinople saw an intellectual and artistic revival of importance far beyond the borders of the empire. But the borders in this final, Palaiologan phase included only Thrace, the city of Thessaloniki, and a portion of the Peloponnese in southern Greece (see FIG. 3). The city itself was a cluster of villages with a total population of perhaps fifty thousand and its trade was in the hands of Venetians and Genoese. The Turkish threat returned.

By 1304 the Ottomans had captured the last remaining Greek city on the Aegean, Ephesos, and had reached the Marmara Sea opposite Constantinople. By 1376 they had taken Thrace, setting up their capital at Adrianople, and they proceeded by stages to wrest the Balkans from the Serbs. The fall of Constantinople was a foregone conclusion; aid from the West, sought in repeated personal visits by the emperor, was always predicated upon submission to the papacy, which was inconceivable to the Byzantines. Entering the city on 29 May 1453, Mehmet II made it into the capital of a new empire that was soon virtually coextensive with the medieval Byzantine empire but was based in an entirely different culture.

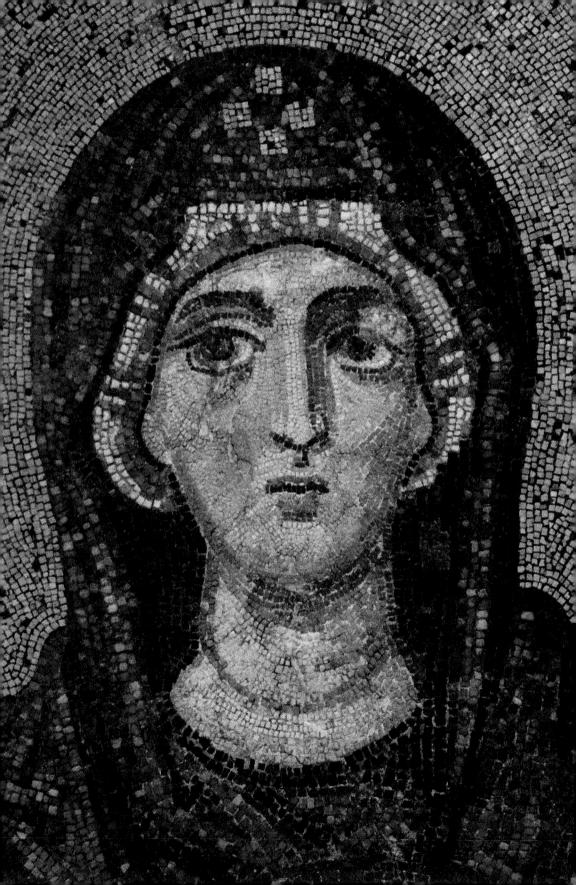

TWO

Icons

than the icon, for the icon both gives Byzantine art its distinctive formal aesthetic, marking a radical divergence from its classical origins, and stakes out a new ideological territory for painting. Because icons evoked such intense involvement, they became in the eighth century the subject of a passionate debate over the place of art in Christian worship. Icons became motives for murder and harsh political repression. But the debate resulted in the formulation of the most exalted theoretical justification for image veneration; perhaps no other culture has assigned painting so essential a role in making the divinity available to the worshipper. This had wide repercussions throughout Christendom, in western Europe as well as in the East. Moreover, the icon was the genre through which the devices and compositions of antique portraiture were transmitted through the Middle Ages to the Renaissance. Icons are the motor-force of Byzantine art.

The art-historical use of the term icon is much narrower than the Greek word *eikon*, from which it derives, which embraces all sorts of images, including sculptures and even mere mental images. In art history the term icon designates a wood-panel painting of a sacred subject intended for cult. By extension the term is applied to sacred images in general, including wall paintings or mosaics and miniature paintings in other media. But the size and mobility of painted wood panels gave them a special place in medieval life. Icons could be opened and shut, be carried in parade through the city, and even accompany troops to battle. They entered the ebb and flow of human affairs.

26. Mother of God in the apse of Hagia Sophia, 867 (detail). Mosaic. Ayasofya Museum, Istanbul.

In a sermon delivered in the presence of the coemperors Michael III and Basil I on the dedication of this mosaic, the patriarch Photios remarked on the lifelike character of the image: "You might think her not incapable of speaking...to such an extent have the lips been made flesh by the colors."

Pagan Origins

The patchy survival of icons into the twentieth century makes their history a difficult subject, and this is due in part to the fragile nature of the art form. Left to themselves, wooden pan-

27. Enthroned Mother of God Between St Theodore and St George, sixth century. Encaustic on board, 27 x 19¾" (68.5 x 49.7 cm). Monastery of St Catherine, Mount Sinai.

There are no inscriptions to label the figures, but the angels should probably be identified as Michael and Gabriel and the soldiers, holding crosses symbolic of their martyrdom, as St Theodore the General, bearded, and St George.

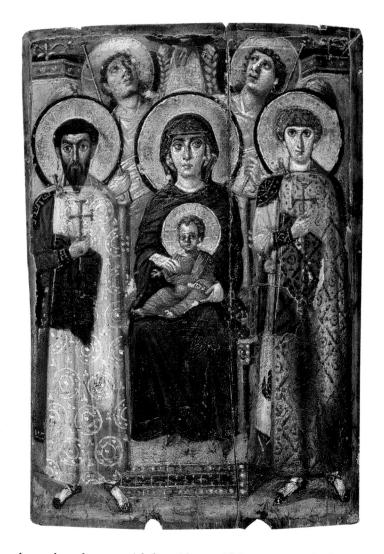

els crack and warp with humidity as if they were actively trying to shed the layer of paint on them; and they are ready food for termites and beetles (FIG. 27). But human intervention has also taken a high toll of the genre: the devout put them in constant jeopardy with candles, while their enemies, whether Christian purists who sought to remove them from religious use or non-Christians bent on the destruction of the religion altogether, found icons an easy prey. Vast numbers of icons survive in Russia from the post-Mongol period (i.e., after the fifteenth century), but the further back one looks the scarcer they become. From the sixth and seventh centuries, the period of the first flowering of icon painting, about three dozen icons survive, but there are none earlier than that.

The origin of icons, however, was much earlier than the sixth century. In spite of the Old Testament prohibition of image veneration, the apocryphal Acts of John mention an icon of St John the Evangelist that was venerated in private with candles and wreaths as early as AD 200. The practice was recognized as an adaptation of pagan practice, and this caused problems from the outset. Eusebios, bishop of Caesarea in Palestine, witnessed this cross-cultural phenomenon in the early fourth century: "I have examined images of his apostles Paul and Peter, and indeed of Christ himself, preserved in color paintings; which is understandable, since the ancients used to honor saviors freely in this way following their pagan custom." Eusebios expressed his disapproval of the practice when Constantina, the sister of the emperor Constantine, wrote to him to procure an icon of Christ. "These are excluded from churches all over the world," he said. His disapproval, however, was relative. When another woman brought him an icon of Paul and Christ he confiscated it but preserved it in his own home, on the grounds that he was preventing its improper use by the woman.

It is significant that these early mentions of icons refer to a domestic situation where popular piety was less constricted by authoritarian control. The home was to remain, throughout the history of Orthodoxy, the primary base for the development of icon cult. Every household had an icon corner, referred to in Greek as to eikonostasi ("the icon stand") and in Russian as the krasni ugal ("the red or beautiful corner"), and visitors upon entering were expected to greet the icons placed there even before greeting their host (FIG. 28). It is significant too that the home belonged traditionally to the women's sphere of control. As women's role in public worship was severely curtailed, the priesthood being restricted

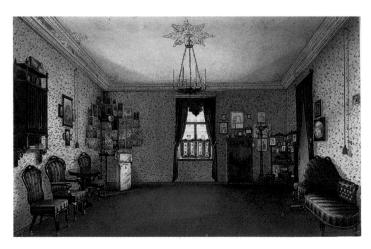

28. IVAN PETROVICH VOL'SKII (1817–68)

Russian Living Room with an Icon Corner. Watercolor on paper, 7 x 11¼" (18.1 x 28.6 cm).

29. Suchos and Isis, c. 200. Tempera on board 24% x 23½" (62.5 x 59.5 cm). Ägyptishe Museum, Staatliche Museen zu Berlin, Berlin.

This icon was destroyed during World War II.

to men, the cult of icons in private gave them an outlet for personal piety. Women were to play a decisive role in maintaining the tradition of icon veneration during periods of persecution.

The archaeology of Syria and Egypt has recovered for us a number of the images of the "saviors" whom the pagans were honoring in their home in Eusebios' time. The icon of Suchos and Isis, destroyed during World War II, was discovered in a house in the Fayum in Egypt (FIG. 29). The painting was executed c. AD 200 in tempera, an egg-based medium, on a light coat of gypsum over wooden panels held together by a frame. The gods sit in a cushioned double throne holding in their laps the symbols of their fertility, the water god Suchos clutching the crocodile sacred to the Nile,

and Isis a sheaf of corn; their offspring Harpocrates is shown in miniature between them. The gods glared directly at the beholder, their countenances ringed with haloes; but, as if this constant gaze was too intense for continual exposure, the frame of the icon was equipped with a sliding lid, allowing the owner to conceal the divine presence. Opening the lid activated the icon, making the gaze suddenly and dramatically shine forth.

In addition to their fertility gods, who would ensure the health and propagation of the family, domestic worship also included military gods, guardians who would assure one's safety in this life and the next. Heron in his military dress was the most popular in the latter category. On a panel in Brussels he is accompanied by a Syrian god (on the left; FIG. 30). Both are clothed as soldiers; Heron carries a spear and sword and wears a gorgon's head on his cuirass to frighten off all evil. His companion carries a double-headed axe and a cobra-entwined spear. A black servant, in miniature, stands behind Heron, while a woman, possibly the owner of the icon, stands in the bottom left corner.

The veneration of such images included candles, incense, and wreaths, and the placing of cushions before them for the worshippers. Unlike the grand statues that inhabited the pagan temples – the "idols" that Christians most abhorred–these painted icons were approachable, touchable gods that were part of everyday life.

30. Heron and Anonymous Military God, c. 200. Tempera on board, 95% x 736" (24.5 x 19 cm) without frame. Musées Royaux d'Art et d'Histoire, Brussels.

Although pagan, these panels represent a radical departure from the norms of classical painting, a departure sometimes mistakenly attributed to Christian art. The figures are static, and frontally posed, with minimal attention to their anatomy or their spatial setting. While classical paintings typically present a kind of stage on which the figures act out a story among themselves, these figures instead turn to engage the spectator, looking for viewer response. Narrative gives way to eye contact. The halo, the ring of light or fire around the head, both emphasizes the power of the god and attracts the viewer's eye like a sunburst.

Sixth-century Icons

Many of the earliest Christian icons, those of the sixth century, are governed by a similar aesthetic. In the icon of *Christ and St Menas* the frame is painted on the heavy slab panel rather than

31. Christ and St Menas, sixth century. Tempera on board, 22% x 22%" (57 x 57 cm). Musée du Louvre, Paris.

constructed around it, but the medium remains tempera and the figures have the same squat proportions and static poses (FIG. 31). The artist suggests a background of green hills against a desert sky of orange, perhaps meant for a Nile landscape. But the figures do not inhabit the landscape, they stand before it, their feet resting on the picture frame as they enter into the viewer's space. As in the *Heron* icon, the figures are not modeled but outlined with strong black lines. Christ, *philanthropos* (lover of men), puts an arm over the shoulder of Abbot Menas as if escorting him into Paradise.

If this aesthetic was the sole inspiration for icons, Byzantine painting would have remained straitened indeed. Other sixth-century icons, however, breathe quite a different air, standing directly in the tradition of ancient Roman portrait painting. In the *St Peter* icon from St Catherine's Monastery, Mount Sinai, the apostle dresses like a classical orator with his right arm wrapped in the sling of his mantle (FIG. 32). Carrying the keys of his office as first apostle and the cross of his martyrdom, he stands confidently before a semicircular niche, and both the niche and the figure are deeply shadowed by light falling from the left. The slight turn of the head, the unequal eyes, and the ruddy complexion give liveliness to the

Opposite

32. St Peter, sixth century. Encaustic on board, 36½ x 21" (92.8 x 53.1 cm). Monastery of St Catherine, Mount Sinai.

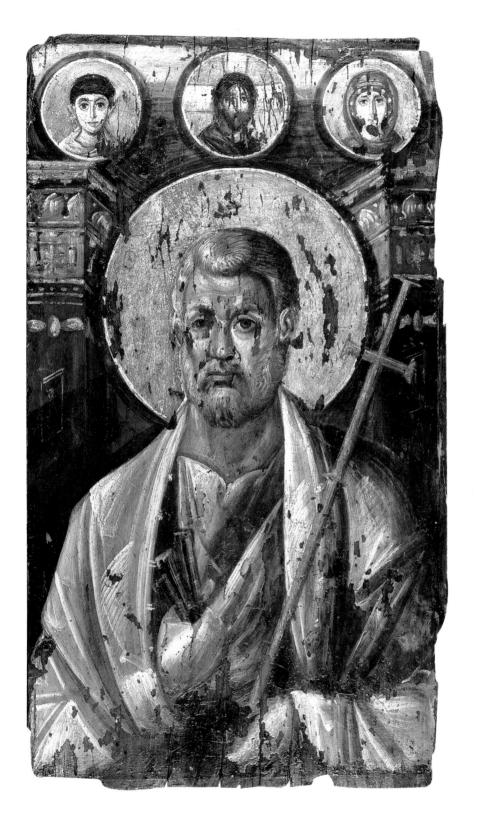

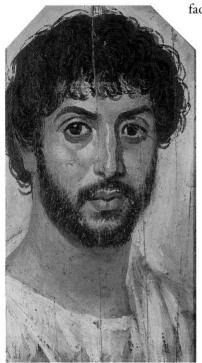

33. Mummy portrait of a middle-aged man, from the Fayum, c. AD 200. Encaustic on board, 16¼ x 7¾" (41.5 x 19.5 cm). State Pushkin Museum of Fine Arts, Oriental Section, Moscow.

face. Moreover, instead of tempera the artist has employed

encaustic, pigments in a wax medium; this was the preferred medium of Roman portrait painting, best witnessed by the mummy masks of the Fayum (FIG. 33). The translucence of the wax gives the facial tones a glow similar to that of modern oil paints. The half-length format too is typical of Roman portraiture, just as the full-length figure is typical of the pagan icon tradition. Yet from the latter the painter retains the halo, now sharp as a dinner dish, and an arbitary scale that allows him to insert three mini-icons at the top.

These portrait techniques could also be used within the traditional format of the pagan icons. The *Enthroned Mother of God* from Mount Sinai retains the full-length figure format of the pagan icons; like the fertility goddess Isis, Mary sits on a high-backed, cushioned throne, and all figures are haloed (see FIG. 27). But unlike the pagan icons the technique is encaustic, with a rich impasto of glowing flesh tones, and portrait-type lighting creates a kind of spatial shelf for the figures. The angels twist to look toward the hand of God, which pours a ray of light on the divine Mother from above.

The Byzantine icon, then, represents a wedding of the pagan icon genre to Roman secular portraiture. The portrait element was extremely important to Christians in rationalizing their image veneration, but it was less important to their pagan predecessors. Pagan philosophers such as Dion Chrysostom (c. 40-120) readily admitted that the gods had no human form at all, but "in the complete absence of the original model," he said, "one represented them as human because the human was the most godlike form on earth." Christians, on the contrary, insisted on the authentic portrait character of their icons; because Christ and the saints had genuine, breathing, human bodies they were truly paintable. Thus in the legend of St John's icon referred to above, the apostle himself verified the fidelity of his likeness by comparing the painting to his reflection in a mirror; and it was believed that in the fifth century Eudokia, the wife of Emperor Theodosios II, had discovered the portrait of the Mother of God which St Luke the evangelist had painted during her lifetime. By claiming portrait status for their icons Christians hoped to distance them from the icons of their neighbors.

From the outset, then, Byzantine icons were enriched with all the devices and compositions of Roman portraiture, and the previously pagan icon genre, a minor genre of limited artistic possibilities, was thus enlarged and transformed into a medium of major importance for Western art. At the same time portraiture brought with it a wealth of earlier associations. Classical literature describes portraits as so lifelike as to deceive viewers; they are sent as reminders of absent friends; young men fall in love with women presented to them in portraits. By insertion in the portrait tradition Christian icons gained all this web of sentimental connotations, and this is reflected in literature. Icons were expected to evoke personal reactions from the viewer, including even affection.

Christian claims of historical authenticity for their icon portraits, however, were founded on faith more than fact. While portraits of St Peter show considerable consistency in his blocky face,

gray hair, and short beard, early representations of Christ show a considerable disparity and reflect a genuine uncertainty about how he ought to look. In the time of Bishop Gennadios of Constantinople (458–71) "a painter who dared to paint the Savior in the likeness of Zeus" found his hand withered. The bishop healed him and instructed him that "the other form of Christ, that is the one with short, frizzy hair, is the more authentic." Both types were in circulation on sixth-century icons, along with an old-man type, called the Ancient of Days. The Zeus type came to win out not because it was more "historical" but because it was more forceful. The great male gods of antiquity - Asklepios, Serapis and even Suchos (see FIG. 29) - all assumed the broad forehead, long hair, and full beard that characterized Zeus, the father of the gods. Christ could hardly be seen as less powerful than they.

No image demonstrates the appeal of this facial type more forcefully than the icon of the *Blessing Christ* at St Catherine's Monastery on Mount Sinai, in which the Savior is given Zeus' full parted shoulder-length hair and his rounded beard of medium length (FIG. 34). All the verist tricks of Roman portraiture are added to convey the powerful presence of Christ.

34. *Blessing Christ*, sixth century. Encaustic on board, 33 x 18" (84 x 45.5 cm). Monastery of St Catherine, Mount Sinai.

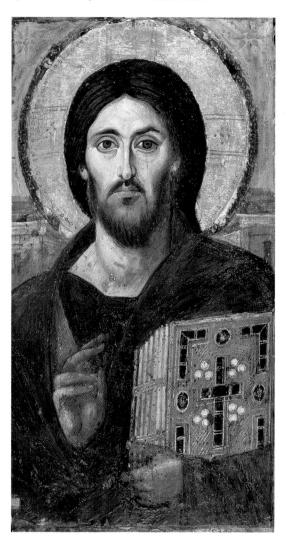

As in mummy mask portraits, Christ's left eyebrow arches higher than the right, and his moustache is crooked. Like St Peter, he stands before a niched wall, and he turns slightly to his right, making his left shoulder higher than his right. But alongside these naturalistic techniques a new device is used here that is foreign to Roman portrait painting, and that is the more than life-size grandeur of the figure. This is difficult to appreciate in pocket-size reproductions, but on approaching close enough to worship, the viewer would discover that Christ is more than human in scale, and by implication superhuman in nature. Larger-than-life scale remains an option throughout Byzantine painting whether on panels or in murals.

Icons in Church

Scale is closely linked to the destination of a given icon. Icons meant for private domestic use would have been more intimately scaled, while those intended for public display in church would be scaled to carry across a greater distance. The Blessing Christ was clearly intended for church use, and very likely made in Constantinople itself, judging from the high quality of the painting. In spite of considerable resistance, already in the fifth century icons were being set up in churches. But the next step was a momentous redefinition of the holy, for in the sixth century icons invaded the very sanctuary space of the church and were placed both in the curving vault of the apse and on the templon, the columned barrier separating the area of the clergy from that of the laity. This altered decisively the Christian religious experience, interposing images between the worshipper and the holiest sacrament of the altar. This in turn inspired the development of the icon genre beyond painted panels to include saints executed in precious materials, in mosaic and in marble.

At the same time icons involved patronage in the highest circles of government and court. The grand cathedral of Hagia Sophia, erected in 532–7 by the emperor Justinian I, set the pace for church decoration around the Byzantine world (see FIG. 19). Its *templon* carried an extensive set of silver relief icons including Christ, his Mother, angels, prophets, and apostles. These have not survived, but some of the marble relief icons from the *templon* of the church of St Polyeuktos (524–7) have been recovered in excavations. The wealthy Anikia Juliana (461/3–527/9), heir of the Theodosian family, commissioned the church and personally oversaw its furnishing. Each of these strongly modeled figures of Christ and the apostles glowed in the light of its own oil lamp, the dowel

hole for which is visible at the bottom of the image. Painted, the images would have come to life in an eerie, almost magical way. The *Blessing Christ* repeats the pose and gesture of the panel painting from Sinai (FIG. 35).

Meanwhile larger than life-size iconic figures peered out of the apse

above the altar. In surviving examples in Rome, Ravenna, and Cyprus (as presumably in the lost churches of Constantinople) the long, processional lines of the basilica converged on a glimmering gold conch alive with many-figured compositions. At the Panagia Angeloktistos Church in Kiti, Cyprus, the standing Mother of God assumes the pose known as the hodegetria ("the guide who shows the way"), for she holds her child in her left arm

and points to him with her right

(FIG. 36). This mosaic repeats the composition of the icon which the empress Eudokia brought from Jerusalem and installed in Constantinople, where it gained special renown for its power to cure the blind. In Kiti, Mary's staring face is severely geometrical, but her body sways gracefully as she steps forward, and the archangels Michael and Gabriel stride energetically to her side, their copious garments swishing around them. The charm of the graceful figures distills a thousand years of Hellenistic painting, while its compelling confrontational stance speaks of the new accomplishment of icon painting.

The icon had come of age as an art form and occupied the most holy place in the church building. It had also come to occupy a central place in the life of the Byzantines on all levels. On the popular level miracle stories multiplied around icons; the touch of an icon was thought to have curative powers and saints were imagined to step out of icons to help people in need. Among the middle class, merchants in Rome were hanging little icons of St Symeon Stylites, a Syrian ascetic, over their shops to protect their goods. Among the military, in 626 an icon of Christ was carried around the defenses of Constantinople to ward off a joint

35. *Blessing Christ*, from the church of St Polyeuktos, 524–7. Marble relief, 15 x 13¾" (38 x 35 cm). Istanbul Archaeological Museum.

The defacement of this relief is tangible evidence of the violence of Iconoclasm; nine more panels survive from the same church, in equally battered condition.

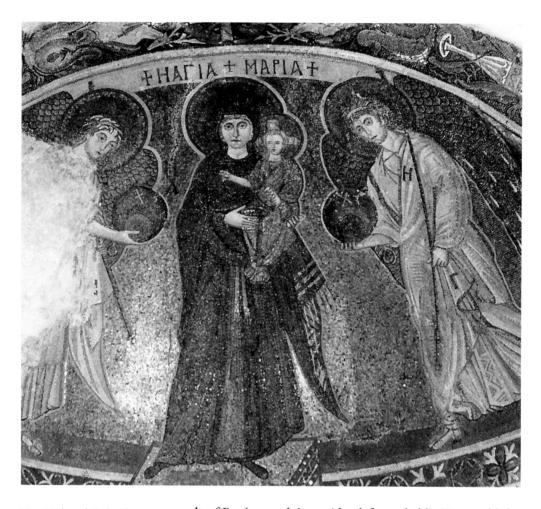

36. Mother of God with Angels, sixth century. Mosaic. Church of Panagia Angeloktistos, Kiti, Cyprus.

assault of Persians and Avars (the defenses held). Nor could the emperor be left out of this development. Leo I (457–74) insisted on including himself and his spouse in an icon of the Mother of God at the Blachernai Church in Constantinople; Justin II (565–78) placed a mosaic of Christ Enthroned directly over his own throne in the Chrysotriklinos, the golden reception room of the Great Palace; and Justinian II (685–95) put Christ's image on the face of his gold coinage, his own image being on the reverse.

The icon was also the subject of serious religious reflection. The reciprocal gaze of the saint seemed especially meaningful. On an icon of the archangel Michael, the poet Agathias (c. 532–c. 580) remarked, "The mortal man who beholds the image directs his mind to a higher contemplation. His veneration is no longer distracted: engraving within himself the [archangel's] traits, he trembles as if he were in the latter's presence. The eyes encourage deep thoughts, and art is able by means of colors to ferry over the

prayer of the mind." By gazing in the eyes of the icon one could transmit prayers directly to the saint. However, the lack of a more theoretical justification for icons was a distinct weakness in the movement, and Hypatios, the sixth-century bishop of Ephesos, when pressed to defend their use in church, could only argue weakly that "simple folk" seemed to need them.

Iconoclasm and the Theology of Icons

The mesmeric power of icons can be gauged by the violence of the reaction they eventually provoked. The brutal hammer blows that erased the features of Christ from the St Polyeuktos icon speak of a rage born of profound fear of the icon's burning gaze. The movement called Iconoclasm, literally the destruction of icons, took advantage of the theological weakness of icon veneration, but it was more than an academic debate. When a few of the bishops of Asia Minor raised the issue of the Old Testament prohibitions of idolatry, the emperor Leo III (717-41) took up the cause. In spite of the riot he caused, he removed an icon of Christ prominently displayed over the Chalke ("bronze") gate of the imperial palace, and he promulgated an edict against icons (726). The success of Leo's expeditions against the Arabs seemed like divine confirmation of his religious stance, and his son and successor, Constantine V (741-75), expanded the iconoclast campaign with harsh measures against monks. St Stephen the Younger was dragged from his cell and torn to pieces in the streets of Constantinople, making him the first martyr for icons. But the emperor also found it necessary to purge his government of officials sympathetic to icons, who were publicly beaten and executed. Churches were systematically stripped of their icons and relics.

The theological issues behind such intense reactions were not simple. Constantine V convoked the Council of Hieria in 754 to spell out the iconoclast position. Beyond the scriptural prohibition it argued that icons of Christ separated his human nature from his divine, since only the human nature could be depicted. But the heart of the problem was the question of worship. The placement of icons on the *templon* before the altar and in the apse above it had seriously jeopardized the status of the Eucharist as the prime focus of Christian worship. The council tried to reassert the pre-eminence of the sacrament over images by decreeing that only the Eucharist was an adequate symbol of Christ's presence.

St John of Damascus, a theologian from Syria, now beyond the Byzantine borders, led the Orthodox defense of icons. The argument took two forms. first of all, the defense of icons was

couched as a defense of the Incarnation, that is, the "humanification" of Christ. St John wrote, "When he who is bodiless and without form, immeasurable in the boundlessness of his own nature, existing in the form of God, empties himself and is found in a body of flesh, then you may draw his image and show it to anyone willing to gaze upon it." Icons were thus an assertion of the full humanity of Christ, a doctrine of cardinal importance for Byzantine humanism; for in marked contrast with the geometric and calligraphic art of Islam, Byzantine art would always be concerned principally with the human figure.

The second line of defense against Iconoclasm appealed to a neo-Platonic image theory that stressed the transparency of images. The Second Council of Nicaea, convoked by the empress Irene in 787, explained it in the following terms: "the honor which is paid to the image passes on to that which the image represents, and he who does worship to the image does worship to the person represented in it." In other words, it was not the material icon that was being venerated, but through it the saint or Christ himself.

The council, however, did not stop at affirming the permissibility of icons; it decreed the necessity of actively venerating icons whether "in the churches of God, on holy vessels and vestments, in panels or on walls, at home or on the streets, for the more often they are seen in their pictorial representations, the more the beholder is excited to the recollection and desire of the ones represented, and to offer them greeting and reverent worship." It is most interesting that at this point the council expressly employed the language of love. Epipothesis ("desire") is the word used for the lover's yearning or longing, while aspasmos ("greeting") is the word used for embracing and kissing, and in fact icons are commonly touched and kissed. The churchmen expected the faithful to fall in love with saints through their icons.

The decree was not sufficient to put Iconoclasm to rest, for in 813 Leo V the Armenian revived the imperial policy, though he managed to rally very little popular support for the cause. Again it was an empress, Theodora, wife of Theophilos (829-42), who after her husband's death oversaw the final rehabilitation of icons (March 843). As Irene had done before her, she flaunted

Theoktiste Instructing her Granddaughters Thekla, Anna, Anastasia, Pulcheria, and Maria in the Veneration of Icons, in John Skylitzes, Synopsis Historiarum, mid-twelfth century. Tempera on parchment, page 161/2 x 10¾" (35.5 x 27 cm), miniature 1½ x 7½" (5 x 18 cm). Biblioteca Nacional, Madrid (Ms. vitr. 26-2, fol. 44v).

the imperial edict by a clandestine worship of icons in her chambers within the palace. A precious miniature in the *Synopsis Historiarum* of John Skylitzes shows her five daughters being instructed to venerate an icon of Christ held by her mother, Theoktiste (FIG. 37). Skylitzes narrates: "She put icons in their hands (she kept them in a box) and holding them to the girls' faces and lips, blessed them and roused them to love icons." In the privacy of home, where the anti-icon edict was difficult to enforce, the cult was always kept alive, especially among women.

The Restoration of Icons

The defeat of the imperial policy of Iconoclasm represented a victory of popular religious practice over imperial policy. Theodora and the patriarch Methodios celebrated the event with a solemn procession of icons from the Blachernai Church to Hagia Sophia on 11 March 843. Subsequently, Theodora's son Michael III (842–67) restored the image of Christ to the Chalke gate, to the imperial throne room, and to gold coinage. And in 867, along with his co-emperor Basil I, he began the redecoration of Hagia Sophia by

installing a series of mosaic icons of single full-length saints, starting with the image of the Mother of God in the apse (see FIG. 26). Thus mosaic icons of single saints were the principal theme for the initial program of Hagia Sophia, and the cathedral set the pace for the redecoration of churches throughout the empire.

The miracle of the post-Iconoclast revival is that after the hiatus of a century artists returned to sacred themes with such sensitivity and competence. During Iconoclasm artists had found employment executing secular themes. Constantine V hired artists to replace the Life of Christ mosaics at the Blachernai Church with trees and birds (like the still-surviving Byzantine mosaics in the Great Mosque of Damascus). Similarly, in the Milion arch in the Augustaeum, he replaced mosaics of ecumenical councils with scenes of chariot races. But nothing prepares us for the achievement of the mosaic of Hagia Sophia. The enthroned Mother of God, dressed entirely in blue and holding a gold-clad Christ child in her lap, appears so lifelike that she is about to speak, according to the patriarch Photios who preached on the dedication of the image. Indeed the artist gave life to the figure by moist lips, a warm glow in the cheeks, a glance slightly askew, and a play

38. St Ignatios the Younger, in the north tympanum of Hagia Sophia, late ninth century. Mosaic, height 8'2½" (2.5 m).
Ayasofya Museum, Istanbul.

of light blue and green shadows. Thus he achieved in mosaic a vibrancy not inferior to that achieved in encaustic in the sixthcentury icon of the Enthroned Mother of God from Sinai (see FIG. 27). But the diversity of styles available in the sixth century, whether reflecting the realism of portraits or the severity of pagan icons, was still available in the ninth; the thirteen-foot St Ignatios the Younger in Basil I's decoration of Hagia Sophia (FIG. 38) has a rigid symmetry of face and an immobile fixity of stance, outlined with heavy contours like the figures in the St Menas icon. A controversial patriarch supported by Basil I, Ignatios was canonized in 886.

Few wood-panel icons survive from the ninth and tenth centuries to compare with the mosaic

39. St Nicholas, tenth century. Tempera on board, 16% x 13" (43 x 33.1 cm). Monastery of St Catherine, Mount Sinai.

icons of Hagia Sophia; nevertheless the new direction is clear. While most early icons were painted in encaustic, after Iconoclasm artists turned to tempera, with its matt finish and harder edges. The *St Nicholas* icon is typical (FIG. 39). The background is a space-denying gold leaf; and while the figure retains the half-length format typical of ancient portraits, the saint inhabits a very shallow space close to the picture plane, his elbows exactly meeting the corners of the frame. Something of ancient portrait technique survives in the soft shading of the face and the slight turn of the head; but the feeling is cool and reserved. This is the direction that Middle Byzantine sanctoral icons were to follow.

The most important locus for the development of icons in the period after Iconoclasm was the *templon* barrier enclosing the sanctuary part of the church. Innovations in *templon* icons had farreaching effects on images elsewhere in church. A critical step was

40. *Crucifixion*, ninth century. Tempera on board, 6½ x 5½" (16.6 x 13.9 cm). Monastery of St Catherine, Mount Sinai.

the introduction of narrative icons in a continuous painted beam atop the colonnade of the *templon*. Rare in the period before Iconoclasm, narrative icons are ubiquitous from the tenth century on. Narrative introduced a new, charged atmosphere into the icon repertoire. Again the impetus seems to have come from the private sphere.

Sometimes an inscription offers insights into the mentality involved, as in a miniature icon of the *Crucifixion*, clearly made for private use (FIG. 40). The inscription speaks in the voice of the viewer/owner, very likely a monk, in addressing Christ: "Who is not struck with fear and trembling at the sight of you, O Savior, hanging on the cross? You tore asunder the garment of death but are covered with the robe of incorruptibility." The powerful

emotions excited by the image focus on the nakedness of Christ. Pre-Iconoclasm Crucifixions had shown the Savior clothed in an ankle-length tunic, but the new humanism of the post-Iconoclasm period insisted on displaying the exposed body wearing only a loin cloth. Yet the viewer felt the offense, the shame of stripping the Savior, and therefore he insisted in the inscription that Christ was in fact fully clothed, even though his garment of "incorruption" was invisible. The attendant figures of Mary and St John the Evangelist seem to tremble in consternation at the sight. The naked body of Christ was to become a central theme for wall decoration in church.

The placement of a narrative set of icons on the *templon* represents an attempt to integrate their very direct appeal with the official cult of the liturgy. As a dramatic performance, the liturgy re-enacted the institution of the Eucharist at the Last Supper; but its prayers also commemorated the entire life of Christ comprehensively (referring expressly to his Incarnation, teaching, death, and resurrection), while its readings followed the course of his life discursively in the cycle of the year from his birth (Christmas) to his sending of the Holy Spirit (Pentecost). Icons illustrating the life of Christ therefore presented the devout with a vivid illustration of the history that liturgy presented more abstractly in prayer and symbol.

A tenth-century icon of the Washing of the Feet is the earliest surviving fragment of such a narrative set (FIG. 41). The horizontal split of the wood gives evidence that it comes from a plank placed horizontally across the top of the templon. The narrative moment chosen is Jesus' humble service of washing his disciples' feet in preparation for the Last Supper, when Peter spoke with enthusiasm, "Lord, not my feet only but also my hands and my head!" (John 13:9). Details of the setting in the upper room and the reactions of the other apostles are all subordinated to the personal encounter between Christ and Peter.

The earliest surviving complete beam (now divided) belongs to the early twelfth century and includes twelve subjects: the Annunciation, Nativity, Presentation, Baptism, Transfiguration,

41. Washing of the Feet, panel from a templon beam, tenth century. Tempera on board, 10 x 10¼" (25.6 x 25.9 cm). Monastery of St Catherine, Mount Sinai.

42. Entry into Jerusalem, Crucifixion, and the Resurrection, section from a templon beam, early twelfth century. Tempera on board, 17¾ x 42¾" (45 x 118 cm). Monastery of St Catherine, Mount Sinai.

Raising of Lazarus, Entry into Jerusalem, Crucifixion, Resurrection, Ascension, Pentecost, and the Dormition (FIG. 42). As in the Washing of the Feet, each composition is reduced to emblematic simplicity for maximum legibility. The eye glides easily from the humble prophet Christ on his donkey, to the graceful curve of his naked body on the cross, to his powerful trampling of Hades as he pulls Adam and Eve from their tomb in the Resurrection. But the Washing of the Feet was not in this set, evidence that the set could expand or contract; the stories surrounding Christ's birth and death were favorite areas for amplification. The purpose of the set was to present in legible sequence the steps by which Christ had worked the salvation of humankind.

Opposite

43. Entry into Jerusalem, from templon beam of the church of the Monastery of Christ Pantokrator, Constantinople, twelfth century. Enamel on silvergilt, 14¼ x 12¼" (36.7 x 31.3 cm), without framing. On the Pala d'Oro, S. Marco, Venice.

Byzantine goldsmiths were unmatched masters of their craft; *cloisonné* enamel involved pouring ground glass into compartments constructed of gold wire (*cloisons*), firing the glass until it fused with the gold, and grinding and polishing the whole to a mirror-like smoothness.

The sacredness of the *templon* screen as the enclosure of the all-holy rite of the Eucharist inspired the use of the most precious possible materials for the festival icons. Six brilliant enamel icons which belonged to the royal monastery of Christ Pantokrator have survived, having been robbed by the Crusaders and incorporated into the Pala d'Oro altarpiece in Venice (FIG. 43). Their extraordinary size (they are the largest surviving Byzantine enamel plaques) and their bold labelling in capital letters made them suitable for their architectural setting.

In addition to the narrative set, a single-saint templon beam was also introduced at this time, called the Great Deesis. The central unit of the set was a Deesis composition, that is Christ flanked by Mary and John the Baptist, who turn to him in prayer. John is entitled the "Forerunner," as the last of the prophets and witness to the Messiah. This set of three celestial powers was enlarged by saints placed on either side, similarly turning toward Christ in prayer, beginning with the princes of the apostles, Sts Peter and Paul. Other apostles, saints, and angels followed in hierarchic order.

44. Triptych of Constantine VII
Porphyrogennetos, 945–59.
Ivory, 9 x 11½" (23.6 x 28.7 cm). Palazzo Venezia, Rome.

The wings are wrongly assembled, the outsides facing in.

Although Deesis icon beams of the tenth century have not survived, their hierarchical order was frequently copied in private, portable icons, such as the ivory triptych of Constantine VII Porphyrogennetos (FIG. 44). Like most ivories, it was originally painted and gilded, ivory being chosen for its preciousness and durability. Its triptych format, common in ancient pagan icons, permitted its safe transport. Unfolded for the emperor's veneration, it presented a rearrangement of the program he might have found on a *templon*: the Deesis is in the upper middle register over the most distinguished of the apostles: Peter and Paul,

John and James, and Andrew, Peter's brother. On the doors eight military saints carry swords and the crosses of martyrs, ready to defend the peace of the empire. Bishop saints appeared on the outside of the doors. The inscription asks Christ to preserve the emperor from harm and grant him peace.

The purpose of the Great Deesis icon beam may also be described as in a sense liturgical, for it presented to the laity in strict order the saints whose invocation was repeatedly sought in the course of the liturgy. The ranking of the saints gave the worshipper reassurance of the correctness of his veneration. One eleventh-century monk expressed this sentiment when he wrote: "I render to the holy and venerable icons of Christ and the saints, realized with colors and other materials, a gradation of honor and veneration according to the proportion of the venerability of each prototype."

While the organization of the *templon* beam had a certain formality, icons elsewhere on the barrier were more freely chosen. The intervals between the columns of the *templon* were originally left open, but in the eleventh century the closing off to lay view of the holy of holies offered suitable framing for icons of larger scale. Because their lower placement made them more accessible, these grand icons had an enormous impact on the faithful. Church-goers came to touch and kiss them, to light candles before them, and speak directly to them in terms of endearment. Besides the Blessing Christ, whose choice was almost standard, the selection of saints depended on the dedication of the local church and the enthusiasm of its sponsor. The Mother of God in her many manifestations was the most popular choice.

Icons in Public

Not only in the privacy of home and in the sanctity of church, but even in the teeming streets and forums of the city icons held sway in the world of Byzantium. Like national flags in the modern world, they rallied the masses, led parades, and magnetized emotions. Whether the occasions were solemn and official or festive and commercial, indeed even in the fury and strife of battle, icons were plunged into the middle as powerful and magic symbols.

Perhaps the most traveled icon in Constantinople was that of the *Mother of God (Hodegetria)*, the city's most prized icon. Brought from Palestine by the empress Eudokia, as we have seen, and lost in the Turkish conquest, it was the most copied of all icons. The mosaic copy now in the Orthodox patriarchate in Istanbul is monumental in conception as well as in actual dimensions, being

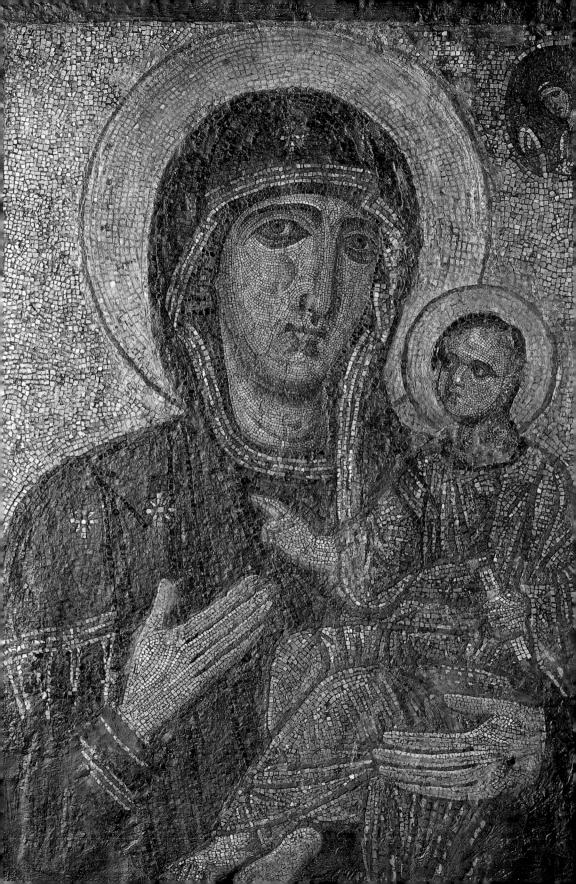

over-life size (FIG. 45). Commissioned by John Komnenos and his wife, Anna Dalassena for the monastery of the Mother of God Pammakaristos around 1060, it stands at the beginning of a series of precious icon panels executed in mosaic. The original Hodegetria was enshrined beside a miraculous well in a monastery near the Great Palace. In Lent it went to the church of the Mother of God in Blachernai, on anniversaries of the emperors' funerals it went to their burial chapel at the monastery of Christ Pantokrator, and every Tuesday during the rest of the year it made an excursion into the city. The exact route of the Tuesday procession is unknown, but its participants are mentioned: a cross-bearer led the way, the brothers of the confraternity of the icon carried the image mounted on a wooden pallet, deacons waved flabella (ceremonial fans) and swung smoking censers around it, cantors followed leading the people in song, and finally came the laity, men and then women. The icon-bearers claimed to feel a force within the icon directing their way.

It was the same icon that the emperor himself saluted when celebrating a military victory, and several such triumphs are described by the historians. Typically the parade route for a triumph stretched from the Golden Gate to Hagia Sophia. In 1167 Manuel I solemnized his victory over the Hungarians along the same route. The roadway was hung with purple and gold cloth, and prisoners of war preceded the dignitaries. The procession was recorded in the *Annals* of Niketas Choniates:

When the time came for the emperor to join the triumphal procession, he was preceded by a gilded silver chariot drawn by four horses as white as snowflakes, and ensconced on it was the icon of the Mother of God and unconquerable fellow general of the emperor. The most glorious and most great emperor mounted on a stately horse arrayed in the imperial regalia. Close behind came Kontostephanos, the man responsible for the triumph, receiving praise for his victory and congratulations for his generalship.

A twelfth-century miniature in the Skylitzes manuscript offers a striking illustration of such a procession, in which the emperor John I Tsimiskes rode in triumph behind an icon-laden carriage (FIG. 46). This time, however, it was the enemy's icon. Having captured the image in his 971 victory over the Bulgarians, the emperor brought it to Constantinople to contain its power, much as centuries earlier the Romans on conquering Asia Minor brought home the statue of Cybele, the local mother goddess.

Opposite

45. *Mother of God,* c. 1060. Mosaic on board. Greek Orthodox Patriarchate, Istanbul.

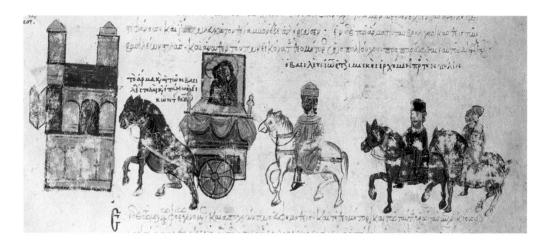

46. Triumphal Procession of John I Tsimiskes into Constantinople with the Preslav Icon, in John Skylitzes, Synopsis Historiarum, mid-twelfth century. Tempera on parchment, page 14 x 10%" (35 x 27 cm), miniature 1½ x 7½" (5 x 18 cm). Biblioteca Nacional, Madrid (Ms. Vitr. 26–2, fol. 172v(a).

Several accounts tell of icons going to war, but few such icons have survived. One is the Mother of God entitled *Nikopoios* ("maker of victory"), which is now housed in S. Marco in Venice (FIG. 47). It is a twelfth-century painting of very delicate, linear style, Mary assuming a frontal pose holding her Child before her. In the final Crusader assault on Constantinople in 1204, the emperor Alexios V carried the icon about the city, confident that it cast a protective net over his troops. But at the last minute the Mother of God seemed to switch sides, for both Alexios and the icon were taken captive by Henry of Flanders; the Venetians claimed it as booty, proof that Mary had given them their victory, and it came to be honored as fervently in Venice as it had been in Constantinople.

Many other surviving icons may have served in processions, but the historical circumstances of their creation and use are lost. One class of icons, however, contain clear evidence of their processional use for they are bilateral icons, that is, they are painted on both sides for simultaneous double viewing, possible only when carried in procession. The Hodegetria icon may have inaugurated the genre, for the fact that it was venerated on Good Friday suggested the addition of a Crucifixion on its reverse. The combination of Mary and the Crucifixion is the most common on bilateral icons, offering a poignant juxtaposition of the mysteries of life and death, Christ in the arms of his tender mother and stretched in his final agony on the cross. On the Vladimir Mother of God, the reverse of which carries an altar with the instruments of the Passion, the Child kisses his mother with enthusiasm and puts his arm around her neck (FIG. 48). His mother's darker face, however, expresses deep melancholy, her distant gaze and contracted brow reflecting her awareness of the painful destiny of her Son.

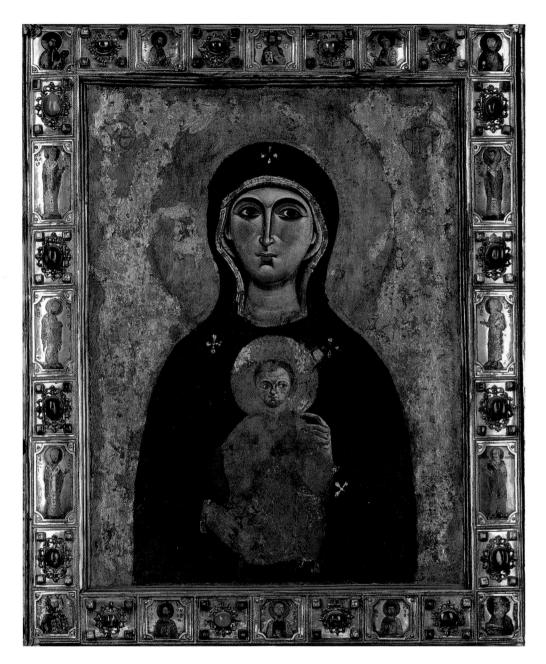

47. Mother of God "Nikopoios," twelfth century. Tempera on board, $1'7" \times 1'1"$ (48 x 36 cm). S. Marco, Venice.

48. Vladimir Mother of God, twelfth century (detail). Tempera on board, 30% x 21½" (78 x 54.6 cm). Tretyakov Gallery, Moscow.

Opposite

49. Enthroned Mother of God with Prophets and Saints, c. 1100. Tempera on board, 19% x 16%" (48.5 x 41.2 cm). Monastery of St Catherine, Mount Sinai.

This is the full icon of which a detail appeared as FIG. 4.

This icon type, called the *Elevusa* ("compassionate"), was especially popular under the Komnenian dynasty. The icon itself was brought from Constantinople to Kiev probably in 1131, and transferred by Andrej Bogoljubski to Vladimir in 1155, where it became the chief palladium of the Russian state, playing a role parallel to that of the *Hodegetria* in the capital. Transferred to Moscow in 1395, it was credited with saving the city from repeated attacks by the Mongols.

The Mother of God

The paradox of the Mother of God images is that the tenderest ones were regarded as the most powerful. This paradox relates to the place of the Mother of God in Byzantine life, for while women in general were second-class citizens in Byzantium, both men and women agreed in placing the divine mater-

nity of Mary at the center of worship. While the West commonly refers to her as the Virgin Mary, in Byzantium her title was theotokos ("God-bearer" or "Mother of God"), a title defined at the Ecumenical Council of Ephesos in 431. The calendar was punctuated with feast days in her honor, there were more churches dedicated to her than to anyone else (136 known in Constantinople alone), and she was the commonest subject in icons. The prophets surrounding the Mount Sinai Enthroned Mother of God (FIG. 49) unfurl scrolls that announce her cosmic importance. Mary seems to read that of Symeon, "Mine eyes have seen thy salvation which thou hast prepared in the presence of all peoples, a light for revelation to the Gentiles and for glory to thy people Israel" (Luke 2:30-32). Above him, Moses beholds Mary in the miraculous fire that ignited a bush without consuming it (Exodus 3:2), while on the other side Jacob sees her in the ladder that reached to heaven (Genesis 28:12). All of revelation is shown to be epitomized in Mary. The same extravagant claim is framed poetically in the most popular hymn to the Mother of God, the Akathistos. She is named, among other things, mother of the unsetting star, dawn of the mystical day, rock that quenches thirst, column of fire, tent of the world, flower of immortality, land flowing with milk and honey, impregnable wall, vehicle of the Cherubim, and living temple. To the Byzantines, Mary embraced all of life.

TAPITATAGOITTITOTATWAKEOTHG TAPITATAGOITTITOTATWAKEOTHG TAHNTWIFAHONTIGVHITAH EAHOGAN

TACAPETACMANITAKATETEMMÉNI ANAPECAOTÁ AECEVIENEIC VYX HI NITIN PERITAPETO CONTREITHNK

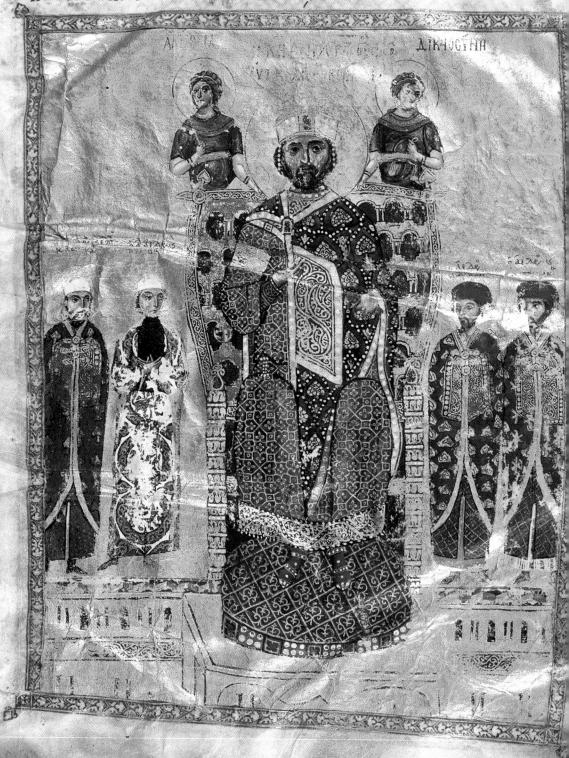

THREE

The Secular Domestic World

The Palaces of Constantinople

As for the southern side [of the Great Palace], Theophilos first extended the terraces, and laid out the gardens. Then he built there a number of chambers, namely the Kamilas, as it is called, and next to it a second chamber, and then a third which today houses the wardrobe of the empress. The ceiling of the Kamilas is speckled with gold and upheld by six columns of Thessalian green marble. The lower part of the walls is riveted with slabs of the same marble, while the upper part has gold mosaic representing figures picking fruit. The floor is paved with Prokonnesian marble.

Gardens and representations of gardens amid glittering surfaces of gold glass and dark green marble, these are the details that impressed the anonymous historian called the Continuator of Theophanes when he described how Theophilos (829–42) expanded the living quarters of the Great Palace.

Since the palace was demolished by the Crusaders in 1204, such descriptions are our best evidence of its appearance in medieval times. Only a few bare, ruined bays of the wing known as the Boukoleon survive, its spacious windows overlooking the Marmara Sea (FIG. 51). Unfortunately, the general loss of domestic architecture makes the study of Byzantine secular art difficult. Nevertheless, the temporal realm is critical for an understanding of the manifold integrity of Byzantine art, for in addition to its better-known religious and imperial aspects, the art of Byzantium expressed a great range of human sensibilities, not excepting the scientific, the erotic, and the frivolous.

50. Nikephoros III
Botaniates and Courtiers,
from the Homilies of John
Chrysostom, 1078–81.
Tempera and gold on
parchment, 16¾ x 12¾"
(42.5 x 31 cm). Bibliothèque
Nationale de France, Paris
(MS. Coislin 79, fol. 2r).

51. Portion of the Boukoleon wing of the Great Palace, tenth century. Istanbul.

Among palaces, the Great Palace was exceptional in that besides being a residence of the ruling family it was also the seat of government. It included the throne room (the Chrysotriklinos), reception rooms for managing affairs of state or receiving foreign ambassadors, the treasury (and mint), barracks for the imperial guard, and a harbor (at the Boukoleon). Liutprand of Cremona (c. 920–72), Germany's ambassador, tells how the Magnaura hall was outfitted for Constantine VII's reception of the delegation from Umayyad Spain:

In front of the emperor's throne was set up a tree of gilded bronze, its branches filled with birds, likewise made of bronze gilded over, and these emitted cries appropriate to their different species. Now the emperor's throne was made in such a cunning manner that at one moment it was down on the ground, while at another it rose higher and was seen to be up in the air. This throne was of immense size and was, as it were, guarded by lions, made either of bronze or wood covered with gold, which struck the ground with their tails and roared with open mouth and quivering tongue.

Mechanical inventions, called *automata*, including animal fountains, some of which spouted wine, startled and entertained the visitor. A profusion of gold overwhelmed him. The medieval Great Palace was a house of marvels.

This tenth-century palace contrasts sharply with the classicism of Early Byzantine palaces. In Constantinople the plans of two fifth-century palaces have been recovered along with fragments of the Great Palace in its sixth-century stage, and a number of mosaic pavements survive from other houses around the city. Most complete is the plan of the palace of the praepositus Antiochos, which lay along the north flank of the hippodrome. The praepositus sacri cubiculi, or grand chamberlain, was a eunuch, charged with managing the emperor's receptions and his treasury. Under Arkadios (395–408), Antiochos rose to a position of extraordinary wealth and influence, enabling him to erect his ostentatious palace in the heart of the city. The design was unusual within the tradition of Roman palace or villa architecture, reflecting the occupation of its owner (FIG. 52). Instead of planning a sequence of private courtvards with surrounding halls, Antiochos had his palace laid out as a single, large, semicircular courtyard, called a sigma, surrounded by an arcaded stoa, from which all halls of the palace were equally accessible. The five domed reception rooms were

Below

52. Reconstruction of the palace of Antiochos, Constantinople, 416–8.

53. *Grazing Horses*, from the floor of the Great Palace, late sixth century (detail). Mosaic. Mosaic Museum, Istanbul.

54. Triumph of Dionysos, detail, late fifth century. Mosaic floor. Istanbul Archaeological Museum.

Dionysos appears on a chariot in the center of this mosaic; below, a satyr steadies the drunken Silenus on his donkey, while ecstatic maenads and music-makers follow.

graded by size: the more important the occasion, the grander the hall. High dignitaries would have arrived in two-horse carriages. This was theatrical architecture, baroque in its curved spaces. No provision was made for family intimacy, for the eunuch had no family; his entire existence was his public persona. The climax was the large hexagonal hall, an uncommon plan, which was finished in marble and surrounded with little garden porches.

Of the early phase of the emperor's Great Palace only a single coherent unit has been recovered by archaeology. That unit, much more conservative in design than Antiochos' residence, consisted of a huge quadriporticus, that is, a rectangular courtyard with stoas on all sides 216 by 184 feet (66 by 56 m), followed by a single-naved rectangular hall. Dated late in the reign of Justinian or his successor Justin II (565–78), the stoas of the quadriporticus sheltered extraordinary mosaics, sections of which survive (FIG. 53). Scenes of hunt mix with children's games and rural rustic life; mythological beasts cavort with accurately observed grazing horses; even a Dionysiac procession was included. Wealthy Roman villas had been decorated with these subjects for centuries. What is unusual is the encyclopedic range of subjects and the refinement of execution; none of the comparable mosaics of

Antioch or North Africa can match the mastery of figure drawing and the range of colors of the closely fitted *tesserae*.

Imperial patronage set a standard for luxury and ostentation that the aristocracy sought to emulate. Mosaics of similar quality have been found in a scattering of houses elsewhere in the city. A late fifthcentury house in the Koca Mustafa Paşa Street, discovered in 1995, shows an exuberant *Triumph of Dionysos* (FIG. 54). Dionysos on his chariot appeared in the center while around him swirled his troop of satyrs and maenads. The myth of Dionysos is one of the most common subjects of late Roman domestic mosaics all around the Mediterranean. The cult of Dionysos survived long into the Middle Ages in a culture nominally Christian.

In the early period, then, the houses of Constantinople continued the architectural and decorative repertoire of houses of the Roman imperial era, with

open courts, shady colonnades, and richly decorated interiors. A family portrait from a late fifth-century tomb in Constantinople represents the well-dressed aristocratic owners of such houses (FIG. 55). Law regulated clothes permissible within the city: barbarian trousers and coats of fur were strictly forbidden. With gestures of prayer appropriate to the tomb, the gentleman wears an ankle-length civilian *chlamys* (cloak) fastened with a *fibula* (clasp), signs of his status in court, and his wife wears a simple *palla* or shawl over her tunic; their son carries a codex, signifying his literate upbringing.

When we turn to the medieval period of the ninth century and later, we find a domestic architecture that departs radically from the Roman mode and looks instead to the contemporary world of Islam for inspiration. The emperor Theophilos set the pace when his ambassador John the Synkellos brought back designs of a palace he had seen in Baghdad. John, whom Theophilos later made patriarch, persuaded the emperor to erect a copy on the eastern shore of the Bosporos, complete with Arab-style decoration; only in its churches, one of which was next to the emperor's bedroom, did it depart from its model. In view of the fact that Theophilos spent his entire reign waging bitter war against the Arabs in Asia Minor, his adoption of Islamic-style architecture is all the more remarkable. The enemy's material culture, prizeworthy for its elegant, cosmopolitan style, was evidently regarded as ideologically neutral, not tainted by its foreign origin.

Medieval Byzantine domestic architecture, then, was lodged solidly in contemporary fashions familiar around the Mediterranean. Polo grounds were added in the Great Palace as the Persian horse sport replaced the ancient chariot-racing, the preferred Roman

55. Family portrait from the Silivrikapi tomb, late fifth century. Limestone relief, 3'7" x 6'6" (1.08 x 2m). Istanbul Archaeological Museum.

This relief was recently discovered in a very large vaulted tomb not far from the Dionysiac mosaic in FIG. 54, and it must have belonged to a distinguished family of landowners in the region.

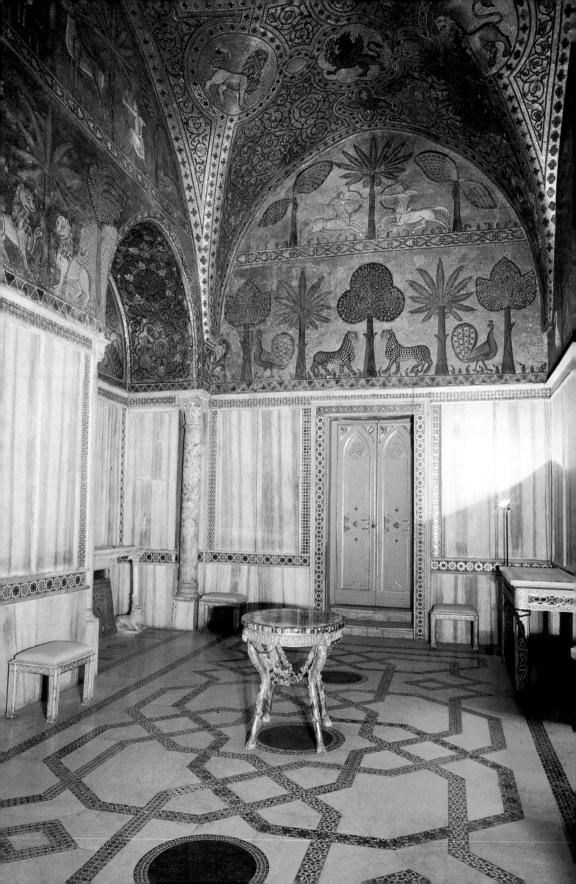

sport. The taste for *automata*, mentioned by Liutprand, was a fad shared by the caliphs of Baghdad and Cordoba. To form a notion of the interior decoration of the now vanished chambers such as the Kamilas, one can best examine the palace in Palermo, which was decorated by Byzantine artists, albeit later, for the Norman king William I (1154–66; FIG. 56). Brilliance of surface was all important; pavements and walls were clad in marble, with colorful little colonnettes in the corners. The wall zone was capped with a cornice of inlaid decoration, above which started the mosaic zone, in which paired leopards, peacocks, and centaurs inhabit a garden of solemn symmetry, glass leaves glistening against a gold sky.

The Great Palace extended from the hippodrome to the Marmara, and from Hagia Sophia to the church of Sts Sergios and Bakchos. Further west along the Marmara the wealthy families of the capital erected palaces of their own, high-walled enclaves, insulated from the dangers of the surrounding city. Not a trace of these has survived, but sources emphasize their height, their overhanging balconies, and their rich churches. The emperor had a second palace at the far north corner of the city in the Blachernai section, to which Alexios I Komnenos (1081–1118) moved his residence (see FIG. 25).

The Fashions of Palace Life

The Great Palace served as a grand theater where imperial ceremony unfolded with precisely ordered splendor. A ninth-century document lists fifty-nine higher officials and five hundred subordinate officials who were expected to attend palace receptions. The ambassador Liutprand witnessed how, during the week before Easter, Constantine VII distributed sacks of gold and cloaks of honor to members of the court by rank. Different colors distinguished different ranks. A portrait of Nikephoros III Botaniates (1071-8) conveys some sense of this hierarchy of court (see FIG. 50). The emperor, attended by Truth and Justice, sits on a high throne wearing two blue tunics with closely worked geometric patterns beneath a dark blue cloak, or sagion. Four high courtiers flank him on either side, carefully labeled. Closest at his right hand is the beardless eunuch, the protovestiarios, traditionally the keeper of the wardrobe but in fact charged with the most sensitive negotiations of state. Large roundels of lions decorate his splendid white robe, a white turban on his head. To his right is another eunuch, the secretary charged with drawing up official correspondence and edicts, wrapped in a red cloak with a closely worked pattern of gold spade leaves. The two officials to the emperor's left are mem-

56. Marble and mosaic decoration in the Chamber of King Roger, in the Palazzo Normano, Palermo, 1154–66.

57. Bulls against palmette diaper pattern, tenth century. Silk, 12½ x 7%" (32.7 x 20 cm). Treasury of St Servatus, Maastricht.

bers of the civil aristocracy bearing the rank of proedros; they wear red-tasseled hats and red cloaks over tunics of a blue diaper pattern. The front fastening of the cloaks distances them from the Roman chlamides of Early Byzantine times, which fastened on the right shoulder.

An elaborate language of dress governed fashions in the Byzantine court. But besides marking the wearers' place of precedence in the court, garments also placed them in a cosmopolitan world of style, for the patterns were widely shared around the Mediterranean. A tenth-century fragment of silk shows a closely spaced diamond pattern of spade leaves akin to the design worn by the emperor's secretary, except that this is interrupted

by frames containing bulls (FIG. 57). But garments with spade and heart leaves appear as early as the seventh century on Iranian reliefs and were subsequently widely used in the Islamic world. Byzantine silks thus present a curious contradiction, for although their manufacture, use, and sale were carefully reg-

of property, and banishment), yet most of their motifs were not distinctively "Byzantine." They belonged to a cosmopolitan world of style. A fragment in Sens, with a pattern in blue against a purple ground, contains a large repeat pattern of birds and griffins flanking a tree within roundels (FIG. 58). The large size of the units required an exceptional technological skill. But again the motifs appeared first in ancient Iranian textiles and were widely diffused in the Islamic world; and the Byzantine weaver, to keep the pattern current with Islamic fashion, added a pseudo-Arabic inscription in the framing roundel.

The two principal stages of textile production, spinning and weaving, are illustrated in an eleventh-century Job manuscript (FIG. 59). Spinning was exclusively women's work, but weaving involved men as well. The work was done either in workshops, whether imperially sponsored or guild operated, or in the privacy of wealthy homes. In Constantinople women in the

58. Paired birds and griffins in roundels, second shroud of St Potentien, twelfth century. Silk, 57 x 38" (145 x 97 cm). Cathedral treasury, Sens.

59. Women Spinning and Weaving, in the Book of Job, eleventh century. Tempera on parchment. Bibliothèque Nationale de France, Paris (Ms. gr. 134, fol. 184v).

textile business seem to have been organized in a guild which sponsored an annual festival called the festival of Agathe.

In the widespread sharing of motifs with Islam, what distinguished Byzantine fashion was the retention of garments of classical cut - variations on the forms of ancient tunics and chlamides - and a love of brilliance. Observers from Germany were shocked to see that in Constantinople both men and women accented the deep-dyed fabrics of their clothing with accessories of gold, gems, and enamel; meanwhile Islam, on the other side, forbade the use of gold for religious reasons. The emperor, as we have seen, was heavily weighted with gems and pearls, including ornaments dangling from his crown and from the hems of his robes. A unique set of bracelets found in Thessaloniki exhibit a greenground cloisonné enamel decoration typical of the ninth or tenth century, with a variety of bird and floral motifs (FIG. 60). These were probably articles of female attire, but enameled temple pendants containing perfume were worn in headdresses by both men and women (FIG. 61). A pair of these pendants found in Kiev show addorsed birds and sirens flanking a tree of life, very likely carrying fertility symbolism. The gold-ground setting of the decoration is typical of eleventh- and twelfth-century enamels.

The Great Palace, besides being Constantinople's most glamorous showplace for fashions in dress, was also important for the world of secular learning. While in western Europe learning became the preserve of the clergy and education fell to monastic schools (the first reader being the psalter), in Byzantium secular learning continued to flourish, spurred by the demand for an educated civil service, and institutions of higher learning enjoyed imperial patronage (Homer was the beginning text). A school in the Magnaura hall of the Great Palace flourished under the patronage of Michael III (842–67) and Constantine VII (945–59);

and Constantine IX (1042–55) founded schools of law and philosophy. The dean of the law school enjoyed senatorial rank and received his silk robe of office from the emperor. Not until the twelfth century did a theological school sponsored by the patriarch offer competition to the secular system.

In keeping with their perennial cultivation of secular, classical literature, Byzantines took special pride in sprinkling their speech with quotations from Homer and Euripides. In a similar manner, the educated class delighted in being able to recognize classical depictions, whether of the labors of Herakles or the loves of Zeus, on precious objects. The approach, however, was completely eclectic. After the early *Iliad* manuscript (see FIGS 13 and 14), artists do not seem to have undertaken the continuous illustration of the epics, or of the tragedies. Rather they preserved vignettes of famous moments from classical literature, used, for example, on ivory boxes intended for keeping valuables. The Veroli

60. Pair of bracelets, ninth century. Gold and *cloisonné* enamel, height 2¼" (5.7 cm), diameter 3" (7.5 cm). Archaeological Museum, Thessaloniki.

61. Pair of temple pendants, eleventh or twelfth century. Gold with *cloisonné* enamel decoration: left pendant, 2% x 2%" (6 x 5.4 cm); right pendant 2½ x 2¼" (6.4 x 5.7 cm). The Metropolitan Museum of Art, New York.

62. Helen and Castor, and Belerophon and the Nymph of Peirene, on the Veroli Casket, tenth century (detail). Ivory and bone on wood core, $4\frac{1}{2} \times 6\frac{1}{2}$ " (11.5 x 16.6 cm). Victoria and Albert Museum, London.

63. Casket with warriors and mythological figures, tenth or eleventh century. Bone plaques over wood, $4\% \times 17\% \times 7\%$ " (11.6 x 43.7 x 18.1 cm). The Metropolitan Museum of Art, New York.

The enframing rosette bands, like those of the Veroli Casket (see FIG. 62), were mass produced; the warriors, enthroned, on foot, or on horseback, juxtaposed with mythological figures such as the winged youth in the center, tell no coherent story.

Casket has a dozen such scenes placed side by side, enframed with borders of rosettes (FIG. 62). On a front panel two subjects are grouped together perhaps because they both involved stories of chaste horsemen: on the left Hippolytus resists the flirtations of his step-mother Phaedra, and on the right Bellerophon, who rejected Queen Anteia, waters his winged steed Pegasus at a stream (illogically, the water nymph holds a torch). The skillful and very frank representation of the nude in these ivories is unusual in surviving Byzantine art, but Theodore Balsomon, an ecclesiastical author of the twelfth century, records seeing houses of the rich in Constantinople with stuccos and gilded paintings of nude figures that he considered positively erotic.

Boxes made of ivory and of bone constitute the largest body of Byzantine secular art to survive, counting over a hundred complete or incomplete examples. In addition to an erotic interest they sometimes strike a humorous note. On a box in New York horsemen and footsoldiers make menacing gestures, but some of the latter have forgotten to cover their backsides (FIG. 63)! Its rosette borders and fine execution put this box in the same family as the Veroli Casket, although it is made of bone, with some saving in

expense. Other boxes, perhaps meant as dowry presents, included Adam and Eve, showing them harvesting or working at the forge together as models of marital collaboration (FIG. 64). Ironically, such sharing of manual labor was more characteristic of the lower classes in Byzantium, while ivory boxes were decidedly a product intended for an elite audience.

A secular spirit also animates the unique manuscript of the Joshua Roll, even though the subject is biblical (FIG. 65). The loss of the opening of the manuscript deprives us of information on its precise occasion and dedication. Instead of the standard codex format of medieval books, the manuscript assumes the form of an antique parchment scroll over thirty feet (10 m) long (now divided into its constituent sheets). It is therefore a picture scroll, the text being only excerpts, treating the story of Joshua like the campaigns of the emperors illustrated in continuous scroll fashion on the spiral columns of Theodosios and Arkadios. The painting manner derives from classical manuscripts, such as the *Iliad* (see FIG. 13). figures in delicate ink washes with white highlights, move against a lighter background of cities and mountains, suggesting an atmospheric perspective. In Roman fashion, personifications are inserted to identify topographical features of mountains and cities.

The theme of the manuscript is really the land and its possession through conquest, which was Byzantium's major preoccupation in the tenth century, when the manuscript was made. After three centuries on the defensive, suffering yearly raids from the Arabs, the vigorous leadership of General Nikephoros Phokas (subsequently Emperor Nikephoros II Phokas, 963–9) retook Crete and eliminated the Arab presence in Anatolia. It has been pointed out that the humiliations inflicted on defeated Philistines in the scroll reflect the ceremonies imposed by the Byzantines on defeated Arabs. Although certainly painted in Constantinople, the Joshua Roll is concerned with the country Byzantium claimed for itself.

64. Adam and Eve at the Forge, and Adam and Eve Harvesting, plaques from a casket, eleventh century. Ivory, 2% x 3%" (6.7 x 9.8 cm) and 2% x 3%" (7 x 9.5 cm). The Metropolitan Museum of Art, New York.

Country Life

The markets of Constantinople brought a large concentration of industry and crafts to the capital, but in the Byzantine empire, as in pre-industrial societies in general, the real source of wealth was the land, on the produce and tax of which the economy was built. Byzantines inherited and improved on Roman agricultural methods. Sericulture was introduced in the sixth century to break the Persian monopoly on the silk trade; horses were harnessed for plowing in addition to oxen and mules; grains were improved for longer keeping; watermills and presses were built to process grain and wine. Romanos Lekapenos (920-44) and subsequent emperors sought to preserve the independence of free peasant farmers from the incursions of large landholders. Monasteries too played an important role in the agricultural sphere, starting with the incorporation by Basil the Great of Caesarea (c. 329–79) of farming into the routine of monastic life. When St Athanasios (c. 927-c. 1001), with the patronage of Nikephoros Phokas,

65. Joshua Pays Homage to the Archangel before Jericho, from the Joshua Roll, tenth century. Ink and color washes on parchment, 12¾ x 20¾" (31.5 x 51.5 cm). Biblioteca Apostilica Vaticana, Rome (мs. pal. gr. 431, sheet iv).

Left

66. Springtime Activities in the Countryside, from the Homilies of Gregory of Nazianzos, eleventh century. Tempera on parchment, 14¼ x 10¾" (37 x 26.5 cm). Bibliothèque Nationale de France, Paris (Ms. gr. 533, fol. 34).

Above

67. *Birdcatcher*, from pseudo-Oppian, *Kynegetica*, eleventh century. Tempera on parchment. Biblioteca Marciana, Venice. (Cod. gr. 479, fol. 2*v*).

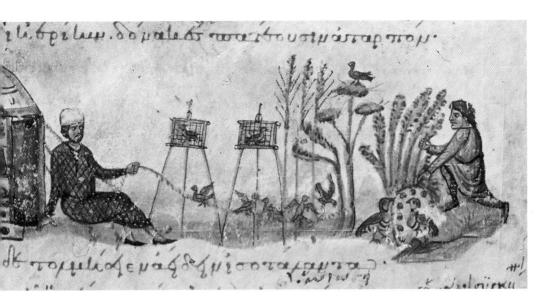

founded the Great Lavra Monastery on Mount Athos, he introduced irrigation and watermills to make his community selfsufficient. His efforts were too successful: before long the monastery was exporting its produce, and land speculation was threatening the monks' ideal of poverty.

The activities of rural life played a large part in the imagination of Byzantium. When Gregory of Nazianzos, preaching in Caesarea on the Sunday after Easter, sought to exhort his congregation to a renewal of spirit he turned to nature's springtime renewal for lessons. The eleventh-century artist who illustrated the sermon showed the occupations of springtime in the country in six registers: a goatherd amuses himself playing his flute, a cattleman spends his leisure with a lute, a farmer prunes his grapevines, a fowler watches his traps, a fisherman drops a line, and bees swarm about their hives (FIG. 66). Gregory mentioned each of these activities (even noticing the extraordinary hexagonal geometry of the bees' hives), but the artist is far more specific than the theologian when he comes to describing the fowler reclining by his tent, because he wanted to give an accurate picture of country life. The precise method of hunting illustrated is that found in the Kynegetika, a textbook on hunting that the Byzantines attributed to Oppian, which advises the fowler to set up mirrors on tripods in order to attract the wild birds into his snare (FIG. 67). The artist adds contemporary details not in the text, such as the hunter's servant, in the short tunic of the lower classes, who clamps a basket over a bird, and the hunter's dress and tent. The hunter wears a turban and a long white kaftan (kabbadion)

opening in front, and his tent is ornamented with animals. The authenticity of this detail is guaranteed by the description of a tent in the Byzantine novel *Digenis Akritas*. In this romance the hero regularly lives in tents and one of the wedding presents offered to him was "A gold-embroidered tent, spacious and lovely, having many outlined shapes of animals; the ropes were silk and the poles were silver." It is the leisure of this kind of hunting camp of the well-to-do that is represented both in the *Kynegetika* and in the sermons of Gregory.

The Byzantines inherited their high esteem of agriculture from the Romans, and many aristocrats were serious farmers or gardeners. The learned Photios (c. 810–c. 894), adviser to Basil I and later patriarch, was interested in correcting ancient texts on agriculture by observing actual results in the field. The apostle to the Slavs, St Clement (d. after 915), who with his teaching laid the foundations of Slavonic literature, also improved the orchards of Bulgaria by grafting cultivars onto native wild stock. The emperor Constantine IX Monomachos (1042–55) became

68. Ornithological illumination, from Dioskorides, *De materia medica*, sixth century. Tempera on parchment, 15½ x 13½" (38 x 33 cm). Österreichische Nationalbibliothek, Vienna (Cod. med. gr. 1, fol. 483v).

famous for instant gardens created by wholesale transplanting.

This elite interest in agriculture and horticulture explains the large number of surviving manuscripts dealing with these subjects. Over fifty manuscripts survive of the *Geoponika*, a sixth-century collection on farming which was re-edited under Constantine VII; translations of the book were made into Arabic, Armenian, and Latin. A herbal describing plants and their uses by the first-century pharmacologist Dioskorides, the *De materia medica*, enjoyed a similar circulation.

The illustrations of this literature constitute an informational art, an art of facts. Scientific observation was an essential branch of Byzantine art. A sixth-century edition of Dioskorides' herbal includes an ornithological treatise as an appendix. Its frontispiece (FIG. 68) shows twenty-four species of birds, all neatly distinguished in shape and

plumage, starting in the upper left with the ostrich, the bustard, and the moorhen. The tenth-century New York edition of Dioskorides includes over 750 illustrations of plants, wild as well as cultivated (FIG. 69). Several different grapevines were accurately observed. The caliph of Cordoba requested a copy of the book from Romanos II (959–63).

The life of the wealthy provincial landowners can be glimpsed in the *Digenis Akritas*, which is set in Cappadocia along the Byzantine–Arab borders. Here Greek–Muslim relations were full of both danger and romance. The Christian hero is himself of mixed parentage and takes a bride from across the border. His dress is called "Roman" but it is thoroughly Arab: "A marvelous kaftan ornamented with griffins, thrice purpled and sprinkled with gold, and a precious white turban with gold inscriptions." Literary sources preserve the real-life names of some of these mixed families, and archaeology has preserved some of their dwellings.

In this rural mountainous province, rich in mining and cattle, the soft volcanic rock made it economical to hew living spaces directly out of the mountainside. Many of these complexes, previously mistaken for monasteries, are fine examples of great

69. Bramble Bush, botanical illumination, from Dioskorides, De materia medica, tenth century. Tempera on parchment, 15% x 11½" (39 x 29 cm). Pierpont Morgan Library, New York (MS. m.652, fol. 25v).

70. Facade of Açik Saray Mansion no. 7, early eleventh century. Cappadocia, Turkey.

landlords' mansions. Facades are designed in tiers of horseshoe arches, a hallmark of Islamic design (FIG. 70). The closest parallels are to be found in Umayyad Spain. Typically the house is arranged around a courtyard, the nucleus of which exhibits a plan that can best be described as an inverted T. At Hallac, in Cappadocia, a large transverse hall, fully sixty-five feet (20 m) long, preceded the principal reception room, placed in vertical position (FIG. 71). Other rooms were located symmetrically in the angles of the T, and a women's room lay to the left, beside the kitchen. It assumed a domed, four-column plan. The church, also a domed, four-column building, was somewhat removed on the right side of the courtyard, perhaps because it accommodated burials. Wall surfaces were membered with horseshoe arches carved in relief, details decorated in painted zigzag and checker patterns common in the Islamic world. But the most important borrowed element is the plan itself. The inverted T is a basic unit of domestic architecture all around the Islamic world from Samarra in Iraq, to Fustat in Egypt, to Medinat al-Zahra in Spain.

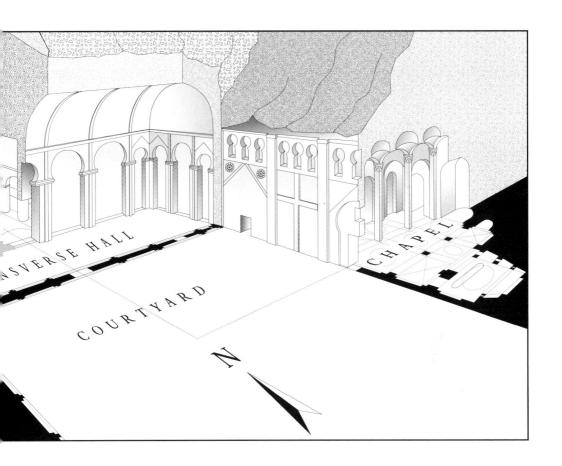

The Byzantines of Cappadocia saw their culture as part of a larger cosmopolitan world. Intermarriage was not uncommon, and products and ideas freely passed from one side to the other. Besides sharing fashions of house and dress with the Arabs, the Byzantines also shared much of their lifestyle. Byzantines commonly took meals sitting on the floor like the Arabs, as noticed by the abbot Blessed Luke of Stiris (d. 953), who thought the custom positively heathen. Some forms of entertainment were also shared by both cultures; the scarf dancers shown on golf and enamel plaques on "the crown of Constantine IX Monomachos" appear in Islamic art from Cairo to Sicily (FIG. 72). Surrounded by vines and birds, and wearing a skirt of heart-shaped leaf pattern, the dancer kicks up one leg behind her and holds a long, billowing scarf over her head.

Even the vessels from which Byzantines took their meals owed much to Islam. The common Byzantine *sgraffito* ceramic technique, in which the light-colored glaze is scraped away to reveal a darker earth-colored ground, was borrowed from Islamic lus-

71. Reconstruction of Hallaç mansion, Ortahisar, Cappadocia, early eleventh century.

72. Dancing girl, from "The Crown of Constantine IX Monomachos," eleventh century. Gold and enamel, 4 x 1¾" (10 x 4.6 cm). Magyar Nemzeti Múzeum, Budapest.

73. Plate with cheetah, deer and hare, early 13th century. Engraved cut-slip ceramic ware, height 1¾" (4.6 cm), diameter 8¾" (22.2 cm). The Metropolitan Museum of Art, New York.

terware ceramics (FIG. 73). The motifs too are shared: a cheetah pounces on a deer while a hare scampers by. In elite circles expensive Arab wares were prized. A lobed turquoise bowl of opaque cut glass, with hares etched into each of its five sections, came into Byzantine hands in the late tenth century, at which point the owner had it rimmed in gold and enamels (FIG. 74). It came to Venice after the Crusader sack of Constantinople in 1204.

The Christian religion, with its colorful rites and its elaborate theological edifice, provided the general framework and orientation for both public and private life in Byzantium. But religion neither absorbed nor erased the secular. In the domestic realm, whether in the capital or in the countryside, a wide range of interests was pursued, generating an art of great diversity.

74. Islamic bowl of ninth century, in Byzantine setting, tenth century, reworked in the fifteenth century. Turquoise cut glass, with setting of silvergilt, gems, and enamel, height 2½" (6 cm), diameter 7½" (18.6 cm). S. Marco Treasury, Venice.

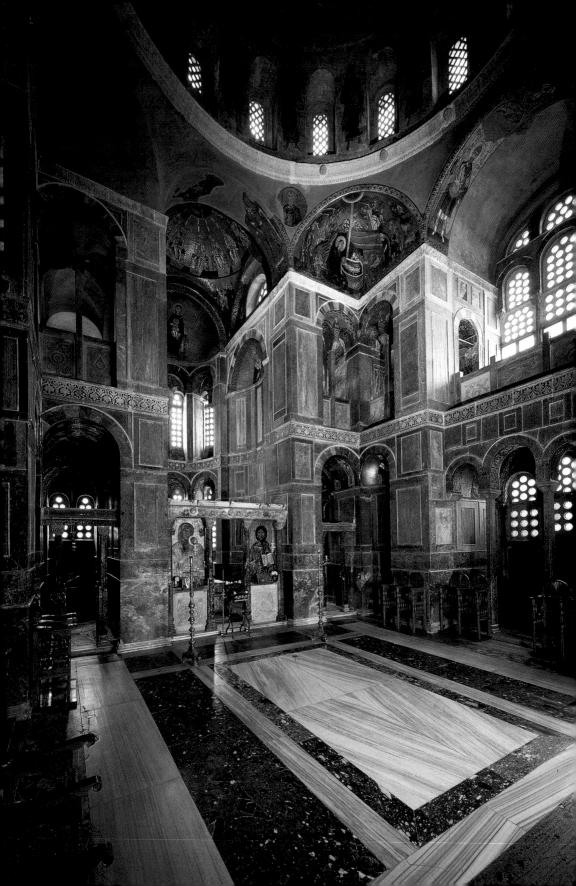

FOUR

A Temple of Transformation

owhere is the East–West dichotomy in Christendom more striking than in the church building. The image that dominated the church in the West was the painful image of Christ's body stretched on the crucifix, which was placed above the choir screen at the crossing where the long tunnel of the nave met the arms of the transept. In the Byzantine church, by contrast, an overseeing image of the Blessing Christ, placed in the circle of the central dome, reached out as if to embrace the faithful gathered in the nave below, and the building itself was an intimate vessel of very modest dimensions. These stark contrasts call for explanation.

The decorated church was the most ambitious accomplishment of Byzantine art in the expense involved, in the complexity and subtlety of the imagery, and in the sublimity of its purpose FIG. 75). Found in all the regions where the rites of the Orthodox church were observed, including many lands outside the boundaries of the empire itself, churches are the most visible monuments of Byzantine culture. Their tightly woven programs of images are so wedded to the architectural vessel as to constitute a single unit, an environmental work of art. Together with the ritual that they contained, they constitute a single symbolic matrix.

Basic to the approach taken here is the assumption that the church, beyond being a container for iconography, is a container for a religious experience, to which the imagery must constantly be referred. Religious experience may seem an extremely nebulous referent for an historical inquiry, but the manner of worship, that is the liturgy, is extremely well documented in Byzantium and has been the subject of exhaustive scientific research in recent years. What the Byzantines did in church and how

75. Katholikon of Hosios Loukas, Stiris, Greece, early twelfth century. Interior view, looking southeast.

A marble screen, the *templon*, separates the nave of the church from the sanctuary (the icons in the screen are recent additions).

they understood what they were experiencing is not mere speculation. Furthermore, historical sources witness the depth of the emotional impact of this experience.

For example, according to the *Russian Primary Chronicle*, when Prince Vladimir of Kiev sent ambassadors to Constantinople in 987, they had opportunity to observe Muslim and Roman Catholic rites along their route. Their experience of Byzantine worship, however, was absolutely overwhelming. Basil II's diplomacy involved taking them personally to Hagia Sophia, calling their attention to the beauty of the edifice and the chanting. When they returned to Vladimir they reported:

We knew not whether we were in heaven or on earth. For on earth there is no such splendor or such beauty, and we are at a loss how to describe it. We know only that God dwells there among men, and their service is fairer than the ceremonies of other nations. For we cannot forget that beauty. Every man, after tasting something sweet, is afterward unwilling to accept that which is bitter, and therefore we cannot dwell longer here.

The historical accuracy of the story need not be scrutinized; what is significant is that the chronicler framed his description of the ambassadors' experience in terms of a transformation effected by the beauty of church and ritual – a transport to a spiritual realm – that left them changed and unable to bear their previous way of life, which had all turned sour. They had to be baptized, as eventually was Vladimir and with him his people. It was this kind of transformational experience that gave unity and purpose to the many separate elements that entered into the design and decoration of the Byzantine church.

Churches might be divided according to the nature of their foundations, whether cathedral (the bishop's church), *katholikon* (the principal church of a monastery), or private domestic chapel. Further, one might distinguish them by sponsorship. But while the patronage of individual churches is sometimes known, the origins of the decorative system itself remains anonymous, embedded in the collective religious experience of the people. The same subjects appear in imperial, monastic, and lay churches, and the same Byzantine rite was observed in all of them.

More decisive is the difference between earlier and later churches, separated by the divide of the seventh- and eighth-century crisis. This division into two phases is valid both for the architecture and the figural programs, and it corresponds to a major shift in the character of Byzantine worship. In architecture the contrasts

are between open, public spaces of the early buildings and the closed, compact spaces of the later ones; in iconography the early churches show loose, narrrative programs of iconography and the later ones a strictly selective set of subjects; meanwhile, the corresponding development in the ceremonial is from participatory processional movement toward a more static ritual dominated by appearances and showings by the clergy.

Early Byzantine Churches

Basilicas dominate the early phase of Byzantine church architecture. When around the year 450 the wealthy senator named Stoudios demonstrated his piety by erecting a church on his estate in the south-west sector of Constantinople, he naturally chose the basilica form. A square atrium, surrounded by porches or stoas, opened into a broad central nave with aisles and galleries on either side, leading to the apse, where the sanctuary was located (FIG. 76). Entrances opened on all sides, and the people took an active role in the four processional movements of the liturgy: the processions accompanying the entrance of the clergy, the readings of sacred scriptures, the offertory of bread and wine, and the communion.

76. Church of St John the Baptist of Stoudios, Istanbul, c. 450. North aisle of the church, looking east.

The monastery of St John of Stoudios played an important leadership role in the religious and intellectual life of Constantinople. But while monasteries were important patrons of the arts, the artists were generally laymen.

Nothing remains of the mosaic decoration of Stoudios' church, but the contemporary basilica of the Mother of God of Blachernai was decorated, according to the account of a ninth-century deacon, "with pictures of God's coming down to us, and going on to his various miracles as far as his Ascension and the Descent of the Holy Ghost," which were destroyed during Iconoclasm. In other words, it had a narrative program of the Life of Christ, starting with his birth. The mention of miracles is significant because they are a prominent part of the repertoire of Early Byzantine art which gradually fell into disuse later on.

The sixth-century church of S. Apollinare in Classe, Ravenna, erected by another very wealthy private citizen, Julianos Argentarios, preserves an Early Byzantine set of mosaics of the Life of Christ. The miracles of Christ account for half of the program. Against a solid gold background that denies indications of time and place, Christ delicately applies a finger to one eye of the blind man, who comes toward him leaning on a staff; two figures witness the miracle, one making a gesture of amazement (FIG. 77). The iconography of such subjects circulated widely in the Byzan-

77. Healing of the Blind, c. 500. Mosaic panel. S. Apollinare Nuovo, Ravenna.

In the sixth century it was still acceptable to represent Christ either beardless, as here, or bearded, as in the following FIG. 78.

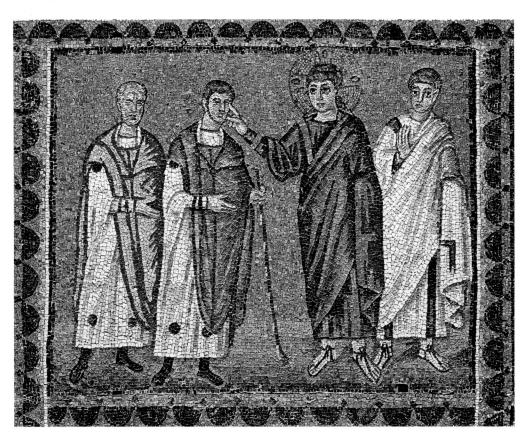

tine world, as witnessed by manuscript illumination. In a precious Gospel book written in gold on purple-dyed parchment, the *Healing of the Blind* was shown in the bottom margin of the page on which the text of Matthew 20:31–34 narrates Christ's meeting with two blind men outside Jericho (FIG. 78). Trees on the right evoke the outdoor, roadside setting of the miracle, and four

78. Healing of the Blind, from the Codex Sinopensis, c. 500. Tempera and gold on parchment, 115% x 9%" (29.5 x 25 cm). Bibliothèque Nationale de France, Paris (Ms. suppl. gr. 1286, fol. 29*r*).

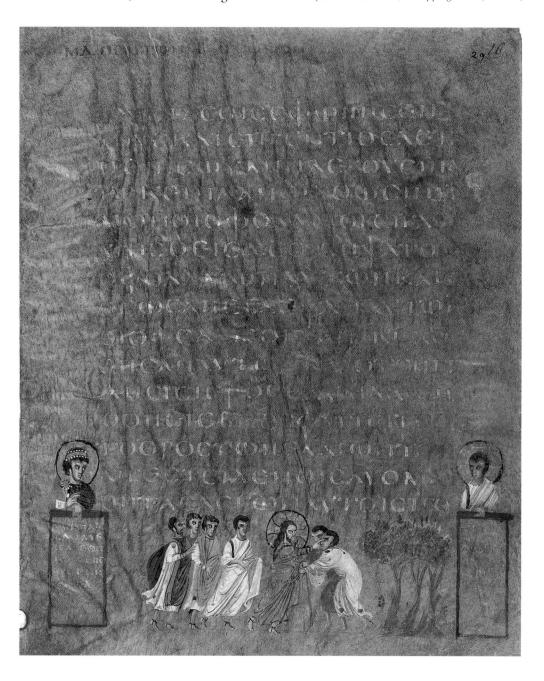

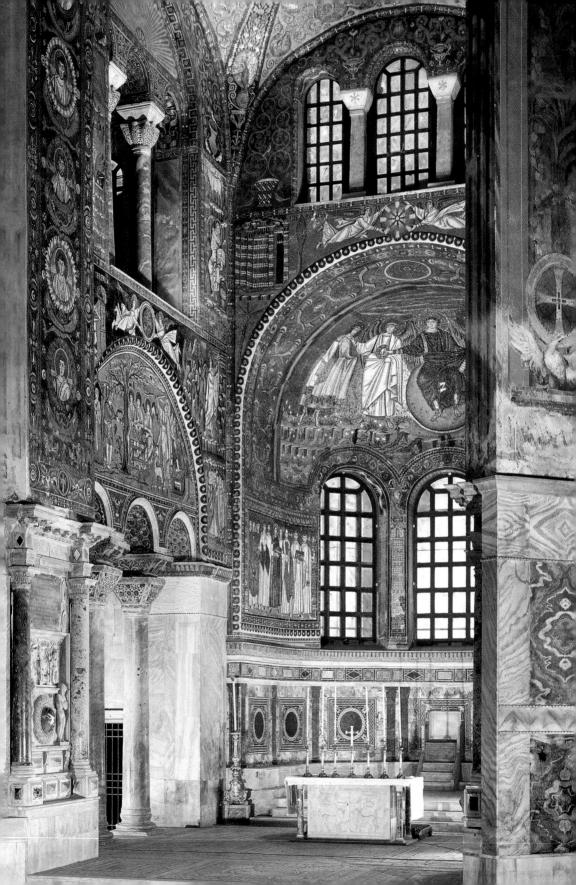

disciples follow Christ with eager step. The purpose of the illustration is explained by prophets holding texts on either side: on the left is David with a citation of Psalm 139:5, "Thou layest thy hand upon me;" on the right the text of Isaiah 35:5 is held by its author, "Then the eyes of the blind shall be opened." The miracles were to be taken as demonstrating that Christ had fulfilled the ancient prophecies of the coming of a Messiah.

A similar didactic point was made in another, now vanished, set of early Byzantine mosaics. In Justinian's church of St John in Ephesos (erected 548–65) the subjects included both Old Testament and Gospel narratives to demonstrate the fulfillment of Jewish prophecies in Christ. This time still another Healing of the Blind was included, that of John 9:1–7, which was effected by sending the blind man to wash his eyes in a pool called Siloam, a name which John explains means "sent." The inscription that accompanied the mosaic read: "The name of the pool is *Sent*, but dost thou understand who is sent by whom, so that thou mayest have a perfect view?" The miracle was addressed to the spectator in the nave of the church: if he understood that Christ was sent by God, then he had acquired perfect vision.

While these narratives led the viewer down the pathway of the nave, the sanctuary, the goal of all processions, was treated as a separate architectural unit, with subjects referring directly or symbolically to the celebration of the Eucharist. The sanctuary of S. Vitale in Ravenna (dedicated 547) is the best-preserved example (FIG. 79). The broad arches that flank the altar contain Old Testament prefigurements of the Eucharist. On the left Abraham offers a meal to his three mysterious visitors (Genesis 18:1–8), and in the adjacent scene Abraham raises his hand to sacrifice his son Isaac (Genesis 22:1–19). The Eucharistic theme continues on the opposite side with the offerings of Abel (Genesis 4:4) and Melchisedek (Genesis 14:18). Above the arches stand the prophets and evangelists whose works are read in the liturgy.

Within the apse itself the mosaics refer more literally to the Eucharist, showing the opening procession of the Byzantine liturgy (FIG. 80). The procession moves to the viewer's right, that is, into the apse, and according to Byzantine ritual the place of honor is at the head of the procession. The Gospel, therefore, because it stands for Christ himself, leads the procession, carried by a deacon. Another deacon accompanies the Gospel, swinging his fragrant censer. Next comes the bishop himself, Maximianus, carrying the customary processional cross and wearing the stole of his office, a thin white band, over a copious *phelonion*, or chasuble. Although the erection of the church was financed by the same

Opposite

79. S. Vitale, Ravenna, 548. General view of the decoration of the sanctuary.

All the surfaces of the sanctuary are covered with glistening mosaics and marble revetments, emphasizing the special holiness of the place of the altar, where the Eucharist was offered.

80. Entrance of Bishop Maximianus with Justinian,548. Mosaic panel.S. Vitale, Ravenna. Julianos Argentarios who built S. Apollinare in Classe (it may be his face directly behind the bishop's), the presiding bishop Maximianus claimed special credit for the church and had his name inscribed in large capitals over his head. Behind him walks the emperor Justinian, making an offering of gold plate to the church. Strategically placed in the center of the panel, he wears a gorgeous purple *chlamys* called the *sagion*, decorated with a panel of gold material called the *tablion*. The clasp on his shoulder and the diadem on his head are set with gems and pearls, while large teardrop pearls (called *prependoulia*) dangle from them. The emperor is accompanied by members of his court, followed by

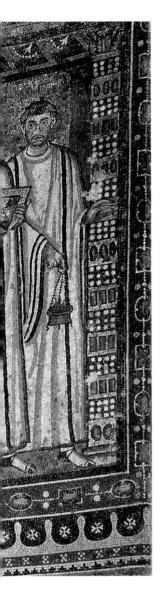

81. Presentation in the Temple (or Encounter with God), from the Kalenderhane Camii, sixth century. Mosaic, 4'3" x 4'3" (1.3 x 1.3 m). Istanbul Archaeological Museum.

This panel originally decorated the church which is now the Kalenderhane Camii (mosque).

the military, wearing torques of gold. Since the emperor himself never visited Ravenna and his support of the church of S. Vitale is nowhere mentioned, one must assume that his insertion into the procession here is rather a Ravennate pledge of allegiance to their distant sovereign. Theodora and the women of the court enter in a separate procession on the opposite side of the sanctuary; men and women were separate in Byzantine worship. Theodora wears a *chlamys*, which has now lost its military significance; longer and lighter, it has become the garb of the empress as well as her husband.

These literal representations of the procession of the liturgy have a celestial counterpart in the curve of the apse. Here the patron of the church, St Vitalis and the deceased founder, Bishop Eclesius, approach an eternally youthful Christ to receive from him the crown that rewards their virtuous lives.

In Constantinople only a single sanctuary mosaic survives from the early phase, but it gives an important indication of things to come (FIG. 81). In the sixth-century apse of a church, which is called by its Turkish name, the Kalenderhane Camii, the mosaic narrates how Christ's parents presented him in the temple as a child to be received by the prophet Symeon (Luke 22:2–35). Because

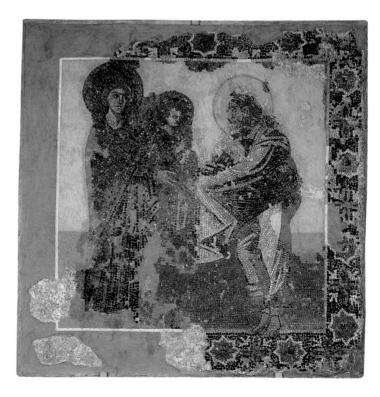

Opposite

82. Santa Maria dell' Ammiraglio (the Martorana), Palermo, 1143–51. View into the dome.

The patron of this church, an Orthodox Christian named George of Antioch, served as admiral of the fleet of King Roger II of Sicily.

biblical subjects were capable of many interpretations, it is important in each instance to observe what construction the Byzantines put on them. In Western art the subject is called the Presentation in the Temple, emphasizing the offering that anticipated Christ's self-offering death. Byzantine art, on the other hand, names the story the Encounter with God, emphasizing Symeon's recognition of the Savior. In the mosaic panel Symeon runs forward with anticipation, his feet breaking through the border and his arms outstretched with desire toward the Child. This desire for Christ. and literally for the Body of Christ, was to become one of the chief leitmotifs of Middle Byzantine art. In contrast to the motionless and static figures of Ravenna, the lunging figure of Symeon, with its strong three-dimensional feeling of lights and darks, testifies to the stronger survival of Hellenistic painting in Constantinople. a phenomenon we have observed in the contemporary Great Palace mosaics as well (see FIG. 53).

Church architecture of the early period came to a climax in Justinian's cathedral of Hagia Sophia, which was unsurpassed in scale in the Middle Ages. Its general spacial layout of nave flanked by aisles and galleries repeats the plan of the Stoudios basilica, but its soaring hundred-foot (30 m) dome was a unique engineering feat, accomplished by the mathematicians Anthemios of Tralles and Isidore of Miletos. The only images mentioned in its pre-Iconoclast phase are the icons of the *templon* described above.

Medieval Byzantine Church Design

Like the Gothic, Byzantine comprises a great international school of architecture, but while the protracted naves of the Gothic perpetuate the basilica plans of the early church, Byzantine architecture in the period after Iconoclasm abandoned processional spaces in favor of smaller, centrally organized plans (FIG. 82). To the visitor entering the nave all of the church was visible at once, unlike the basilica, which must be experienced by walking its length. Medieval Byzantine churches are centripetal spaces, lifting one's gaze toward the dome. Plans based on the cross, the circle, and the octagon are laid out with all the symmetry of a flower or a crystal. While Gothic architecture was tied to ambitious experiments in making structures ever higher and lighter, Byzantine architecture displayed its virtuosity in subtlety of design and refinement of detail.

Several factors contributed to this change in direction. In the first place, Constantinople had a plentiful heritage of grand churches from the early period, basilicas as well as the enor-

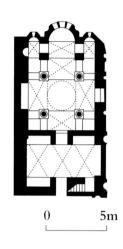

b

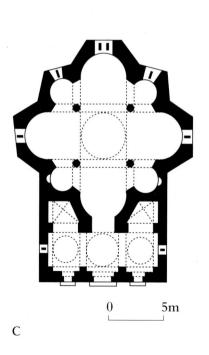

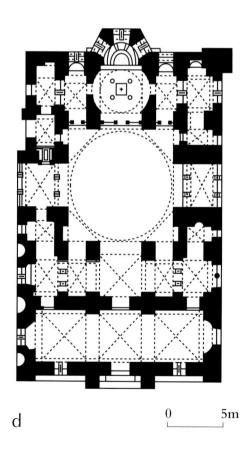

108 A Temple of Transformation

mous vaulted Hagia Sophia and Holy Apostles. Only in the new cities – Sofia, Venice, Kiev – was there any call for additional churches on this scale. A second factor was certainly the development of the medieval liturgy. Popular participation in the processions gave way to a more static liturgy structured around a series of appearances–dramatic moments when the clergy would sally forth from the sanctuary for the showing of the book and the sacrament. Third, the new aesthetic may be traced to the new domestic context of church architecture. It is significant that all of the new churches erected by Basil I (867–86), who was a very energetic builder, were private churches within the imperial palace. The houses of the well-to-do, such as those of Cappadocia, also regularly contained churches or chapels. The reduced scale of these churches matched their residential circumstances.

The plans of the new churches are also indebted to their domestic context, where domed and centrally planned structures were not unusual for reception rooms or elegant bedrooms. Three such domed plans gained popularity as church designs: the domed cross, the four-column cross-in-square, and the domed octagon (FIG. 83a, b, and c respectively). These alternative nave plans could each be modified by the symmetrical addition of side bays and conches yielding many variations. Each offered different surfaces for decoration.

The simplest of the designs was a dome over a cross-shaped ground plan, and it appears in the period immediately after Iconoclasm (FIG. 83a). At the convergence of the broad, barrel-vaulted arms four pendentive vaults effect a transition to the circle of the dome. Because this type required no marble columns and its vaulting was relatively simple, it became popular in outlying areas where columns were scarce and masonry crews less sophisticated. Nifont, the first bishop of Pskov in Russia, chose it for the church of his Mirozhski Monastery (FIG. 84); and so did the prince Alexios Komnenos for his church of St Panteleimon (1164) at Nerezi in the Macedonian Republic of the former Yugoslavia. The cross-shaped plan presents large flat wall surfaces for painting. Variations could be introduced by adding a second story or by multiplying surrounding bays.

Opposite

- 83. Four types of church ground plan:
- **a**. Transfiguration cathedral, Mirozhski Monastery (1153–6), Pskov;
- **b**. Funeral Chapel, church of the Mother of God Pammakaristos (1310–15), Constantinople:
- **c**. Holy Apostles (c. 1000), Athens.
- **d**. Katholikon, Hosios Loukas (early eleventh century), Stiris.

84. Transfiguration cathedral of Mirozhski Monastery, Pskov, 1153–6. View into south barrel-vaulted arm.

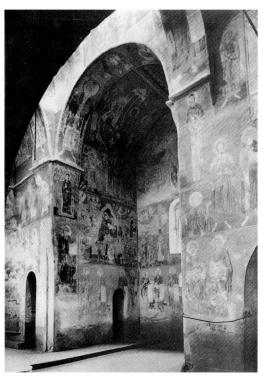

85. Church of the Mother of God Pammakaristos, now the Fethiye Camii (mosque), Istanbul, 1310–15. View into the dome.

In Constantinople, however, and in the Aegean basin, the most popular type was a dome resting on four columns placed within a square plan (see FIG. 83b). This was the plan used by the emperor John II Komnenos in his churches of the Pantokrator in Constantinople (see FIG. 20), and in the Palaiologan period it was used by Martha Glabas in the burial church she erected in 1310–15 for her husband (FIG. 85). On the ground level the church-goer stands in a cubical space with a marble column in each corner; on the next level the corners above the columns are vaulted over, transforming the space into a cross; finally groin vaults enclose

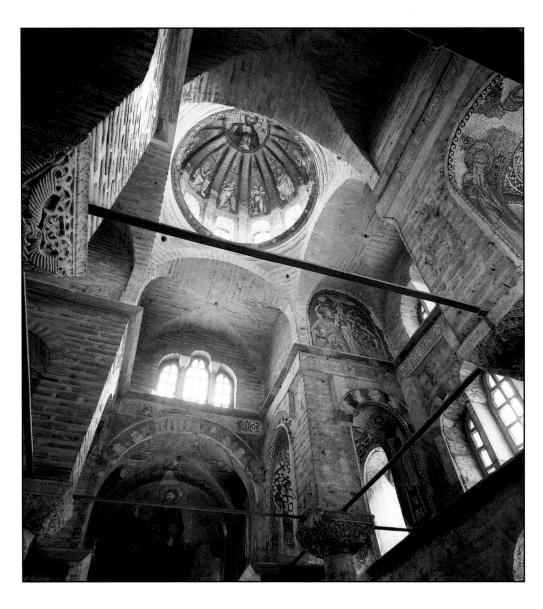

the cross, and in the center pendentives effect a transition to the circle of the drum and dome. The succession of forms – from square, to cross, to circle – constitutes a tightly designed unit. This unit could be expanded with apses on the ends of the cross, resulting in the roseate plan of the Holy Apostles in Athens (see FIG. 83c). The monolithic marble columns set the tone for the decoration of the interior with marble revetments, and the vaults presented complex surfaces for mosaic or fresco at different heights.

The third nave plan was the most unusual and the most elegant, with an ambitious vaulting system consisting of a dome on eight arches over a cubical nave (see FIG. 83d). This is the plan of the church, known as the Katholikon, erected by unknown benefactors to shelter the remains of the miracle-working ascetic Hosios Loukas in the early eleventh century in Stiris, Greece (see FIG. 75). The diagonal arches across the corners of the cube enclose squinch vaults, while the axial arches open into cross arms. This design offered a broader and more unified nave than the four-column plan; the dome of Hosios Loukas spans a full twenty-eight feet (8.5 m), which is large for a Middle Byzantine church. A complexity of angled views from lighted to shadowed spaces surrounds the nave.

This central domed space, called the nave, constituted the congregation space. But the entire church comprised three distinct spaces in east-to-west succession. In front of the nave (i.e., to the west) lay the fore-church or narthex, and to the east the bema or sanctuary. The different uses of these parts naturally affected their decoration.

The Medieval Decorative System

Each of the three church types presented a somewhat different shell for the imagery, and the decoration was never exactly the same even within a given type. The poor preservation of medieval monuments further complicates the picture; not a single church survives in its medieval state, and the loss is most regrettable in Constantinople, where no Middle Byzantine church preserves its decoration. Still, certain consistencies can be found in the surviving material that permit a synthetic approach from which we may hope to gain an understanding of the principles involved in the decorative system. Three eleventh-century mosaic churches in Greece are of paramount importance in studying the program: Hosios Loukas, Stiris; Nea Moni, Chios; and the church of the Dormition, Daphni, near Athens. The sponsors of these

112 A Temple of Transformation

86. Transfiguration, late eleventh century. Mosaic. Church of the Dormition, Daphni, Greece.

The faces of Christ and Elijah (to the left) are modern restorations.

churches remain unknown, with the exception of Nea Moni, erected by Constantine IX Monomachos (1042–55).

The imagery of the Byzantine church engages the spectator on many levels. On the aesthetic level, the wrap-around placement of images affects the viewer very differently from classically framed images. In the church of the Dormition at Daphni the figures of Moses and Elijah are turned in three-quarter poses against the concavity of the vault in a way that allows them to speak to one another across the space that the viewer actually inhabits (FIG. 86). This creates a realism of perspective that is the opposite of Renaissance illusionistic perspective, which attempts to carve out imaginary spaces behind the picture plane. The modeling of the figures in shallow relief against a neutral ground of gold or blue heightens the effect of their projection into our space. As art historian Otto Demus formulated it:

The image is not separated from the beholder by the "imaginary glass pane" of the picture plane behind which an illusionistic picture begins: it opens into the real space in front, where the beholder lives and moves. His space and the space in which the holy persons exist and act are identical. The Byzantine church itself is the "picture-space" of the icons. The beholder feels himself witnessing the holy events and conversing with the holy persons. He is not cut off from them; he is bodily enclosed in the grand icon of the church; he is surrounded by the congregation of the saints and takes part in the events he sees.

This is how the Byzantine aesthetic worked toward involving the spectator. The images themselves involve the church-goer on two different levels according to two large categories, sanctoral and Christological. The saints' images constitute a holy company which the spectator is invited to join.

The lowest zone of imagery is always made up of individual iconic images of the saints, frontally posed and gazing at the visitor. These mural images are supplemented by icons properly so called, wood-panel paintings, that hung on the *templon* barrier or were exhibited on icon stands. Generally, saints are grouped by classes: military saints, monks, physicians, women, and bishops. At Pskov and Sopočani, in Serbia, they are full-length figures, larger than life-size, ranked in dense array all about the interior (see FIG. 84 and FIG. 87). They stand above a low dado zone at a height where they are accessible to the church-goers, who greet them upon entering. According to Orthodox tradition, the faithful upon

87. Monks in file in the church nave , 1164. Fresco. Sopočani, Serbia.

88. Christ Pantokrator in the dome, with Prophets in drum below, late eleventh century. Mosaic. Church of the Dormition, Daphni, Greece.

first entering circulate to venerate the images of the saints. The traditional greeting of the image begins with *proskynesis*, a thrice-repeated deep bow in which one touches the ground with one's right hand and makes the sign of the cross. Next one touches and kisses the image, an action that is called *aspasmos* in Greek. finally one converses with the saint, addressing one's prayers to the holy figure, perhaps offering a candle to reinforce one's petition.

In his treatise On Icons, St John of Damascus urged the faithful to "embrace [saints' icons] with the eyes, the lips, the heart; bow before them; love them; for they are likenesses of the communion of saints, who shared the sufferings and the glory of Christ." Entering the church meant joining the ranks of a company of friends.

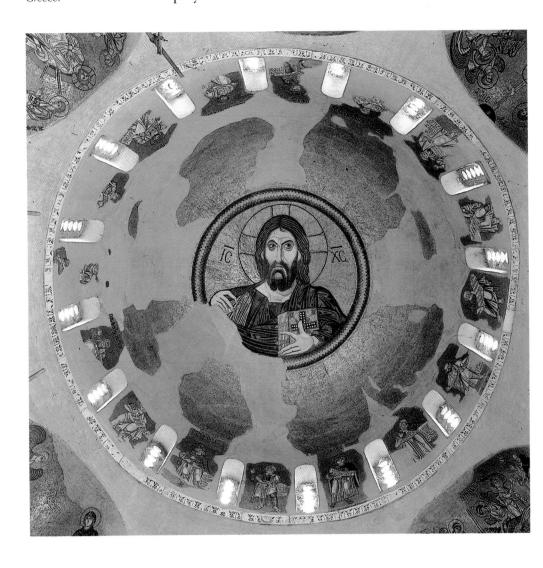

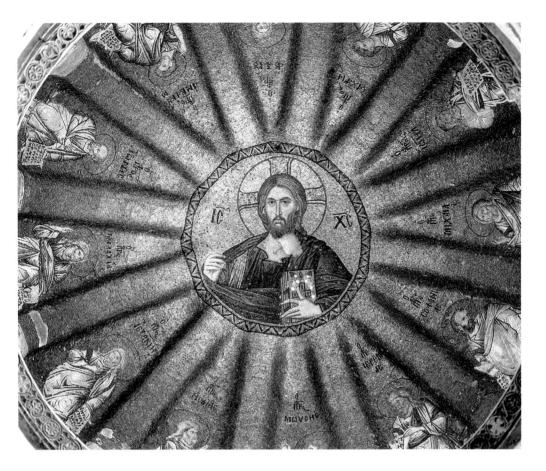

Christ in the Dome

While the sanctoral images are placed close to the church-goer, the Christological images in the vaults are out of reach, where they operate in a more spiritual and profound way. One must begin with the culmination of the program, the awesome half-length image of Christ in the dome, for it is both the most distinctive image of the Byzantine system and the key to the rest.

The half-length Christ leans from a circular frame clutching the Gospel in his left hand and blessing with his right (FIGS 88 and 89). This is an iconography that we have encountered already in the sixth century (see FIGS 34 and 35). What makes it special here is its location in the cup of the dome, where it seems physically to embrace the space below. When assigned this location in the ninth century, starting with its installation in Hagia Sophia, this iconography acquired a new name as *Pantokrator*. Commonly translated "All-Ruler," the term might suggest to us some sort of cosmic governor; but the Greek word *krateo* means both ruling

89. Christ Pantokrator and Prophets in the dome, 1310–15 (detail). Mosaic. Funeral chapel of the church of the Mother of God Pammakaristos, now the Fethiye Camii, Istanbul.

and holding and the Byzantines commonly interpreted *Pantokrator* as "All-Holder," referring to God's encompassing and sustaining nature. Gregory of Nyssa says God is *Pantokrator* "because he holds the orb of the earth in his palm, and he measures the depth of the sea with his hand; he includes in himself every spiritual creature in order that all might remain in existence, ruled by his all-containing power." "All things reside in the *Pantokrator*," according to the theologian pseudo-Denis, "He contains and embraces all." Curved in the concavity of the dome, Christ encompasses the space below him.

The location of the image is critical to its experiential meaning: this is an image made for standing beneath. One entered under the umbrella of this image in order to be embraced by Christ and transformed into him, for in the space below, under the all-seeing eye of the *Pantokrator*, the church-goer experienced the ritual of the liturgy, and the liturgy had as its goal a transformation into Christ. This was accomplished in two stages: the stage of enlightenment, which is the first half of the liturgy, consisting of readings from sacred scripture; and the stage of communion, or union with Christ in reception of the Eucharist.

In the Byzantine rite the bishop or priest administered communion to the faithful on the step before the *bema*, underneath the dome. In the Middle Ages the faithful received communion only a few times a year, after careful preparation by fasting and confession. The purpose of the rite was understood as assimilation into Christ. The patriarch Maximos (580–662) explained, "The holy reception of the immaculate and life-giving sacraments brings about a resemblance to Him, which effects a communion and identity with Him by participation, after which the human person is deemed fit to be changed out of a man into God. [Jesus Christ] transforms us into Himself." The Christ in the dome, then, is the full, perfect self that the beholder becomes in communion.

The Selected Narrative

The Byzantine church was a very special kind of space, laid out in rigorous centrality around a vertical well of light covered with a dome. The dome defined a magical space for the encounter with the divine. One did not enter this space to work out puzzles in iconography, but to be transported to another level of existence. The narrative Christological subjects, occupying the vaults below the dome, reinforce this experience. Their unifying theme is the Body of Christ.

While art history of the 1980s and 1990s has explored many aspects of the body and the constructions that images have put on it, in studies of gender, sexuality, and social dominance, the centrality of the body to Byzantine art has been left to one side. The theme of Christ's Body presents many anomalies to contemporary philosophy, requiring its own categories; for it takes as its premise a belief in the Incarnation, which might be translated as "God-made-Body." This premise attaches miraculous, magical valences to Christ's Body wherever it appears in imagery, giving it powers to transform itself and everyone in contact with it. In its "natural" life on earth Christ's Body is the vehicle of human salvation and in its sacramental presence in the rite of the Eucharist it is the church-goer's contact point with the divine.

While in the West the doctrine of salvation is closely tied to the idea of a "satisfaction" for sin made to Divine Justice by the sacrifice of Christ's death - hence the centrality of the crucifix - in the Orthodox view salvation was accomplished by the Incarnation itself. God's assumption of human nature effected a change in human nature as such. This is the central doctrine of Orthodox theology and it is referred to as the doctrine of theosis or divinization. St Athanasios summarized it in his famous dictum: "He became man that we might be made divine." This view gives the Body of Christ an extraordinary centrality in Byzantine thought, and hence in Byzantine art. The theologians pseudo-Denis and Maximos the Confessor developed this doctrine in the sixth and seventh centuries, and Symeon the New Theologian gave it vivid new expression in the eleventh century: "God was undivided in substance before Christ, my God, took upon him human limbs. For when he assumed the form of a human body, he bestowed his Holy Spirit, and by this means is united in substance to all the faithful; and this unity is inseparable and indissoluble."

The sequence of narrative scenes in the upper vaults reads from left to right around the nave, beginning with the Annunciation, often repeating subjects on the *templon* beam. These subjects have been called the Festival Scenes, because of a rough parity with the great feasts of the calendar year. But the official liturgical list of the twelve feasts includes subjects not represented, and it omits precisely the subjects that receive greatest attention in the images, namely the events connected with the fate of Christ's Body in his Passion, Death, and Resurrection. The set might better be called the Selected Narrative, understanding that it comprised a more limited selection than the early Byzantine nave narratives, but could be expanded when necessary. In each scene the story takes a turn that distinguishes it from usage in Western art.

Overleaf

90. *Nativity*, late eleventh century. Mosaic. Church of the Dormition, Daphni, Greece.

Because most of the laity could not read, they found pictorial narratives extraordinarily compelling and read them with close attention. The scenes carried a conviction not unlike that of documentary television. The Second Council of Nicaea (787) described the impact of the image of the Nativity: "When Christians see in a picture the Virgin giving birth and angels standing above with shepherds, they acknowledge God born for our salvation, and they confess saying: He who was without flesh was made flesh." The image persuaded them of the reality of the Incarnation, and consequently of their salvation. The Nativity at the church of the Dormition, Daphni, tells several episodes of the Gospel story (FIG. 90). The pensive Joseph in the foreground recalls his painful uncertainty at his wife's pregnancy (Matthew 1:18-25); on the right an angel brings the news to the shepherds, while his companions above the hill adore the Child (Luke 2:8-14). But the most dramatic feature of the image is the new-born Child, lying in a black cave beneath a beam of heavenly light. Byzantine art, in contrast to Western art, always insists on this extra-biblical detail of the cave, recalling how the Roman cult of Mithras had placed that god's birth and salvific work in a cave. Christ's Body arrives like a seed splitting open the earth; his mother assumes the reclining pose of a classical mother goddess.

In the Selected Narrative the Life of Christ continues with his Presentation and his nude Baptism in the Jordan, scenes that strongly assert the physicality of Christ's Body. In contrast, the Transfiguration boldly emphasizes the magic of his Body. This is a quintessentially Byzantine subject, commemorated in the Orthodox calendar but not in the Latin, and it occurs in Western art only when it is borrowed from Byzantine art. The Greek name of the event, therefore, is important: Metamorphosis means transformation. In the Gospel story (Matthew 17:1-9) Christ took his closest disciples, Peter, James, and John, on to a high mountain to pray, and he was transformed into a vision of brilliant light, while Moses and Elijah appeared in conversation with him. At Daphni the Body of Christ in shining white clothes is encompassed by layers of light and gives off rays of light (see FIG. 86). It is a meta-temporal Body that defies the laws of time and space; prophets long dead suddenly appear beside him.

The most important subjects in the Selected Narrative are those associated with Christ's death and resurrection, which Byzantine art develops at some length. In Middle Byzantine art the Body of Christ often appears naked and at Daphni it is even sensuous and alluring (FIG. 91). Although his sex is concealed, it is a broadshouldered, well-developed masculine body. The head is bowed

Opposite

91. *Crucifixion*, late eleventh century. Mosaic. Church of the Dormition, Daphni, Greece.

Though the face of Christ conveys the impression of his death, the body is represented as still animated, with glowing skin and firm muscles; the fountain of blood and water coming from his side symbolized the sacraments of Baptism and the Eucharist.

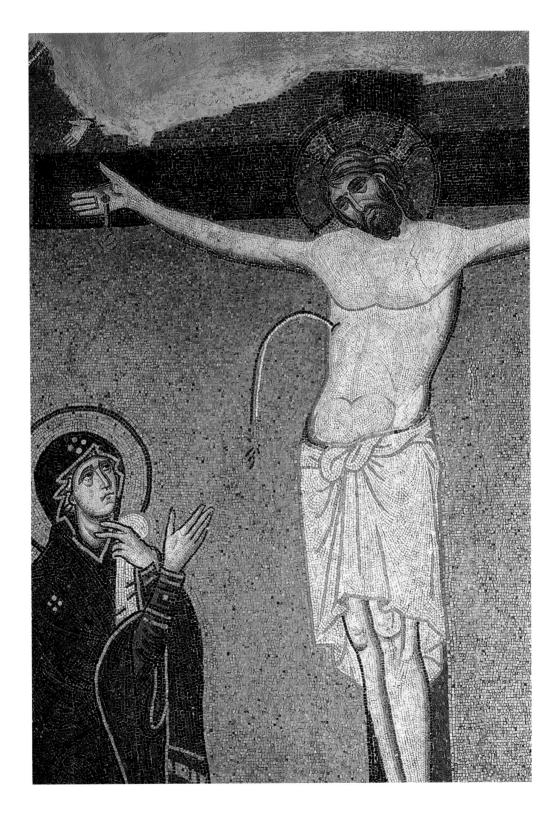

92. *Deposition*, detail of upper half, c. 1042. Mosaic. Church of Nea Moni, Chios. Greece.

in death, but the wounds are discreet and hardly appear life-threatening. A Byzantine reaction to the image is preserved in the acts of the Second Council of Nicaea in the remark of the patriarch Tarasios: "If we saw an image showing our Lord crucified, would not we have wept? For therein is recognized the extent of the abasement of God who became man for us." It is significant that the theologian relates Christ's death not to satisfaction for sin, the Western preoccupation, but to the "God-made-Body" mystery. While the modern viewer, instead of weeping, is likely to feel shivers of

revulsion at the necrophiliac associations of contemplating the dead Body, the Byzantines saw it very differently, for they insisted that even death was unable to dissolve the union of God and Man. As explained by the theologian Anastasios of Sinai (c. 615–c. 700), although the Body was truly dead, the Divinity still dwelt in it. Not only that, but the Body by suffering death became a fountain of life, since the blood and water that spurt from Christ's side were the life-giving sacraments of Baptism and the Eucharist.

Not satisfied with the Crucifixion, the Byzantines wanted to follow the Body of Christ step by step from the cross to the tomb. At the monastic church of Nea Moni on Chios we encounter the removal of the Body from the cross, the Deposition (FIG. 92). The Gospels tell that a disciple named Joseph of Arimathea took the Body of Christ from the cross and wrapped it in linen and laid it in a tomb he owned (Matthew 27:57-66). But besides the Gospel story, the insertion of this scene into the Selected Narrative made direct reference to one of the most dramatic moments of the Byzantine liturgy, the deacon's carrying of the gifts of bread and wine to the altar in the Great Entrance. This ceremony, accompanied with the swinging of incense and the rhythmic chanting of the Cheroubikon hymn, opened the Eucharist proper. Already in the fifth century Isidore of Pelusium (d. c. 435) made the connection of ritual and narrative: "The spreading of the clean sindon [altar cloth] under the sacred gifts signifies the ministry of Joseph of Arimathea." Joseph's contact with the Body of Christ is represented with an affection that complements the eager devotion of Symeon reaching for the Child (see FIG. 81).

The extra-biblical subject of the Lamentation depicts an entirely different kind of veneration of the Body of Christ. Introduced to monumental painting in the twelfth century when a new emotionalism animated Byzantine art, the scene turns our attention to

the grief of the Mother of God. In the church of St Panteleimon of Nerezi in the former Yugoslav Republic of Macedonia the artist places the scene before a descending hill containing the cave where Christ is to be buried (FIG. 93). Joseph of Arimathea, who provided the linen for the shroud, and Nicodemus mourn

93. Lamentation, with monastic saints below, 1164. Fresco. Church of St Panteleimon, Nerezi, former Yugoslav Republic of Macedonia.

94. *Resurrection* (or *Anastasis*), c. 1042. Mosaic. Church of Nea Moni, Chios.

In his resurrection from the cave of the underworld. Christ has broken down the door and scattered the locks and bolts that had held it. At the same time the just of bygone ages arise from their sarcophagi: on the right, Adam and Eve, with St John the Baptist furthest right; on the left, David and Solomon, the latter bearing portrait features of the bearded Constantine IX Monomachos, the sponsor of the church.

at Christ's feet, while John, the beloved disciple, doubled over, raises his hand to his lips. But Mary's grief knows no restraint. She clutches the Body in her lap, one knee showing below and one above. Cradling his head in her right arm, she draws him up to kiss him on the lips! This is the counterpoise to her kiss of her infant in the contemporary Vladimir icon (see FIG. 48), and the Byzantines felt keenly this tragic contrast. In a sermon of the late tenth century Mary is imagined to address the dead Christ: "I raised you in a mother's arm, but leaping and jumping as children do. Now I raise you up in the same arms, but lying as the dead. Then I dipped my lips in your honey-sweet and dewy lips. Many times you slept on my breast as an infant, and now you have fallen asleep there as a dead man." This returns us to the human situation in brutal reality, for it is known that burial practices in medieval Greece involved exactly this kind of emotional outpouring, including hugging and kissing the corpse.

A powerful Resurrection concludes the set of mosaics that encircle the nave at the church of Nea Moni, Chios (FIG. 94). Restored to vigorous life, the Body of Christ strides firmly out of the black pit of hell, whose doors he has broken asunder. While Western art preferred to represent the Resurrection by the Gospel story of the women who discovered the empty tomb (Matthew 28:1–7), the Byzantines chose the dramatic story told in the

apocryphal Gospel of Nicodemus (Chapter 24) of Christ delivering Adam. Indeed, the Greek name of the scene, the Anastasis, has an active sense to it, meaning raising as well as rising. The rising of Christ's Body raises up with it all the dead. As in the Transfiguration, the Body of Christ is meta-temporal; its touch revivifies the first man in his tomb. The artist, faced with the task of conveying the supernatural state of the risen Body, has given Christ superior size, relative to attendant figures, and clothed him in flashing black and gold. Behind Adam appears Eve and a crowd of the just, led by the shaggy-haired John the Baptist. The spectator believed that his contact with the Body of Christ in the rites of the church would raise him as well. This belief is given added conviction by the insertion of a contemporary portrait of the patron of the monastery, the emperor Constantine IX, in the person of the royal prophet Solomon. He appears in a green halo beside the red-haloed David, his father.

95. Communion of the Apostles and Concelebrating Fathers, right half of the composition, c. 1265. Fresco. Sopočani, Serbia.

In their clerical robes the bishop saints surround the altar in much the way as the clergy of the period would have surrounded it when offering the Eucharist.

The Sanctuary

While the laity gathered beneath the dome surrounded by the Selected Narrative of the deeds of the God-made-Body, the sacramental transformation of the bread and wine into the Body and Blood of Christ was entrusted to the clergy, who gathered around the altar in the bema, or sanctuary. The bema was screened by the templon, which we have seen was blocked more and more with icons, starting in the tenth century. In the eleventh century, moreover, monastic sources mention the closing of the templon with a curtain during the solemn recitation of the prayer of consecration. The rites of the altar therefore became more secret, adding to the sense of sacredness. The imagery of this space, accordingly, had a certain esoteric character, referring to the actions of the clergy. As in early Byzantine churches, the Eucharist is the principal theme of the sanctuary; but the emphasis has changed.

The frescoes of the *bema* of Sopočani in Serbia represent the sanctuary program in the thirteenth century (FIG. 95). On the lowest level a row of life-size bishops converges from either side. Although they are identified as the

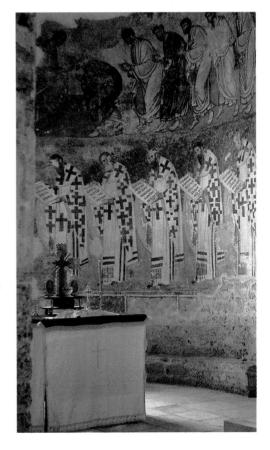

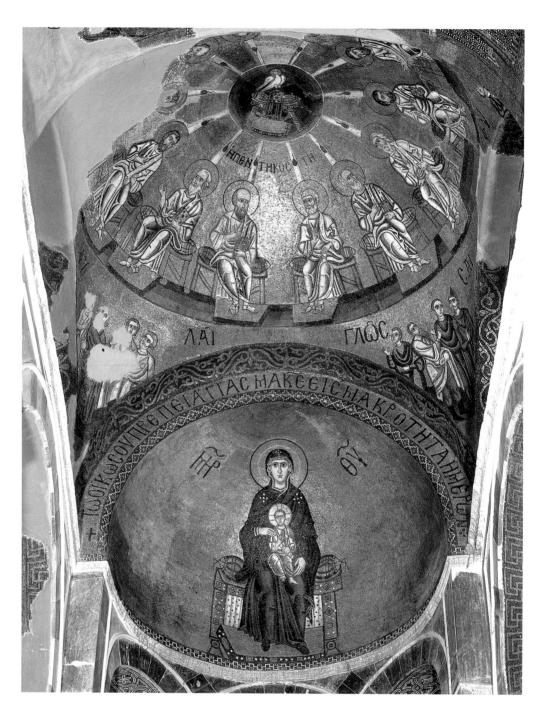

96. *Pentecost* and the *Mother of God*, early eleventh century. Mosaics over the sanctuary. Katholikon, Hosios Loukas, Stiris, Greece.

bishops of an earlier age – Sts Chrysostom, Basil, Gregory – they represent the actual performance of the liturgy. They wear a type of *phelonion* or chasuble which was introduced in the eleventh century, with a striking pattern of black crosses on a white field, and they carry scrolls which the clergy in fact used for their secret prayers. On this level, then, the saints who celebrated the liturgy in past ages encircled the actual celebrants, reading the same texts they read.

Above this "realistic" procession a second procession takes us further back in history to the celebration of the Last Supper. The apostles, six on each side, approach to receive the Eucharist from Christ, who is represented twice, offering the chalice on one side and the bread on the other. Their outstretched hands, like those of Symeon in the Presentation or Joseph in the Deposition, express their longing for the sacramental Body which will seal their mystical union with Christ.

The space in the vault of the apse is generally assigned to the figure of Christ's mother holding her child. This early Byzantine tradition was revived in post-Iconoclasm times in the mosaics of Hagia Sophia (see FIG. 26). Insofar as the Eucharistic rite was believed to re-enact the "God-made-Body" mystery, it was most appropriate that the human parentage of Christ should preside over the altar this way. At Hosios Loukas the vault in front of the apse is assigned to the Pentecost, the descent of the Holy Spirit on the apostles, with the dove of the Spirit resting on a throne at the center (FIG. 96). Both the Incarnation and the Eucharist were believed to be the work of the Spirit. According to the Gospel, the Virgin's miraculous conception was attributed directly to the Holy Spirit. In the angel's words, "The Holy Spirit will come upon you, and the power of the Most High will overshadow you" (Luke 1:35). Similarly in the consecration of the liturgy, the priest bending over before the altar prayed, "O Lord, who sent your Holy Spirit on your apostles at the third hour, send down your Holy Spirit upon us and upon these gifts here offered, and make this bread the precious Body of your Christ."

While the clergy received communion of bread and wine separately, the Byzantine rite prescribed *commixtio* for the laity, the bread being broken into the chalice of wine and administered by a spoon. The chalice itself was of gold and was kept concealed until the moment of communion. At this moment the curtain was drawn and the doors of the sanctuary opened and the deacon emerged holding the veiled chalice on high, while the choir chanted: "Blessed is he that comes in the name of the Lord! God is the Lord and has revealed himself to us!" The priest then unveiled the chalice brought to administer communion to the faithful.

Romanos II, 959-63. Sardonyx, enamels, and pearls, height 8%" (22.5 cm) diameter 51/2" (14 cm). S. Marco Treasury,

97. Chalice of Emperor

Venice.

The richness of the chalices employed intensified this revelatory climax. That of Romanos II (959-63) is one of the most splendid to survive (FIG. 97). The Byzantine goldsmith re-employed an antique cup of sardonyx, distinguished by fifteen flutings, over which he added fifteen enamels framed with pearls. The enamels offer a kind of recapitulation of church iconography, including a Blessing Christ flanked by Peter and Paul, the Mother of God flanked by archangels, as well as bishops and evangelists. The emperor's inscription encircles the foot: "Lord, hear the prayer of the true-believing emperor Romanos."

Liturgical manuscripts also belonged to the clergy's space in the sanctuary, and few besides the clergy enjoyed their illuminations. One of the commonest subjects was the set of four evangelists that accompanied the Tetraevangelion, the book of the four Gospels (FIG. 98). Because the authors were understood to be the eyewitnesses of the "God-made-Body" mystery, they were given a super-real status compared to other saints. The evangelist John said of his witnessing, "He who saw it has borne

98. St Matthew, from the Tetraevangelion or Book of the Four Gospels, mid-tenth century. Tempera and gold on parchment 8½ x 6¾" (21 x 17 cm). National Library, Athens (Ms. 56, fol. 4v).

witness – his testimony is true, and he knows that he tells the truth – that you also may believe" (John 19:35). His reality is pledge of the truth of his words. In the tenth-century Gospel in Athens, St Matthew is given an unusual physical presence through evocation of ancient painting techniques. The relaxed pose and the thoughtful hand-to-chin gesture recall classical portraits of the philosopher Epicurus. The artist gives mass to the figure by light that falls from the left, a principle observed in the furniture as well. The everyday tools of the scribe's trade have been laid out on the desk – a pen, a stylus, and an ink well–and the book Matthew is writing is open on the lectern to the first words of his Gospel.

The most important focus of the sanctuary, however, was the cross. In religious processions such crosses were carried in lead position (see FIG. 80), but their usual place was behind the altar, where they were the focus of every bow and prayer in the liturgy. The

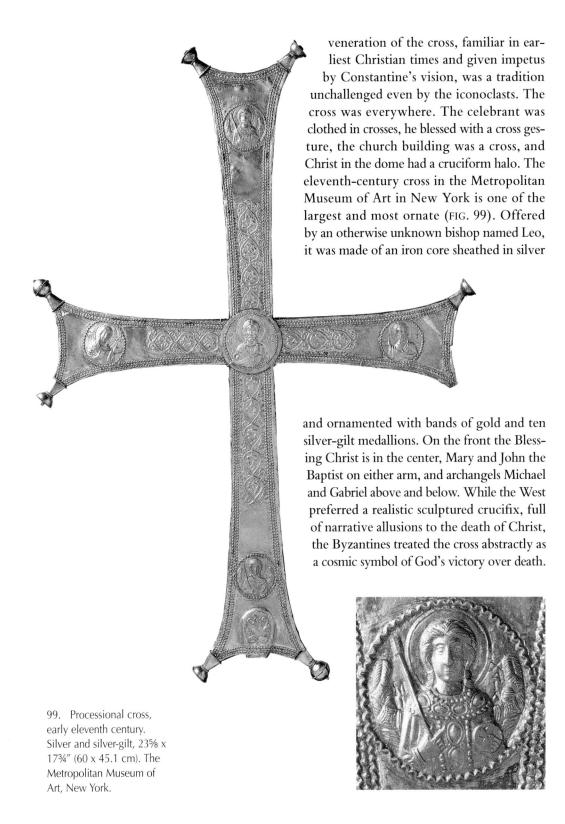

The Narthex

In front of the church lay a transverse entry hall called the narthex (FIG. 100), which served a variety of purposes. In monasteries it was commonly used for the night-time chanting of the Hours, saving the expense of lighting the larger nave. The Hours, the regular schedule of daily prayer consisting of psalmody, readings, and hymns, were the monks' most important responsibility. Stalls for the monks lined the walls. Other occasional uses of the narthex included the Maundy Thursday washing of the feet as well as the rites of burial.

The sanctoral program of the nave of the church might be expanded in this space, but overhead subjects were chosen to remind the monks of their communal solidarity in Christ. The Washing of the Feet is one such subject generally assigned to the narthex. At Chios the twelve apostles sit on a long bench, reminiscent of the monks' places in stalls below, and they remove their san-

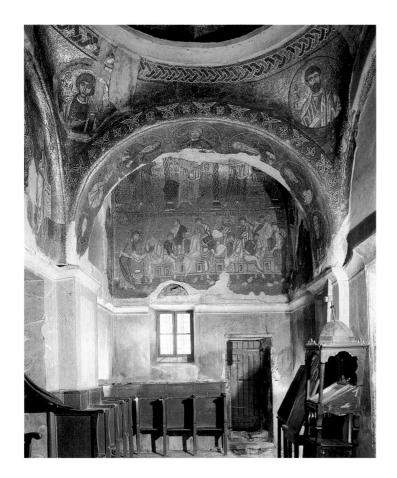

100. Inner narthex of the church of Nea Moni, Chios, c. 1042. General interior view to the north, including mosaic of the *Washing of the Feet*.

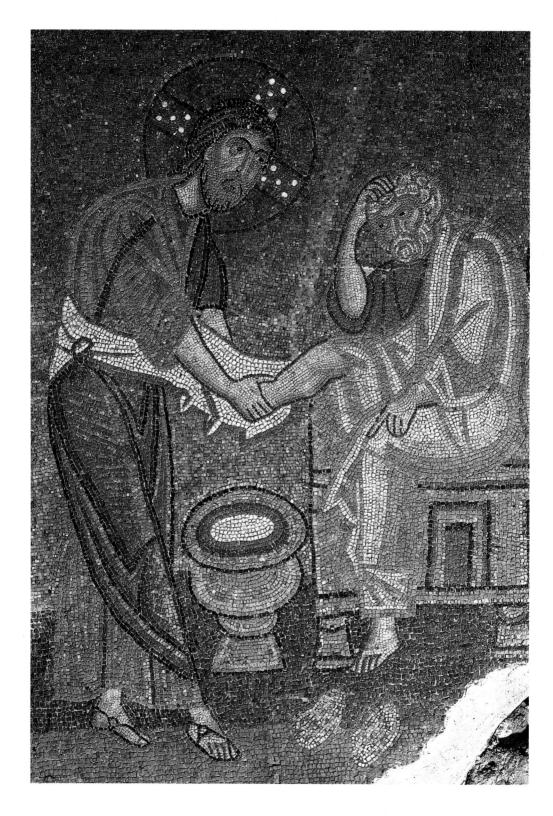

134 A Temple of Transformation

dals (FIG. 101). Christ, wearing a towel around his waist, is drying Peter's feet, while the apostle protests, "Lord, not my feet only but also my hands and my head!" (John 13:9). The monks were to contemplate here the lesson in fraternal charity spelled out by Christ: "I have given you an example, that you should do as I have done to you" (John 13:15). The narthex at Chios also included the full complement of the apostles in the scenes of the Betrayal, the Ascension, and Pentecost. With the Betrayal went the inscription, "Watch and pray that you may not enter into temptation" (Matthew 26:41), an apt motto for the nightly vigils of the monastic community.

The use of the narthex for funeral rites inspired in some churches another development in the Byzantine program, that of the Last Judgement. This theme was developed episodically, spreading left and right, so that whenever one entered or left the church one passed through or beneath the apocalyptic vision. Christ the judge appeared in the center, over the door from the narthex to the nave, enthroned among the angels with his Mother and John the Baptist making intercession on either side (the Deesis). Further out, the twelve apostles sat on thrones as judges, according to Christ's promise (Luke 22:30), as in the palace chapel erected by Vsevolod III in Vladimir (FIG. 102). Elsewhere, angels roll up the heavens like a scroll and the dead arise from their tombs; a river of fire flows from beneath Christ's feet to consume the condemned on his left, while the just are gathered in groups on his right in paradise. This cataclysmic vision of the world's end was seen as the universal fulfillment of the promise of the Resurrection scene.

Opposite

101. Christ and Peter, detail from the *Washing of the Feet*, c. 1042 (see FIG. 100). Mosaic. Narthex of the church of Nea Moni, Chios.

102. Apostles, detail from the *Last Judgement*, c. 1195. Fresco. Palace Chapel of St Demetrios, Vladimir, Russia.

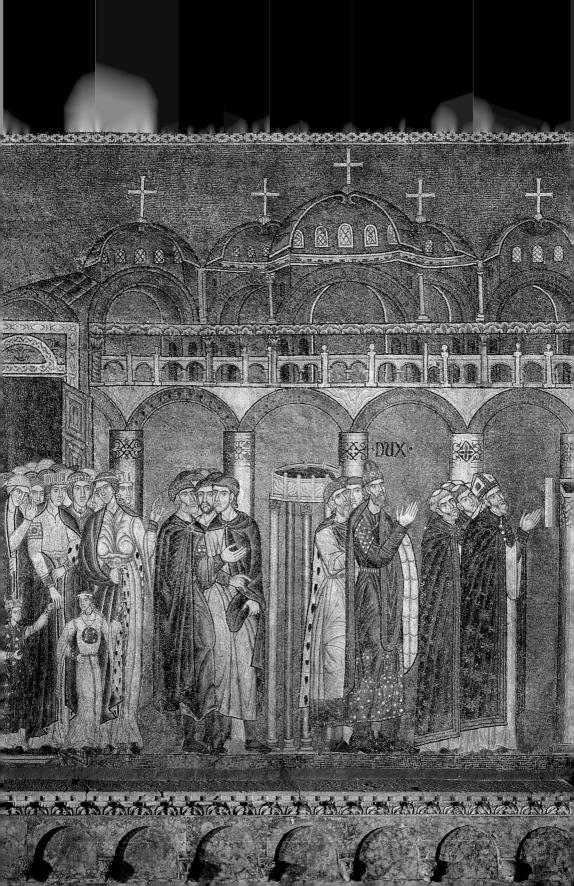

FIVE

A Cosmopolitan Art

Art and Diplomacy

Under the ruthless Basil II (967–1025) the Byzantine empire embraced all of present-day Turkey and the Balkans; yet its cultural influence, like waves from a stone in a pond, spread far beyond its boundaries. To the north, the Slav nations, the Bulgarians, the Russians, and the Serbs, had received Christianity in its Orthodox form from Constantinople, and with it came their first literature and a new ideology. And paradoxically, as the political fortunes of Byzantium waned its religious hold on the minds and imaginations of men was ever greater. But beyond the Orthodox world, the emperor, deriving his right to govern from his status as Roman emperor, was the model for rulers in other Christian states; his powerful imagery and the fashions of his court were mimicked in Italy and Germany to the west and in Georgia to the east. Furthermore, trade put Byzantine products in markets all around the Mediterranean, and the Byzantine imagery of the Christian mysteries became part of the lingua franca of Christian iconography from England to the Near East. Even among people whose adherence to Christianity was older than Constantinople itself, the city's authority as Christian capital was pre-eminent, and Armenians, Georgians, and Syrians found Byzantine iconography an apt medium for their faith (FIG. 104). In addition, the reliance of the Italian Renaissance on techniques and iconography learned from Byzantium, gave Byzantine art a central role on the world stage. Byzantine art was the backbone of European art.

Byzantine art, then, had an inside and an outside – a life of its own on its native soil among a Greek-speaking population that shared a common history and a common ideology, and a second life in the outside world, transplanted to new conditions among

103. Discovery of the Body of St Mark, 1253–68 (detail). Mosaic on the west wall of the south transept of S. Marco, Venice.

104. T'OROS ROSLIN Nativity and Adoration of the Shepherds, Gospel Book, 1262. Tempera on parchment, 11½ x 9" (30 x 21.5 cm). Walters Art Gallery, Baltimore (Ms. W. 539, fol. 208v).

T'oros Roslin, an Armenian artist, was both scribe and illuminator of this Gospel Book, which he produced for another T'oros, a priest, to be donated to a monastery. It contains over fifty narrative subjects from the life of Christ.

very diverse peoples. The richness and complexity understood by insiders could only be partly appreciated by outsiders. Yet it is one of the glories of Byzantine art that, transplanted, it was able to offer a vehicle of self-expression to so many culturally and ethnically diverse peoples.

The emperor Constantine VII Porphyrogennetos, whose coronation ivory showed him touched by Christ (see FIG. 21), offers a special instance of the depth of Byzantine culture for the insider. His portrait is complemented by Theophanes Continuatus' description: "In his personal appearance the emperor Constantine Porphyrogennetos was tall in stature. His complexion was milk-white; he had fine eyes; their expression was genial. He was beaknosed, had a long face, ruddy cheeks, and a long neck. Broadshouldered, he held himself as erect as a cypress tree." A serious scholar in his own right and skilled in painting and calligraphy,

Constantine was the guiding light of a rebirth of art and letters in the tenth century. He assembled a considerable library within the Kamilas palace and organized the production of a huge encyclopedic project called the Excerpta, a compilation of moral and political gems from ancient and Byzantine authors in fiftythree sections. For his son and successor, Romanos II, he compiled a trilogy of volumes on the conduct of diplomatic, military, and ceremonial affairs in the empire, and he also sponsored the composition of the Geoponika, the most widely circulated of his publications.

But outside the Greek-speaking world Byzantine manuscripts did not circulate widely, for the simple reason that they could not be read. Translations were made, but only of a limited selection. The Islamic demand for translations was limited to manuscripts of practical, scientific interest, leaving aside books of literature and theology. In Slavic lands, on the other hand, apart from scripture only books of a liturgical nature were translated. The West received from Byzantium only a small number of theological works of neo-Platonic bent - pseudo-Denis and Maximos the Confessor - while they took the works of Aristotle in Arabic translations that had been made from the Greek.

What traveled best and with fewest problems was art. Art works were most welcome, most flexible, most adaptable to new uses. Separated from their original context in Byzantium, however, the works tended to be reinterpreted by their receivers.

Ambassador Liutprand, witness of Constantine VII's marvelous mechanical throne, filled his trunks with valuable purple silks. But he intended them for ecclesiastical use, since they were far too colorful and "effeminate" for Westerners to wear as clothes. It is significant that most of the Byzantine silks preserved in Europe have survived in church collections, where they were frequently used to wrap the relics of saints (see FIGS 57 and 58).

More important than the silks, Liutprand, or his successor as Otto I's ambassador, brought back a bride for his son Otto II. In 962 Otto I the Great, the founder of the medieval German state and its ruler from 936 to 973, was crowned in Rome by Pope John XII as "emperor of the Romans." Emperor Nikephoros II Phokas, however, insisted that he content himself with the title "king of the Franks," but one of the terms of their political settlement was the marriage of his son to the emperor's niece, Theophano. This connection with the imperial family would give Otto II the full right to be called properly "imperator Romanorum augustos," holy emperor of the Romans, and this is the title inscribed over his head on an ivory relief commemorating his marriage in

105. Christ Blessing Emperor Otto II and Theophano, panel celebrating the coronation of the imperial couple, 982–3. Ivory, 7¼ x 4¼" (18.6 x 10.8 cm). Musée National de Moyen Age de Cluny, Paris.

972 into the Byzantine imperial family (FIG. 105). As on the ivory announcing the coronation of Constantine VII a generation earlier, the authority of divine kingship is shown flowing directly from the touch of Christ. The couple must have received royal dress for the occasion, but while the princess wears the *loros* or scarf proper to a coronation, Otto has only the *sagion* or mantle. This misunderstanding, and the inclusion in the lower left of an Italian donor bishop in Otto's service, raise the possibility that the ivory was executed in Italy.

But while Otto II was eager to have the regalia of Byzantine kingship, his wife's dowry included Byzantine silks, jewelry, and ivory boxes, a treasure that has since been dispersed. The

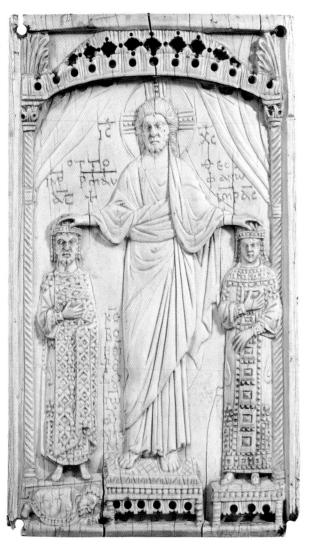

arrival of such importations, however, had important implications for medieval art, as the original pieces came to be reused in new settings. A telling example is the tenth-century ivory relief of the Hodegetria, which may well have arrived with Theophano (FIG. 106). Originally it would have constituted the center panel of a small triptych, but when it reached the abbey of Poussay in France in the early eleventh century, it was made the centerpiece for the cover of a Gospel lectionary. The artist matched the preciousness of the ivory by enframing it with gold panels of repoussé work and settings of rare stones and pearls. Poussay's patron, the holy nun St Menne, is shown in prayer beneath the Mother of God, while the other panels carry Christ above and Sts Andrew and Peter on either side. The latter pair in their classical author stance are reminiscent of relief figures in the triptych of Constantine VII (see FIG. 44).

Sharing imperial regalia meant sharing the authority of the Byzantine emperor. Michael VII Doukas (1071–78), hard pressed by uprisings in the Balkans, shared imperial regalia by sending a crown to

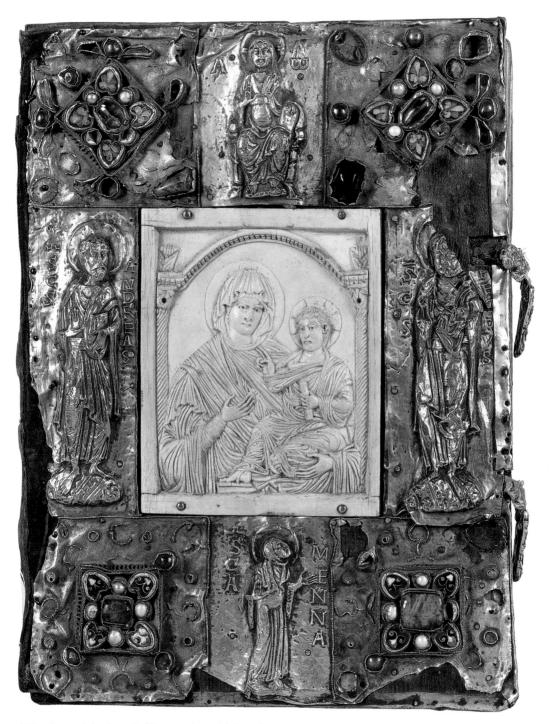

106. Cover of the Gospel of Poussay. Ivory Mother of God, tenth century, set in silver, gold, and enamel cover, eleventh century, 11¼ x 8¼" (28.5 x 21 cm). Bibliothéque Nationale de France, Paris (Ms. lat. 10514, Plat. Sup).

107. "St Stephen's Crown," showing enamels of Michael VII Doukas (centre), his son Constantine (left), and King Geza of Hungary (right), 1074–7. Diameter 2'4" (72 cm). Magyar Nemzeti Múzeum, Budapest.

"Geza faithful king of Hungary" (FIG. 107). The original enamels of the so-called "St Stephen's Crown," expanded by later additions, present a carefully observed hierarchy. Only Michael VII wears the loros, but both he and his son are haloed, carry prominent scepters, and wear crowns ornamented with long prependoulia (dangling gems). King Geza, without halo and with lesser crown and scepter, wears the sagion or mantle patterned with heart leaves.

Italy

No Western country was so indebted to Byzantine art as Italy, where the monuments of early Byzantine dominion in Rome and Ravenna established models of iconography and standards of excellence for subsequent works. The mosaicists of ninthcentury Rome, for example, diligently imitated their predecessors of the sixth century.

Fresh importation of Byzantine art, however, flowed through three important channels: the Benedictine monastery of Montecassino in Lazio in the eleventh century, the Norman kingdom of Sicily in the twelfth, and Venice in the eleventh through thirteenth centuries. Although it was a Latin monastery owing allegiance to the pope, Montecassino enjoyed the patronage of the Byzantine governors of southern Italy, and when Abbot Desiderius (1058-87) rebuilt the church he sent to Constantinople for heavy bronze doors and silver liturgical furnishings, and for mosaicists to decorate the church. Monks were apprenticed to the Byzantine masters who carried the effects of this revival of the arts far beyond Montecassino, influencing the Romanesque art of Cluny in France. But beside the bronze doors little of Montecassino survives. We are more fortunate in the monuments of Sicily and Venice.

The Norman success in wresting southern Italy from Byzantine and Sicily from Arab rule in the eleventh century paved the way for the establishment of a very cosmopolitan kingdom often in competition with Constantinople. King Roger II (1130-54) sought no one's authorization when he had himself entitled "king." He chose to be represented like the Byzantine emperor, appearing crowned by Christ exactly as Constantine VII, except that his chlamys employs the royal French fleur-de-lis pattern. When he built his palace in Palermo, he sent for craftsmen from Constantinople to decorate it, a work carried to completion by his son William I (see FIG. 56).

The sanctuary of the palace's chapel (the Cappella Palatina) contains a Byzantine church program rearranged to suit a Norman architectural setting; the nave, however, reverts to the

108. Cappella Palatina, Palermo, twelfth century. General interior view.

The western half of the church, in the foreground, follows a Romanesque basilica plan, while the eastern half has a Byzantine dome.

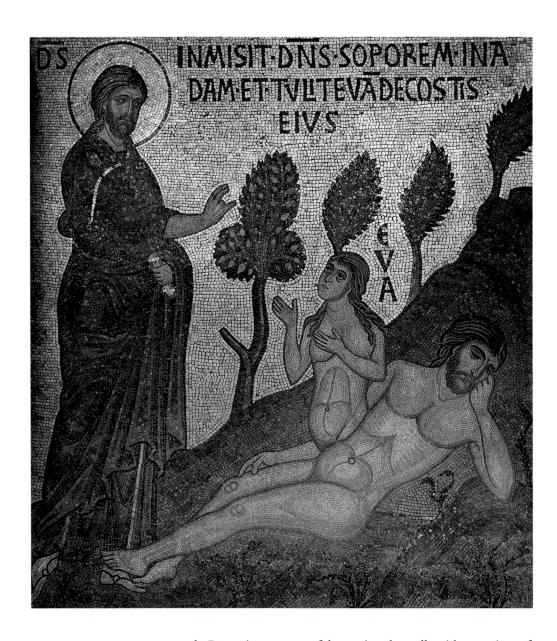

109. *Creation of Eve,* 1154–66. Mosaic. Cappella Palatina. Palermo.

early Byzantine manner of decorating the walls with narratives of the Old and New Testaments (FIG. 108). The *Creation of Eve* gives us some idea of the artistic process involved in creating these mosaics (FIG. 109), for it is closely related to the Byzantine manuscript illumination of the same subject in the Octateuch (FIG. 110). The Octateuch, or "eight books," refers to an edition of the first eight books of the Bible, from Genesis to Ruth, which, starting in the eleventh century, was illustrated in Byzantium with over five hundred scenes, an enormous iconographic undertaking. The

text of Genesis 2:21-23, dealing with the origin of woman, and the illustration that accompanies it, are of fundamental importance in theorizing the relationship of the sexes in Byzantium.

Woman was assigned an auxiliary role to man in Byzantium, but enjoyed important property and legal rights that allowed her to assume roles of considerable power, especially in the Komnenian dynasty. Both her subordination and her essential equality were argued from the Genesis text of her birth from Adam. The Byzantine interpretation of the story, synthesized by Prokopios of Gaza (c. 465-c. 528), whose commentary accompanies the Octateuch

text, explains that woman was made for man, but not by man; she was physically inferior to man but yet his equal in nature and in intelligence and in the sight of God. The commentary speculates that God decided to form Eve from Adam's side instead of from the dust of which he had made Adam in order to instill in man a natural affection for woman. He cast him into a deep sleep, the ecstasy in which revelations are made, so that when awakening he pronounced by divine inspiration: "This is bone of my bones and flesh of my flesh." His sleep is likened to the sleep of the second Adam, Christ, in death, life springing from his side.

In the miniature, Adam reclines naked in a garden full of plants and birds, his head resting on his hand in sleep. From his side the half figure of Eve emerges, hands raised in prayer, gazing at the divine light that emanates from the hand of her creator. How much of the Byzantine commentary was familiar in Sicily is unknown, but the mosaic illustrates one aspect of the commentary more powerfully than the miniature, and that is Eve's faceto-face encounter with her creator, by giving him human form in the body of Christ. Within a decade or two this powerful image was being copied in northern Europe, in Germany, and in England. It is not inconceivable that the artist responsible for another image of the Creation of Eve, in the Genesis initial in the Winchester Bible, visited Sicily; travel between the two was not uncommon. But he takes the image a step further in portraying Eve's intimacy with her creator, as God leans forward and takes her

110. Creation of Eve, from an Octateuch, mid-twelfth century. Tempera on parchment, page 151/2 x 12¼" (39.5 x 31.3 cm). Biblioteca Apostolica Vaticana, Rome (Ms. gr. 746, fol. 37r).

111. Creation of Eve, the Genesis initial from the Winchester Bible, c. 1180 (detail). Tempera on parchment. Winchester Cathedral Library.

Opposite

112. General view of the nave and the barrel vaults of the central crossing, showing the mosaics of the *Crusifixion* and the *Resurrection*. Architecture of the eleventh century with mosaics of the late twelfth century. S. Marco, Venice.

Medieval Venice competed with Constantinople in trade and copied her architecture, with marbleclad palaces, churches of the four-column plan, and S. Marco, a replica of the Holy Apostles Church. by the arm, somewhat the way Christ takes Adam (and sometimes Eve) by the arm in scenes of the Resurrection (FIG. 111).

The climax of Byzantine artists' involvement in Sicily was the decoration of the enormous monastic church, later cathedral, of Monreale, where they covered over eighty thousand square feet (about 7,500 sq. m) with mosaic. The nave program, commissioned by William II (1166-89), repeats that of the Cappella Palatina, concluding the Genesis story with the scene of Jacob wrestling with the angel (Genesis 32:24-30) (see FIG. 5). Here, however, the available wall surface permitted the mosaicist to expand the subject to double the size of the earlier scenes. The subject is emblematic of the human contest with the divine. Jacob is seen first fleeing into the desert out of fear of Esau, and then struggling with the divine angel. At the conclusion of

his night-long encounter with God, the Latin inscription explains, the Angel blessed Jacob and renamed him Israel, a word meaning "He who strives with God." And Jacob realized he had seen God face to face. The angel, with flashing wings and rustling garments but impassive face, slips out of Jacob's grasp. It is at this point that the artist chose to end the Genesis narrative in Monreale and take up the story of Christ's life.

Venice was a special case in the Middle Ages for it was a Byzantine city in the heart of Europe. The city was created on an improbable set of mud flats when local residents of the region took refuge there from the invading Lombards in the sixth century. At the start it was administered by the Byzantine exarch in Ravenna, who appointed a local governor called the *dux* or doge. Even when Charlemagne conquered the mainland of north Italy he was obliged, in 810, to recognize Byzantine sovereignty over Venice. In the tenth century Doge Peter Tribuno (888–920) declared Venice a *civitas* or free city, but it remained oriented toward Constantinople, where they enjoyed special trading privileges. Venice became Europe's emporium of goods from the Orient and Byzantium's entry to the markets of Europe.

The mother-daughter competition between the two cities is symbolized by the erection of Venice's S. Marco, the largest surviving Byzantine church after Hagia Sophia in Constantinople (FIG. 112). As in the capital, Venice's chief church was placed in the city's principal piazza, alongside the seat of government,

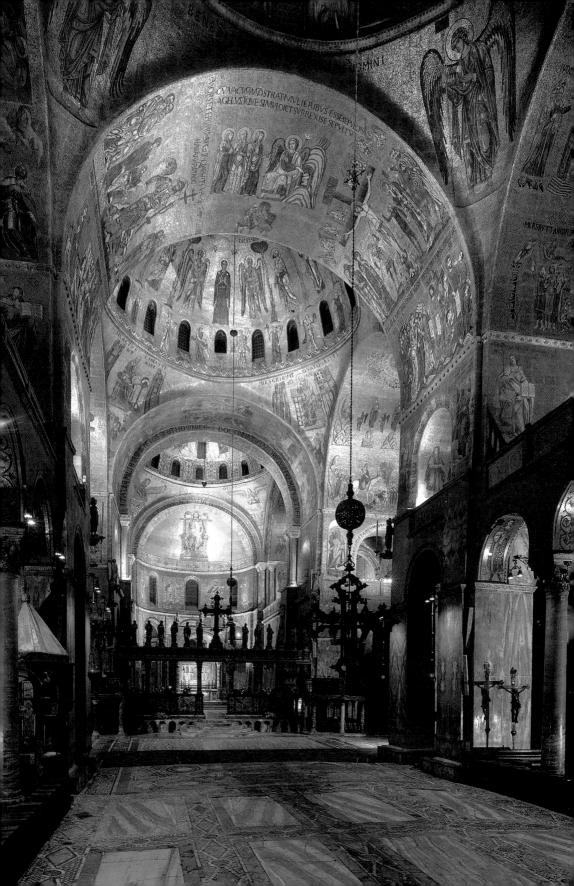

the Palazzo Ducale, emphasizing the close alliance of ecclesiastical and secular rule. The design of the church, five great domes arranged in a cross, copies the now vanished Holy Apostles Church in Constantinople. Begun in 1064, the church was completed by Doge Vitale Falier (1086–96), who placed the relics of the evangelist Mark in the crypt beneath the altar. From Constantinople the emperor sent an annual twenty pounds of gold for the maintenance of the church.

The same doge began the mosaic decoration of the church, an enterprise that lasted into the thirteenth century, with a corresponding evolution of style. Unlike Sicily, which imported entire workshops of artists from Constantinople, Venice seems to have imported single masters, or small groups of two or three, who formed workshops with local artists whose collaboration shows in Western elements in the work.

By the late twelfth century, when the work had progressed to the great western vaults where the Crucifixion and Resurrection are shown, the artists were working in the expressive late Komnenian dynamic style visible at Monreale. Unlike the Byzantine churches that placed separate subjects in separate vaulting surfaces (see FIGS 75 and 85), the great surfaces of the barrel vaults of S. Marco suggested a Western scheme of separate horizontal registers.

The impact of this work outside Venice is indicated by the assimilation of this style in the Wolfenbüttel artist's handbook

(FIG. 113). The transportation of complex iconographic subjects over great distances argues for the common use of model books, but only one has survived. This unique manuscript of twelve pages was produced in a Venetian atelier in the 1240s and was in use in Germany within a generation (after which, when its drawings were no longer regarded as useful, a scribe reused the pages in a monastic handbook). The Christ of the Resurrection reflects the same figure in the mosaics of S. Marco in his energetic stride and billowing mantle. But the fact that Christ raises both Adam and Eve from either side points to the artist's familiarity with a thirteenth-century development in the imagery. In other words, Byzantine style and motifs were penetrating Europe with little or no delay after their invention.

War booty from the Fourth Crusade accounts for another major influx of Byzantine art through Venice. When the competition between the two great

113. Resurrection, second quarter of the thirteenth century. Ink drawing on parchment, 6% x 4¾" (16.1 x 12 cm). Herzog August-Bibliothek, Wolfenbüttel, Austria (Cod. Guelf 61,2 Aug. octavo, fol. 92r).

maritime rivals reached its catastrophic conclusion in 1204, Venice carried off works of all kinds. Large-scale trophies, such as the porphyry statues of Constantine's four sons (see FIG. 11) and the horses from the hippodrome (see FIG. 12), were used in the exterior decoration of the Palazzo Ducale and S. Marco with consequent shifts in meaning: the embracing sons placed outside the treasury of the cathedral were imagined to be conspirators trying to rob it; the triumphant quadriga (team of four horses) of the hippodrome became the horses of the four evangelists on the church facade. The enamel templon icons of the Monastery of Christ Pantokrator were reused in S. Marco for the altarpiece of the church (see FIG. 43), and precious vessels from the imperial palace were added to its treasury. The Nikopoios icon that had defended the capital became the palladium of Venice (see FIG. 47).

The thirteenth-century mosaic of the discovery of the relics of St Mark offers a poignant image of Venice's new situation (see FIG. 103). Although the event illustrated, the finding of the relics within a pier of the church, is supposed to have taken place in 1094, the persons attending the miracle are the contemporary Doge Ranieri Zen (1253-68) and his entourage. The doge has adopted imperial garb to his own purposes, an imperial tunic with gold trim, including the arm bands introduced by Basil II, and a red *chlamys* over his left shoulder, lined with ermine. Behind him a procurator, a high official charged with the financial administration of the church, and a cluster of Venetian nobility dress in Byzantine style. Most interesting is the inclusion, among the women on the left, of a little crowned prince who has been identified as Philip of Courtenay, son of Baldwin II, the Latin emperor of Constantinople (1237-61). The ruler of the now bankrupt Crusader state had to send his son to Venice as surety for a large loan from Venice.

Palaiologan Art

Baldwin's successor, however, was not to be his son but Michael VIII, ruler of the prosperous remnant Greek state of Nicaea and founder of the Palaiologan dynasty, who in 1261 concluded a series of military victories around the Aegean by a surprise attack on Constantinople. Baldwin fled and Michael VIII entered the city in triumph behind the icon of the Hodegetria. As we have seen, the restored kingdom had a very narrow territorial base to start with, and this was gradually eroded by Ottoman conquests.

The empire of the Late Byzantine period was more a spiritual than a temporal kingdom. The patriarch's jurisdiction was broader

114. Healing of the Blind, 1316–21. Mosaic. Church of Christ of Chora, now the Kariye Camii Museum, Istanbul.

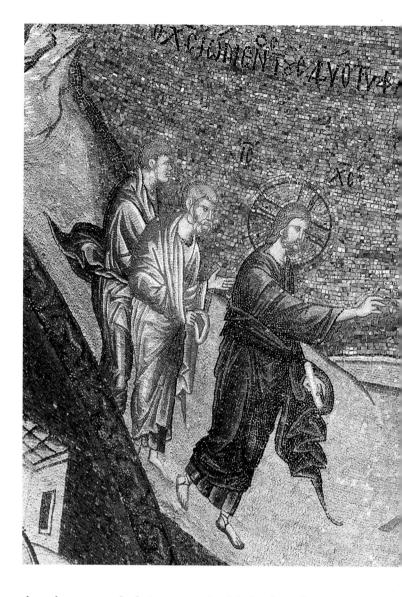

than the emperor's, being recognized in lands no longer under Byzantine rule, in Crete, Serbia, and Bulgaria, as well as in Russia. Monastic life revived: Athos, now under direct jurisdiction of the patriarch, experienced a revitalization, and many monasteries were built or restored in Constantinople, Thessaloniki and nearby Meteora, and in Mistra in the Peloponnese. A small but wealthy elite pursued a sophisticated intellectual life characterized by a lively interest in Artistotle and Plato and contacts with Italian humanists. And in painting a new spirituality emerged, for which historians sometimes assign the term neo-Hellenic and sometimes proto-Renaissance. Now for the first time one

encounters, particularly in Serbia and Macedonia, artists who have left their signatures on their works.

Typical of this art are the churches of the Mother of God Pammakaristos and the Church of Christ of Chora, both in Constantinople and both products of this aristocratic, educated class. The former is an intimately scaled mortuary chapel (see FIGS 85 and 89) erected by Martha Glabas to her husband Michael, a general who distinguished himself in campaigns in Bulgaria and Albania and died soon after 1304. Besides the mosaics, Martha also commissioned the poet Manuel Philes to compose verses honoring her husband, which were carved into the cornices of the church. Compared to the Pantokrator in the church of the Dormition at Daphni (see FIG. 88), the fourteenth-century Christ looks at the beholder with a serene, unfurrowed brow. While some of the severity of the Daphni image is due to nineteenth-century restorations, the later figure is more delicate in cast, with soft hands, narrower face, and long, thin nose - a Christ one might imagine welcoming the soul of the deceased.

The patron of the second church, Theodore Metochites (1270–1332), followed a career in the civil service, rising to treasurer and prime minister of Andronikos II (1282–1328). In his spare time he wrote commentaries on Aristotle, an introduction to astronomy, and essays on ancient Greek history, eventually donating

his extensive library to the monastery, whose church he restored (1316–21). In addition to the usual select set of the Life of Christ in the nave of the church, Metochites filled the two narthexes of his Christ of Chora church with the touching narratives of Mary's infancy and Christ's miracles. The expansive compositions breathe an entirely new spirit, evident in the *Healing of the Blind* (FIG. 114). In contrast to the crowded compositions of Early and Middle Byzantine narratives (see FIGS 77 and 90), these figures inhabit an open landscape in which the placement of distant mountains and architecture reinforces the grouping of the actors in the foreground. figures of slender proportions move with slow

115. *Nativity*, 1350–75. Fresco. Church of the Mother of God Peribleptos, Mistra, Greece.

grace, their garments caught in the breeze. New color combinations are tried: a tree exclusively in shades of blue against the mauve and purple city walls; and the psychological characterization of the actors is explored: blindness is conveyed not only by emptiness of the eyes but by the blank expression of the faces. This was an art that appealed very directly to a wide audience.

Its effects can be followed later in the century at Mistra, in the church of the Mother of God Peribleptos, of anonymous patronage. Home of the governor of the Peloponnesos, who was titled despotes and was frequently the heir to the throne of Constantinople, Mistra became a kind of second capital of the Palaiologan empire. In the Nativity the landscape takes on a life of its own, filling the entire composition (FIG. 115). The towering mountain, with jagged peak and multiple facets, is roughly cleft in the middle to provide a cave. While his mother tries to sleep, the infant Christ, wrapped in swaddling clothes as if a mummy, is presented in a sarcophagus as fodder for the ox and the ass-symbolically, food for mortals. Other mountains, in contrasting tones, provide stages for details of auxiliary narratives of the Magi, the shepherds, and the washing of the new-born. As at the Church of Christ of Chora, the church of the Peribleptos multiplies scenes of the infancy of Mary and the miracles of Christ.

Hundreds of churches of the Palaiologan period, some of them tiny family chapels, others spacious churches of the ruling class, dot the countryside in Greece and Crete, Serbia and Bulgaria, evidence of the common sharing in Orthodox faith. With the conversion of Vladimir of Kiev, the Slavs of Rus' entered into the same community, opening eastern Europe to the culture and artists of Constantinople. It was a rich field for enterprising painters, some mentioned by name in the chronicles. Vladimir's son Yaroslav (1019-54) summoned architects and mosaicists from Constantinople to build and decorate his cathedral of St Sophia of Kiev (1037-46), and at the opposite end of his kingdom another cathedral of St Sophia in Novgorod (1045-52). Even a century later, the iconography of such churches as the Transfiguration of Pskov and the St Demetrios of Pskov (see FIGS 84 and 102) are strictly au courant with developments elsewhere in the Byzantine world and should not be looked upon as "provincial."

The invasion of the Mongols, who sacked Kiev in 1240, brought two centuries of foreign, Islamic domination from which only northern Russia was exempt. The rise of Moscow dates to the Mongol period, in the early fourteenth century, when the exiled metropolitan of Kiev took up residence in the city center opposite the palace of the grand prince, repeating the axis of secular

116. THEOPHANES THE GREEK Concelebrating Bishop, 1378. Fresco. Church of the Transfiguration, Novgorod.

and ecclesiastical power observed in Constantinople. At this point Russia received a new wave of Byzantine art as artists from Constantinople sought work in newly developing centers.

Among them was Theophanes the Greek (active 1378–1405), one of the few Byzantine artists of whom we have any personal information. His biographer Epiphanij the Wise calls him a sage, a philosopher, and an illuminator of books, and tells us that he painted more than forty churches in Constantinople and its environs, in Moscow and Novgorod. What most struck Epiphanij was the spontaneity with which Theophanes worked, dispensing entirely with the model books that other artists used. Though little remains of his vast output, Theophanes' manner may be judged from the massive and vigorous figure of the *Concelebrating Bishop* in the church of the Transfiguration in Novgorod (FIG. 116). Compared to his counterparts at Sopočani, this figure achieves dramatic effect through radical simplification. Theophanes subsequently demonstrated his versatility by painting the frescoes and icons in the church of the Annunciation in the Kremlin of Moscow.

A similar sense of movement animates Palaiologan architecture, whether one looks at the steep proportions of the interior of the church of the Mother of God Pammakaristos in Constantinople or at the undulating roof lines of the church of Sts Peter and Paul at Kozhevniki, Novgorod (FIG. 117). The interior of the latter follows a simple domed cross design of two stories' height; the sloping shingle roof and pointed onion dome are accommodations to the snowy northern climate.

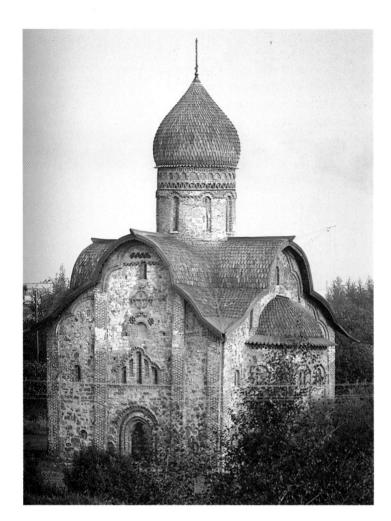

117. Church of Sts Peter and Paul, Kozhevniki, Novgorod, Russia, 1406. View from the west.

The Renaissance

Because Byzantium in a spiritual sense was much wider than the ever-dwindling Byzantine empire, the fall of Constantinople was not the end of Byzantine art; from Russia to Crete the Orthodox church carried forward Byzantine traditions of painting and architecture into modern times. Of wider interest, however, is the impact of Byzantine art on the Italian Renaissance, for in this direction it enters into the mainstream of European art.

The importation of icons to Italy is the starting point for panel painting of the Renaissance. In the Middle Ages the techniques of this genre, were largely lost; the twelfth-century Theophilus, who wrote a handbook of artists' techniques, seems to have been ignorant of panel painting. The rediscovery of the art, so central to European painting of subsequent centuries, was due to direct

contact with painters from Byzantium. Duccio di Buoninsegna (c. 1255–1316), regarded as the master of the *maniera greca* or Greek style, stands at the end of a century-long development of Italo-Byzantine painting. How well he learned his craft can be judged from the triptych he executed with the help of his assistant Simone Martini (c. 1284–1344; FIG. 118). In general composition the Madonna is based on the familiar *hodegetria* type; the child's play with the

119. Head of the Mother of God, detail from the Deesis in Hagia Sophia, late thirteenth century. Mosaic. South gallery, Avasofva Museum, Istanbul.

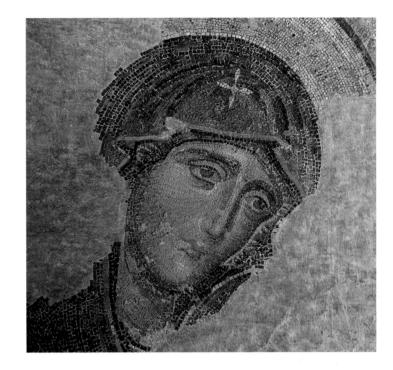

veil is a theme of the Sinai Mother of God with Prophets (see FIG. 4); but the Madonna's face reflects an intimate knowledge of Palaiologan painting, paralleling the face of the Mother of God, perhaps a generation earlier, in Hagia Sophia in Constantinople (FIG. 119). The strong structure of the face, the softness of the modeling with the cool green shadows, even such details as the white veil emerging from the mantle and the gold cross on the forehead, all these traits are found in the Byzantine mosaic. The triptych format too was common in Byzantium, though the pointed pediment of its framing is not, and the choice of saints for the wings-Dominic and Aurea-follows local piety.

When Giotto (c. 1277-1337) broke with this maniera greca he did so by a new understanding of pictorial space. In his revolutionary Arena Chapel in Padua (consecrated 1305) he created box-like spaces in which weighty figures are rooted firmly on the ground (FIG. 120). He is the first to confront the problem of foreshortening figures; the grieving St John extends his arms into the depth of the picture. The iconography of the composition, however, remains thoroughly Byzantine, introduced in the twelfth century. The compositions developed in Constantinople were the starting-point of Renaissance narrative art.

Gradually in the course of the fourteenth and fifteenth centuries Italian art liberated itself from its Byzantine origins, but

120. GIOTTO Lamentation, c. 1303. Fresco. Arena Chapel, Padua.

it did so by transforming its heritage rather than rejecting it. The process can be demonstrated in the work of Antonello da Messina (c. 1430–79), one of the greatest portraitists in history. In the plastic realization of the face of the *Virgin Annunciate* (FIG. 121) we sense a radically different kind of painting from the icons we have been looking at. This is partly due to the medium of oil painting, which Antonello introduced to Venice, and partly due to his use of a real, living woman as his model. Gone are the gold ground and the halo; instead, the Virgin is pictured in natural light against a dark shadow. Most significantly, Antonello shows her lips parted in speech: he has seized the instant of her response to the angel, "Let it be to me according to your word" (Luke 1:38). The Byzantine icon lifted its subject out of time and out of the particulars of narrative; Antonello has put the Virgin back into a precise moment when she was interrupted in

121. Antonello da Messina Virgin Annunciate, 1473-4. Oil on panel, 17¼ x 13½" (42.5 x 32.8 cm). Bayerische Staatsgemäldesammlungen, Munich.

her reading. Yet the composition to which the painting owes its strength is borrowed from a Italo – Byzantine icon of the thirteenth century – a half-length Mother of God with hands crossed on her breast. It is at this point, then, that the icon genre, which depended so heavily on portraiture in its origins, crosses back over to modern portraiture. The half-length pose of the icon would become the most popular portrait format down to Edward Steichen's photographs of celebrities in the 1920s and 1930s.

In architecture too the Byzantine ideas are fundamental to the Renaissance. While Italian architects thought of their work as a return to the principles of classical Rome, this was more true of the details than of the designs themselves. Filippo Brunelleschi (1377–1446), the father of Renaissance architecture, carefully reproduced the classical orders, that is the sequence of column, capital,

122. GIULIANO DA SANGALLO Interior view into the vaulting, Santa Maria delle Carceri, Prato, begun 1485.

and cornice as found in ancient Roman architecture, but his designs of S. Lorenzo and Santo Spirito in Florence are in their spatial organization copies of the Early Byzantine churches of nearby Ravenna. In their high naves and arcaded aisles they are, in effect, Byzantine churches in Renaissance dress. This was literally true of the tiny four-column Byzantine church of S. Satiro in Milan, erected in the ninth century, which Donato Bramante (1444-1514) encased in a new rotunda with classical cornices and lantern in 1482, leaving the interior intact. The same four-column unit, used singly or multiplied in larger complexes, was a favorite ingredient in the architectural projects of Leonardo da Vinci (1452-1519).

But the preferred unit of High Renaissance church architecture was the simpler domed cross of Byzantine architecture. Giuliano da Sangallo (1445-1516) introduced this design in his church of Santa Maria delle Carceri, Prato (FIG. 122; compare FIG. 83a). A dome on a drum rests on pendentives, which in turn rest on four converging barrel vaults. The delicate cornices that would have divided these elements in a Byzantine church are now heavy entablatures with terracotta friezes, supported on the ground level with correct Roman pilasters. But the sequence of spaces is the same, and it is a sequence the architect would never have found in ancient Rome. Even the isosceles triangle that governs the Byzantine design remains, only now the apex of the triangle reaches to the top of the tiny lantern over the dome - a distinctly Renaissance addition. Once introduced, this Renaissance variant on a Byzantine design became a standard church design for Renaissance architects and their followers all over Europe.

On the stage of world art, then, Byzantine art had a preponderant role for a full millennium, based in a city of extraordinary wealth and sophistication. Then, in the last phase before the final fall of Constantinople, Byzantine art passed the creative torch on to the artists of Europe, where it ignited some of the most interesting new ideas of the Renaissance.

324–30 Constantine enlarges Byzantium, laying out new forums and avenues and renaming it

412–13 Theodosios II erects new doubled land walls with moat around Constantinople

Theodosios I dedicates a new forum with triumphal arches and an historiated spiral

Constantius dedicates the first basilica of Hagia Sophia

Constantinople

column

416–18 Palace of Antiochos

360

393

5	
5	
5	
4.	
7	
1	
1	
1-	
0	
)	
12(
1	
'	

\mathcal{C}	c. 450 The basilicas of St John of Stoudios and the Mother of God of Blachernai
451–900	 Justinian erects the new Hagia Sophia in Constantinople, introducing icons on its temple barrier Dedication of S. Vitale in Ravenna Icon of the Christ credited with turning back Persian assault on Constantinople Leo III removes the image of Christ from the Chalke Gate and inaugurates the period of iconoclasm Theophilos expands the Great Palace Patriarch Photios delivers sermon at the dedication of the new mosaics in the apse of Hagia Sophia in Constantinople Basil I's new churches in the Great Palace
901–1200	 945–59 Constantine VII Porphyrogennetos' mechanical golden throne and ivories 1037–46 Yaroslav builds St Sophia in Kiev with craftsmen from Constantinople c. 1042 Constantine IX Monomachos sponsors building of Nea Moni, Chios 1064 Doge Vitale Falier begins a new S. Marco in Venice 1066–71 Abbot Desiderius rebuilds Montecassino in Italy with craftsmen from Constantinople End of 11th century Building and mosaic decoration of the church of Daphni 1136 Dedication of the monastery of Christ Pantokrator in Constantinople by John II Komnen 1140s–1166 Building and decoration of the Norman Palace and its chapel in Palermo 1153–56 Bishop Nifont erects Mirozhskij Monastery, Pskov 1164 Alexios Komnenos erects St Panteleimon, Nerezi
.1455	 Dispersal of Byzantine treasures to Europe as booty of the Fourth Crusade Sopočani, Serbia Giotto's frescoes in the Arena Chapel, Padua Martha Glabas decorates the Pammakaristos church Theodore Metochites decorates church of Christ of Chora

1350-75 Church of the Mother of God Peribleptos, Mistra

Theophanes the Greek paints the Transfiguration church in Novgorod, after which he

paints the churches of the Annunciation and St Michael in Moscow

Historical events

324 325 361–63 370s 392 410 431	Constantine defeats Licinius at the batttle of Chrysopolis, uniting the Roman empire under his sole rule First Ecumenical Council (Nicaea) proclaims the divinity of Christ Emperor Julian tries to reinstate paganism Basil the Great, author of the monastic rule, defines the Christian attitude toward the study of the classics Theodosios I bans pagan cults Visigoths under Alaric sack Rome Third Ecumenical Council (Ephesos) proclaims the divine motherhood of Mary
525-65 568 586 632 754 787 800 843 864 867-86	Reign of Justinian I; Reconquest of Italy and North Africa and new measures against pagans, including the closing of the University of Athens Lombards invade Italy Slavs and Avars invade the Balkans Death of Muhammad marks start of Islamic calendar; Arab conquests of Persia, Syria, Palestine and Egypt halted at Constantinople Council of Hiereia convoked by Constantine V to define Iconoclasm as orthodox doctrine Going against Iconoclasm, the Seventh Ecumenical Council (Nicaea II) decrees the necessity of image veneration Pope Leo III crowns Charlemagne Emperor of the Romans Empress Theodora restores veneration of images, closing the period of Iconoclasm Conversion of Khan Boris of Bulgaria Basil I, first of the Macedonian dynasty which lasts until 1056
987 1061–91 1071 1099	Constantine VII Porphyrogennetos commissions works of historical scholarship and encyclopedism Nikephoros II Phokas, first as general then as emperor (963-69), retakes Crete and Cyprus and drives the Arabs from Anatolia St Athanasios founds the Great Lavra Monastery on Mount Athos Byzantine princess Theophano wed to future emperor Otto II of Germany St Basil II pushes Byzantine boundaries to their largest medieval extent Conversion of Prince Vladimir of Kiev, who marries Anna, sister of Basil II Norman conquest of Sicily Seljuk Turks defeat Byzantine army at Mantzikert and settle permanently in Anatolia First Crusade takes Jerusalem, establishing a set of Latin states in the Near East 18 Alexios I repells Norman invasion of the empire and founds the Komnenian Dynasty which lasts until 1185 Saladin captures Jerusalem, ending Latin rule there
1204 1240 1261 1304 1376 1438–39	Crusaders sack Constantinople, establishing a Latin state in its place and converting Hagia Sophia to Roman Catholic use Mongols take Kiev Michael VIII retakes Constantinople, establishing the Palaiologan dynasty which lasts until 1453 Ephesos falls to the Turks Ottoman Turks take Thrace, establishing their capital in Adrianople Council of Ferrara-Florence fails to resolve Orthodox and Catholic differences

1453

Ottoman Turks under Mehmet II conquer Constantinople

Bibliography

The spellings of Latin and Greek names and places are based on those used in Alexander Kazdhan *et al.* (eds), *Oxford Dictionary of Byzantium*, 3 vols (Oxford University Press: New York and Oxford, 1991).

GENERAL

DURAND, JANNIC (ed.),

Byzance: L'Art byzantin

dans les collections

publiques françaises (exh.

cat.; Paris: Musée du

Louvre, 1992)

EVANS, HELEN C. and
WILLIAM D. WIXOM
(eds), The Glory of
Byzantium: Art and
Culture of the Middle
Byzantine Era, A.D. 8431261 (exh. cat.; New
York: The Metropolitan
Museum of Art, 1997)

KITZINGER, ERNST,

Byzantine Art in the

Making (Cambridge,

MA, and London: Faber
and Faber, 1977)

KRAUTHEIMER, RICHARD and SLOBODAN ĆURČIĆ, Early Christian and Byzantine Architecture, 4th ed. (Harmondsworth: Penguin Books, 1985)

LAZAREV, VIKTOR, Storia dell pittura bizantina

(Turin: Giolio Einaudi, 1967)

LOWDEN JOHN, Early Christian and Byzantine Art (London: Phaidon, 1997)

MANGO, CYRIL, Byzantine Architecture (New York: Harry N. Abrams, 1976)

—, Art of the Byzantine
Empire, 312-1453, Sources
and Documents in the
History of Art Series
(Englewood Cliffs, N.J.:
Prentice Hall, 1972; repr.
Toronto: University of
Toronto, 1986)

MATHEWS, THOMAS F., The Clash of Gods: A Reinterpretation of Early Christian Art (Princeton: Princeton University Press, 1993)

WEITZMANN, KURT (ed.), The Age of Spirituality (exh. cat.; New York: The Metopolitan Museum of Art, 1979)

INTRODUCTION

HERRIN, JUDITH, The

Formation of Christendom
(Princeton: Princeton
University Press, 1987)

HUSSEY, J. M., The
Orthodox Church in the
Byzantine Empire
(Oxford: Oxford
University Press, 1986)

MANGO, CYRIL, Byzantium: The Empire of New Rome (London: Weidenfeld and Nicolson, 1980)

MEYENDORFF, JOHN,

Byzantine Theology:

Historical Trends and

Doctrinal Themes

(London: Mowbrays,

1974)

Ostrogorsky, George, History of the Byzantine State (trans. by Joan Hussey; New Brunswick, N.J.: Rutgers University Press, 1957)

WHITTOW, MARK, The Making of Orthodox Byzantium, 610-1025

(London: Macmillan, and Berkeley: University of California Press, 1996)

CHAPTER ONE

- FIRATLI, NEZIH, La Sculpture byzantine figurée au Musée Archéologique d'Istanbul, Bibliothèque de l'Institut Français d'Etudes Anatoliennes d'Istanbul, 30 (ed. by C. Metzger, A. Pralong, and I.-P. Sodini, and trans. by A. Arel: Paris, 1990)
- GRABAR, ANDRÉ, Christian Iconography: A Study of its Origins (Princeton: Princeton University Press, 1968)
- -. L'Empereur dans l'art byzantin: Recherches sur l'art officiel de l'empire d'orient (Paris, 1936; repr. London, 1971)
- KÄHLER, HEINZ and CYRIL MANGO, Die Hagia Sophia (Berlin: Gebr. Mann Verlag, 1967); trans by Ellyn Childs as Hagia Sophia (A. Zwemmer: London, 1967)
- MAINSTONE, ROWLAND J., Hagia Sophia (London: Thames and Hudson, 1988)
- MANGO, CYRIL, Le Développement urbain de Constantinople (IVe-VIIe siècles) Travaux et Mémoires du Centre de Recherche d'Histoire et

- Civilisation de Byzance, 2 (Paris: Diffusion de Boccard, 1985)
- MATHEWS, THOMAS F., The Early Churches of Constantinople: Architecture and Liturgy (University Park, PA: Pennsylvania State University Press, 1971)
- -, The Byzantine Churches of Istanbul: A Photographic Survey (University Park, Pennsylvania: Pennsylvania State University, 1976)
- MÜLLER-WIENER, WOLFGANG, Bildlexikon zur Topographie Istanbuls (Tübingen: E. Wasmuth, 1977)

CHAPTER TWO

BELTING, HANS, Bild und Kult: Eine Geschichte des Bildes vor dem Zeitalter der Kunst (Munich: C.H. Beck'sche Verlagsbuchhandlung, 1990); trans. by Edmund Jephcott as Likeness and Presence: A History of the Image before the Era of Art (Chicago: University of Chicago Press, 1994)

CORMACK, ROBIN, Writing in Gold: Byzantine Society and its Icons (New York: Oxford University Press, 1985) HARRISON, MARTIN, A Temple for Byzantium:

The Discovery and Excavation of Anicia Iuliana's Palace-Church in Istanbul (London: Harvey Miller, 1989)

- HERRIN, JUDITH, "Women and the Faith in Icons in Early Christianity," in R. Samuel and G. Stedman Iones (eds). Culture, Ideology and Society (London, 1982), pp. 65-83
- KARTSONIS, ANNA D., Anastasis, the Making of an Image (Princeton: Princeton University Press, 1986)
- MAGUIRE, HENRY, The Icons of their Bodies, Saints and their Images in Byzantium (Princeton: Princeton University Press, 1996)
- PELIKAN, JAROSLAV, Imago Dei: The Byzantine Apologia for Icons (Princeton: Princeton University Press, 1990)
- WEITZMANN, KURT, The Monastery of St. Catherine at Mount Sinai. Vol. I, The Icons: From the Sixth to the Tenth Century (Princeton: Princeton University Press, 1976)

CHAPTER THREE

BRETT, GERARD, W. J. MACAULAY, and ROBERT B. K. STEVENSON, The Great Palace of the Byzantine Emperors, First

Report (Oxford, 1947)
CUTLER, ANTHONY, The Hand
of the Master: Craftsmanship, Ivory, and Society in
Byzantium (9th-11th
Centuries) (Princeton:
Princeton University Press,
1994)

GRABAR, ANDRÉ, "Le Succès des arts orientaux à la cour byzantine sous les Macédoines," Jahrbuch der bildenden Kunst, 3rd ser., 2 (1951), pp. 32-60

MATHEWS, THOMAS F. and
ANNIE-CHRISTINE
DASKALAKIS MATHEWS,
"Islamic-Style Mansions in
Byzantine Cappadocia and
the Development of the
Inverted T-plan," Journal
of the Society of
Architectural Historians, 56,
no. 3 (September 1997),
pp. 295-315

MAVROGORDATO, JOHN (ed. and trans.), *Digenes Akrites* (Oxford: Clarendon Press, 1956)

TALBOT RICE, DAVID, The Great Palace of the Byzantine Emperors: Second Report (Edinburgh, 1958)

TEALL, JOHN L., "The Byzantine Agricultural Tradition," *Dumbarton Oaks Papers*, 25 (1971), pp. 35-59

CHAPTER FOUR

DEICHMANN, FRIEDERICH WILHELM, Ravenna, Haupstadt der spätantike Abendlandes, 4 vols (Wiesbaden, 1969-89)

DEMUS, OTTO, Byzantine
Mosaic Decoration: Aspects
of Monumental Art in
Byzantium (London: Kegan
Paul, 1948; repr. New
Rochelle, N.Y.: Caratzas
Brothers, 1976)

DIEZ, ERNST and OTTO

DEMUS, Byzantine Mosaics
in Greece: Hosios Lucas and
Daphni (Cambridge, MA:
Harvard University Press,
1931)

MAGUIRE, HENRY, Art and Eloquence in Byzantium (Princeton: Princeton University Press, 1981)

MATHEWS, THOMAS F., "Transformation Symbolism in Byzantine Architecture and the Meaning of the Pantokrator in the Dome," in Rosemary Morris (ed.), Church and People in Byzantium (Centre for Byzantine Studies, University of Birmingham, 1990), pp. 191-214; repr. in Mathews, Art and Architecture in Byzantium and Armenia, Liturgical and Exegetical Approaches (Aldershot, Hampshire: Variorum, 1995)

MOURIKI, DOULA, The Mosaics of Nea Moni on Chios, 2 vols (trans. by Richard Burgi; Athens: Commercial Bank of Greece, 1985)

TAFT, ROBERT F., The

Byzantine Rite: A Short History (Collegeville, Minnesota: Liturgical Press, 1992)

CHAPTER FIVE

BELTING, HANS, CYRIL
MANGO, and DOULA
MOURIKI, The Mosiacs and
Frescoes of St Mary
Pammakaristos (Fetiye
Camii) at Istanbul,
Dumbarton Oaks Studies,
15 (Washington, D.C.,
1978)

BUCHTHAL, HUGO and HANS
BELTING, Patronage in
Thirteenth-Century
Constantinople, Dumbarton
Oaks Studies, 16
(Washington, D.C., 1978)

BUCHTHAL, HUGO, The

Musterbuch of Wolfenbütel

and Its Position in the Art

of the Thirteenth Century,

Byzantina Vindobonensia,

12 (Vienna, 1979)

BUCKTON, DAVID (ed.), The Treasury of San Marco, Venice (exh. cat.; Milan: Olivetti, 1984)

DEMUS, OTTO, The Mosaics of Norman Sicily (London, 1950)

—, Byzantine Art and the West, The Wrightsman Lectures, III, Institute of Fine Arts (New York: New York University Press, 1970)

—, The Mosaics of San Marco in Venice, 2 vols (Chicago: University of Chicago Press, 1984)

HUTTER, IRMGARD (ed.), Byzanz und der Westen: Studien zur Kunst des Europäischen Mittelalters (Vienna: Österreichische Akademie der Wissenschaften, 1984)

JACOFF, MICHAEL, The Horses of San Marco and the Quadriga of the Lord (Princeton: Princeton University Press, 1993)

KITZINGER, ERNST, The Mosaics of St Mary's of the Admiral in Palermo, Dumbarton Oaks Studies,

27 (Washington, D.C., 1990)

LAZAREV, VIKTOR, Old Russian Murals and Mosaics from the XI to the XVI Century (trans. by B. Roniger and N. Dunn; London: Phaidon, 1966)

LOWDEN, JOHN, The Octateuchs (University Park, PA: Pennsylvania State University Press, 1992)

NERSESSIAN. SIRARPIE DER. Armenian Art (London: Thames and Hudson, 1977) Nersessian, Sirarpie der

and SYLVIE AGEMIAN, Miniature Painting in the Armenian Kingdom of Cilicia (Washington, D.C.: Dumbarton Oaks, 1993)

TALBOT RICE, DAVID, Byzantine Painting: The Last Phase (New York: Dial Press, 1968)

UNDERWOOD, PAUL A., The Kariye Djami, vols 1-3 (New York, 1966), vol. 4 (ed. by Paul A. Underwood; Princeton: Princeton University Press, 1975)

Picture Credits

Collections are given in the captions alongside the illustrations. Sources for illustrations not supplied by museums or collections, additional information, and copyright credits are given below. Numbers are figure numbers unless otherwise indicated.

frontispiece detail of figure 66

- 1 © Josephine Powell, Rome page 7 detail of figure 49
- 4 © Studio Kontos/Photostock, Athens
- 5 Scala, Florence
- 6 Musée du Louvre, Objets d'art # OA 9063, Paris/© Photo RMN Paris, Chuzeville

page 17 detail of figure 12

- Byzantine Collection, Dumbarton Oaks, Washington, D.C. # 49.4
- 10 © Ara Guler, Istanbul
- 11, 12 © CAMERAPHOTO Arte, Venice
- 15, 16 Deutsches Archäologisches Institut Abteilung, Istanbul
- 17 Istanbul Archaeological Museum, # 948
- 18 © Josephine Powell, Rome
- 19, 20 © Ara Guler, Istanbul
- 23 Byzantine Collection, Dumbarton Oaks, Washington, D.C. # 37.23
- 24, 25 © Ara Guler, Istanbul
- 26 Ersin Alok, Istanbul page 43 detail of figure 43
- 27 © Studio Kontos/Photostock, Athens
- 28 Mallett & Son Antiques Ltd. London/The Bridgeman Art Library, London
- 29 Previously Ägyptisches Museum u. Papyrussammlung SMB Berlin # 15978/Bildarchiv Preussischer Kulturbesitz
- 30 Musées Royaux d'Art et d'Histoire, Brussels # E. 7409
- 31 Musée du Louvre, Paris # X 5178/© Photo

RMN Paris

- 32 © Studio Kontos/Photostock, Athens
- 33 By courtesy of Euphrosyne Doxiadis, Athens
- 34 © Studio Kontos/Photostock, Athens
- 36 Department of Antiquities, Nicosia, Cyprus
- 38 Ersin Alok, Istanbul
- 42 © Studio Kontos/Photostock, Athens
- 43 © CAMERAPHOTO Arte, Venice
- 44 Scala, Florence
- 45 © Ara Guler, Istanbul
- 46 Biblioteca Nacional, Madrid
- 47 © CAMERAPHOTO Arte, Venice
- 48 Scala, Florence
- 49 © Studio Kontos/Photostock, Athens page 73 detail from a MS (Biblioteca Marciana, Venice # Cod. Gr. 479, fol. 2v)

see also figure 67 for another detail

- 51 Ersin Alok, Istanbul
- 53 Photograph by Professor Lawrence Majewski, Institute of Fine Arts New York
- 54 © Thomas F. Mathews, New York
- 55 © Ara Guler, Istanbul
- 57 © Treasury of Saint Servatus, Mastricht all rights reserved/photo Karel van
- 58 By courtesy of the Musées de Sens, France, photograph by Jean-Pierre Elie
- 60 © Studio Kontos/Photostock, Athens
- 61 left The Metropolitan Museum of Art, New York # 17.190.679. Gift of J. Pierpont Morgan, 1917
- 61 right The Metropolitan Museum of Art, New York # 17.190.680. Gift of J. Pierpont Morgan, 1917 Photos © 1996 The Metropolitan Museum of Art

- 62 By courtesy of the Trustees of the Victoria and Albert Museum, London # 216-1865
- 63 The Metropolitan Museum of Art, New York. Gift of J. Pierpont Morgan, 1917 # 17.190.237
- The Metropolitan Museum of Art, New York. Gift of J. Pierpont Morgan, 1917 #17.190.139. Photos © 1996 The Metropolitan Museum of Art
- The Pierpont Morgan Library M.652, F.25v/Art Resource, New York
- 70 From Lyn Rodley, Cave Monasteries of Byzantine Cappadocia, 1986, photograph by courtesy of the author, by permission of Cambridge University Press
- The Metropolitan Museum of Art, New York, Rogers Fund, 1971 # 1971.147.2. Photo © The Metropolitan Museum of Art
- 74 Scala, Florence
- 75 Photograph by Bruce White. © 1997, The Metropolitan Museum of Art, New York page 97 detail of figure 97
- 76 © Thomas F. Mathews, New York
- 77, 79 Scala, Florence
- 80 © CAMERAPHOTO Arte, Venice
- 82 Photograph by Bruce White. © 1997, The Metropolitan Museum of Art, New York
- 84 from Hubert Faensen & Vladimir Ivanov Early Russian Architecture, Paul Elek, London 1975, plate 125, photograph by Klaus G. Beyer
- Ersin Alok, Istanbul

- 86 © Studio Kontos/Photostock, Athens
- 87 © Sharon Gerstel, Washington, D.C.
- 88 © John S. Hios/Apeiron, Athens
- 89 © Ara Guler, Istanbul
- 90, 91, 92 © Studio Kontos/Photostock, Athens
- © G.Dagli Orti, Paris
- 94 © Studio Kontos/Photostock, Athens
- 95 © Sharon Gerstel, Washington, D.C.
- 96 © Studio Kontos/Photostock, Athens
- 97 © CAMERAPHOTO Arte, Venice
- 99 The Metropolitan Museum of Art, New York, Rogers Fund, 1993 # 1993.163
- 100 © John S. Hios/Apeiron, Athens
- 101 © Studio Kontos/Photostock, Athens
- 102 © Natalia Teriatnikov, Washington, D.C.
- 103 © CAMERAPHOTO Arte, Venice page 137 detail of figure 120
- 105 Musée du Moyen Age Cluny, Paris # Objets d'art CL392/© Photo RMN Paris
- 108, 109 Canali Photobank, Capriolo, Italy
- 111 Courtesy Winchester Cathedral Library, photograph by Miki Slingsby
- 112 © CAMERAPHOTO Arte, Venice
- 114 © Ara Guler, Istanbul
- 115 Colorphoto Hinz SWB, Basel, Switzerland
- 116 © Natalia Teriatnikov, Washington, D.C.
- 117 © Thomas F. Mathews, New York
- 118 National Gallery, London # 566
- 119 © Ara Guler, Istanbul
- 120 Index, Florence
- 121 Bayerische Staatsgemaldesammlungen, Munich # 8054/Artothek, Munich
- 122 Alinari, Florence

Index

Agathias 54 basilicas 99-100, 106 medieval 106-11 agriculture 87, 89, 90-91 bema 118, 127 medieval imagery in 111, 114, Akathistos 70 Benjamin of Tudela 34 116-27 Alexios I Komnenos, Emperor 38-39, Blessing Christ (icon) 51, 51-52 narthex of 133, 135 40, 79 Blessing Christ (marble relief) 53, 53, sanctuaries of 127, 129-32 Alexios V, Emperor 68 Clement, St 90 Alexios Komnenos (son of John II) Bogoljubski, Andrej 70 cloisonné enamelwork: bone boxes and caskets 84, 85-86 bracelets 82, 83 Alexios Komnenos, prince 109 boxes see caskets icons 62, 62 Anastasios, Emperor 29 Bramante, Donato: San Satiro, Milan pendants 82, 83 Anastasios of Sinai 124 163 clothes: court fashion 38, 79-80, 82, Anastasis see Resurrection, the Brunelleschi, Filippo 162-63 104, 105 Andronikos II, Emperor 153 Bulgaria/Bulgarians 37, 67, 90, 137, episcopal 103 Anikia Juliana 52 152, 155 coinage 29, 57 Anthemios of Tralles: dome of Hagia Buondelmonti, Cristoforo: map of communion 118, 129 chalices 129-30, 130 Sophia 106 Constantinople 21, 26, 32 Antiochos, praepositus 75 Palace of Byzantine empire 7 Communion of the Apostles... (fresco) 127, 127, 129 75, 75-76 map 10-11 Antonello da Messina 160 Virgin phases of 9, 12 Concelebrating Bishop (Theophanes Annunciate 160, 161, 162 the Greek) 156, 156 Aphrodite Complaining to Zeus... Cappadocia, Turkey 91, 93, 109 Constantina 45 (manuscript illustration) 25, 25 mansions 91-92, 92, 93 Constantine I, Emperor ("the Arabs 32, 33, 55, 86, 91, 93, 143 caskets, ivory and bone 83, 84, 85-86, Great") 17, 18-19, 21, 22-26, 33, ceramics 95 architecture 12 ceramics 93, 95, 95 medallion 7-8, 8 Byzantine: church 99-100, 106, Chalice of Romanos II 130, 130 Constantine V, Emperor 55, 58 109-11; Charlemagne, Emperor 32, 148 Constantine VII Porphyrogennetos domestic 73, 76, 77, 91-92, 92, 93 Cheroubikon hymn 124 35, 74, 79, 82, 91, 138-39, 143 Islamic 77, 92 Italian Renaissance Chios: church of Nea Moni 111, 114, coronation ivory 35, 35, 37, 138 162-63 Triptych (ivory) 64, 64 Roman 76-77, 163 see also Constantine IX Monomachos 83, 90-Deposition (mosaic) 124, 124 Constantinople Resurrection (mosaic) 126, 126-27 91, 93, 114 crown of 93, 94 Constantine's Four Sons (porphyry) Arena Chapel, Padua: Giotto frescoes Washing of the Feet (mosaic) 133, 159, 160 133, 135, 135 23, 23, 151 Arkadios, Emperor 27, 28, 75 Christ 15 Body of 33, 60, 97, 118-19, Constantinople: founding of 17; Armenia/Armenians 15, 37, 56, 137 construction under Constantine "humanification" of 55-56 Ascension (mosaic) 8, 9 18-19, 21-24; under Justinian Athanasios, St 87, 89, 119 life of 60-62, 105-106, 119, 122, 29-30; medieval 33-35; decline Athens, Greece: Holy Apostles 109, 124-27 of 12, 40-41; fall (1453) 7, 41 miracles of 100-101, 103 Augustaeum 19, 23, 30 Athos, Mount: Great Lavra representations of 51, 100, 117-18 Baths of Zeuxippos 24, 30, 33 Monastery 89, 152 Christ and St Menas (icon) 47-48, 48 Blachernai church 54, 57, 58 automata 74, 79 Christ Blessing Emperor Otto II and Blachernai Palace (Tekfur Saray) Avars 32, 54 Theophano (ivory panel) 139-40, 40, 41, 79 church of Christ of Chora Baldwin II, Emperor 151 Christ Pantocrator (mosaics) 116, 117, (mosaic) 152, 153, 155 Balsomon, Theodore 85 117-18, 153 church of St John the Baptist of "Barberini Ivory" 17, 32, 35 Christianity, early 21, 26, 95 Stoudios 99, 99-100 Basil I, Emperor 43, 57, 58, 90, 109 Chronicon Paschale 22 church of the Holy Apostles 21 Basil II, Emperor 36, 37-38, 98, 137, Chrysopolis, battle of 17 church of the Mother of God churches, Byzantine 97-98 Pammakaristos (Fethiye Basil the Great of Caesarea 26, 87 early 99-106 Camii) 67, 109, 110,

110, 117, 117-18, 153, 156 Column of Constantine 22, 22 Column of Theodosios 27-28, 28, Fethive Camii (mosque) see church of the Mother of God Pammakaristos Forum of Constantine 22-23, 41 Great Palace 19, 30, 55, 73-75, 74, 76, 77, 79, 82-83, 139; mosaics 54, 76, 76, 106 Hagia Eirene 21 Hagia Sophia 21, see Hagia Sophia hippodrome 18, 19, 26, 51 maps 19, 21, 26, 32 monasteries 34-35 Monastery of Christ Pantokrator 34, 35, 38, 62, 62 Obelisk of Theodosios 26-27, 27, Palace of Antiochos 75, 75-76 porticoes 21, 22 statuary and columns 19, 22, 23, 24, 26, 41 walls 7, 18, 28, 33 Constantius II, Emperor 21 Continuator of Theophanes (Theophanes Continuatus) 73, 138 Creation of Eve (initial from Winchester Bible) 147-48, 148 Creation of Eve (miniature) 147, 147 Creation of Eve (mosaic) 146, 146-47 Crete 152, 155, 157 crosses, processional 131-32, 132 Crowning of Constantine VII (ivory) 35, 35, 37, 138 Crucifixion, the 122, 124 Crucifixion (miniature icon) 60, 60 Crucifixion (mosaic) 122, 122, 124 Crusades/Crusaders 12, 24, 40, 68, 73 Cyprus 32, see Kiti

Damascus: Great Mosque 58
Daphni, Greece: church of the
Dormition 111
Christ Pantokrator (dome mosaic)
116, 117-18, 153
Crucifixion (mosaic) 122, 122, 124
Nativity (mosaic) 119, 122
Transfiguration (mosaic) 113, 114,
122
De materia medica (Dioskorides) 90,
91, 91
Deesis icons 62, 64-65, 135, 159, 159
Delmatius 23

Demus, Otto 114
Deposition (mosaic) 124, 124
Desiderius, Abbot 143
Digenis Akritas (romance) 90, 91
Dion Chrysostom 50
Dioskorides: De materia medica 90, 91, 91
Discovery of the Body of St Mark (mosaic) 137, 151
domes: construction 109-11, 118 and Christ Pantokrator 117-18
Duccio di Buoninsegna 158
Virgin and Child with St Dominic

Eleousa icons 70
enamel, cloisonné see cloisonné
encaustic 48, 50, 50, 51, 58, 59
Enthroned Mother of God Between St
Theodore and St George (icon) 44,
50, 58

and St Aurea 158, 158-59

50, 58
Enthroned Mother of God with
Prophets and Saints (icon) 13, 13,
70, 70, 159
Entrance of Bishop Maximianus with
Justinian (mosaic) 103-105, 104
Entry into Jerusalem (enamel icon) 62,

62
Entry into Jerusalem (tempera icon)
61-62, 62
Ephesos 41, 55

church of St John 103 Eucharist, the 103, 118, 119, 124 Eudokia, Empress 50, 53, 65 eunuchs 79 Euripides 83 Eusebios, bishop of Caesarea 25, 45 Excerpta (compilation) 139

Falier, Doge Vitale 150 fashion, court 38, 79-80, 82, 104, 105 Fayum: mummy mask portraits 50, 50 Florence, Italy:

S. Lorenzo 163
Santo Spirito 163
frescoes: Communion of the Apostles...
127, 127, 129
Concelebrating Bishop

(Theophanes the Greek) 156, 156

Lamentation (church of St
Panteleimon) 125, 125-26

Lamentation (Giotto) 159, 160

Last Indocment 135, 135

Last Judgement 135, 135 Nativity 154, 155

Gennadios, bishop 51

Geoffrey of Villehardouin 41 Geoponika 91, 139 George of Antioch 106 Georgia 37, 137 Gerasa, Arabia 22 Geza, King of Hungary 142, 143 Giotto: Arena Chapel, Padua 159 Lamentation 159, 160 Glabas, Martha 110, 153 Goths 26, 29 Grazing Horses (mosaic) 76, 76 Greco-Roman heritage 7, 9, 24-26, 33, 51, 83, 87, 106, see also Romans Gregory, bishop of Nazianzos: Homilies frontis., 88, 89, 90 Gregory of Nyssa 118

Hagia Sophia, Constantinople 21, 29-30, 30, 32, 57-58, 98, 106, 117 mosaics 39, 39, 43, 57-58, 58, 129, 159, 159 templon icons 52

templon icons 52
Hallaç, Cappadocia: mansion 92, 93
Healing of the Blind (manuscript
illumination) 101, 101, 103
Healing of the Blind (mosaic) 152, 153,
155
Healing of the Blind (mosaic

(Ravenna)) 100, 100
Hector Meeting Hecuba (manuscript illustration) 25, 25

Helena Augusta, statues of 19, 23 Hellenistic art 26, 106

Henry of Flanders 68 Herakleios, Emperor 32

Heron and Anonymous Military God (icon) 46, 47

Hieria, Council of (754) 55 Hodegetria (Mother of God): icon 53, 65, 67, 68 ivory 140, 141

Homer 24, 26 Iliad 24-25, 25, 82, 83, 86

Homilies of Gregory of Nazianzos frontis., 88, 89, 90

Homilies of John Chrystostom 73, 73, 79-80 Honorius 27, 28

Hosios Loukas see Stiris Hypatios, bishop of Ephesos 55

Iconoclasm 53, 55-57, 58 icons (see also mosaics): definition and origins 43-45 domestic 45-47, 52 Eleousa 70

healing powers 53 Joshua Roll (manuscript) 86, 87 Kynegetica 88, 89 and Iconoclasm and after 53, 55-Julianos Argentarios 100, 103-104 Octateuch 146-47, 147 Justin II, Emperor 54, 76 65. Psalter of Basil II 36, 37 narrative 60-62 Justinian I, Emperor 29-30, 32, 33, Synopsis Historiarum 56, 57, 67, processional use 65, 67, 68 76, 103 68 sixth-century 47-52 Entrance of Bishop Maximianus Tetraevangelion 130-31, 131 templon 52, 55, 59-62, 61, 62, 64, with Justinian 103-105, 104 Theoktiste Instructing her Grand-65, 106, 114, 119 Justinian II, Emperor 54 daughters... 56, 57 and war 53-54, 68, 70 Winchester Bible 147-48, 148 Ignatios the Younger, St (mosaic) 58, Kalenderhane Camii (mosque): Wolfenbttel artist's handbook (mosaic) 105, 105-106 150, 150 Iliad (Homer) 24-25, 25, 82, 83, 86 katholikon 34, 35, 98 Martini, Simone 158, 158 Ilias Ambrosiana 25, 25 Kiev 109, 155 Mary, depictions of 39, 70, 129 Irene, Empress 56 St Sophia 155 see also Deesis; Enthroned Mother Irene, Empress (wife of John Kiti, Cyprus: Panagia Angeloktistos of God; Mother of God; Virgin Komnenos) 39, 39 church (mosaic) 53, 54 Maximianus, bishop 103, 104, 104 Isidore of Miletos: dome of Hagia Komnenian dynasty 34, 35, 38-39, 41, Maximos, patriarch 118 Sophia 106 70, 147, 150 Maximos the Confessor, theologian Isidore of Pelusium 124 Kontostephanos 67 119, 139 Islam/Muslims 7, 12, 32, 139, 155 Kynegetica (pseudo-Oppian) 88, 89-Maximus 26, 28 architecture 91-92 Mehmet II, Sultan 41 art 9, 56 Meteora, Greece 152 ceramics 93, 95, 95 Lamentation (church of St Methodios, patriarch 57 textiles 80, 82 Panteleimon) 124-26, 125 Metochites, Theodore 153 Italy: Lamentation (Giotto) 159, 160 Michael III, Emperor 43, 57-58, 82 Renaissance in 12, 114, 137, 152, Last Judgement (fresco) 135, 135 Michael VII Doukas 140, 142, 143 157-63 see also Monreale; law, Byzantine 7, 21, 38, 83 Michael VIII Palaiologos 41, 151, 153 Montecassino; Padua; Palermo; Leo I, Emperor 54 miracles, 100-101, 103 Ravenna; Romans; Sicily; Venice Leo III, Emperor 55 Mistra, Greece 152, 155 ivories 9, 35 Leo V, Emperor 56 church of the Mother of God "Barberini Ivory" 17, 32, 35 Leonardo da Vinci 163 Peribleptos: Nativity 154, 155 caskets 83, 84, 85-86, 86 Licinius, Emperor 17 monasteries 21, 34-35, 143, 133, 152 Christ Blessing Emperor Otto II literature: Byzantine 7, 83 Monastery of St Catherine, Mt Sinai: and Theophano 139-40, 140 Greek 24-26, see Homer Blessing Christ 51, 51-52 The Crowning of Constantine VII Liutprand of Cremona 74, 79, 139 Crucifixion 60, 60 Porphyrogennetos 35, 35, 37 Lombards 32, 148 Enthroned Mother of God Between Mother of God 140, 141 Luke, St 50 St Theodore and St George 44, Triptych of Constantine VII Luke of Stiris, Blessed 93 50, 58 Porphyrogennetos 64, 64-65 Enthroned Mother of God with Veroli Casket 83, 84, 85 Macedonian dynasty 38 Prophets and Saints 13, 13, 70, Macedonian Republic see Nerezi 70, 159 Jacob Wrestling with the Angel Manuel I Komnenos, Emperor 39, 67 Entry into Jerusalem 62, 62 (mosaic) 14, 15 Manuel Philes 153 St Nicholas 59, 59 Jerome, St 24 manuscripts, illustrated 35, 101, 139 St Peter 48, 48, 50 jewelry, cloisonné enamel 82, 83 Book of Job 80, 81 Washing of the Feet 61, 61 John, St 130-31 Codex Sinopensis 101, 101, 103 Mongols 70, 155 John XII, Pope 139 Creation of Eve 147, 147 Monreale Cathedral, Sicily: mosaics John Komnenos 67 De materia medica (Dioskorides) 14, 15, 148 John II Komnenos, Emperor 35, 38, 90, 91, 91 Montecassino, Italy: monastery 143 38-39, 110 Gospel Book 138 mosaics: John I Tsimiskes, Emperor 67, 68 Healing of the Blind 101, 101, 103 Ascension 8, 9 John Chrysostom: Homilies 73, 73, Homilies of Gregory of Nazianzos Creation of Eve 146, 146-47 frontis., 88, 89, 90 Crucifixion 122, 122, 124 John of Damascus, St: On Icons 55-Homilies of John Chrysostom 73, Deposition 124, 124 Discovery of the Body of St Mark 56, 116 79-80 John the Synkellos, patriarch 77 Ilias Ambrosiana 25, 25 137, 151

Joshua Roll 86, 87

Grazing Horses 76, 76

Joseph of Arimathea 124, 125

in Hagia Sophia, Constantinople 39, 39, 43, 57-58, 58, 129, 159, Healing of the Blind (church of Christ of Chora) 152, 153, 155 Healing of the Blind (S. Apollinare Nuovo, Ravenna) 100, 100 Jacob Wrestling with the Angel 14, Mother of God 65, 67, 67 Mother of God (Hosios Loukas, Stiris) 128, 129 Mother of God with Angels 53, 54 Nativity 119, 122 in Palazzo Normano, Palermo 79, Pentecost 128, 129 Presentation in the Temple 105, 105-106 Resurrection 126, 126-27 St Ignatios the Younger 58, 58 in San Vitale, Ravenna 103, 103-105, 104 Triumph of Dionysos 76, 76 Virgin and Child between John II Komnenos and Irene 39, 39 Washing of the Feet 133, 133, 135, 135 Moscow, Russia 21, 155-56 Mother of God (Hodegetria) (icons) 53, 65, 67, 68 ivory 140, 141 mosaic 43, 53, 54, 58, 128, 129 Mother of God "Nikopoios" (icon) 68, 69, 151 mummy mask portraits, Fayum 50, Muslims see Islam narthex 133, 135 Nativity (fresco) 154, 155 Shepherds (T'oros Roslin) 138

Nativity (tresco) 154, 155
Nativity (mosaic) 119, 122
Nativity and Adoration of the
Shepherds (T'oros Roslin) 138
Nerezi, Macedonian Republic:
church of St Panteleimon 109
Lamentation (fresco) 125, 125-26
Nicaea, Second council of (787) 56, 122, 124
Nichetas Choniates 41
Nicholas, St (icon) 59, 59
Nicodemus 125, 127
Nifont, bishop of Pskov 109
Nikephoros II Phokas 86, 87, 139
Nikephoros III Botaniates and
Courtiers 73, 79-80
Niketas Choniates: Annals 67

Novgorod, Russia: church of the Transfiguration (fresco) 156, 156 church of Sts Peter and Paul, Kozhevniki 156, 157 St Sophia 155 nude figures 33, 85

Octateuchs 146-47, 147 Odoacer 29 Otto I the Great 139 Otto II 139-40 Ottoman Turks 40, 41, 151

Padua, Italy: Arena Chapel frescoes (Giotto) 159, 160 Pala d'Oro altarpiece 62, 62, 151 Palaiologan dynasty 41, 151-56 Palermo, Sicily: Palazzo Normano 79, 79, 143 chapel (Cappella Palatina) 143, 145, 146; mosaic 146, 146-47 Santa Maria dell'Ammiraglio 106, 106 Paul the Silentiary 30 Pentecost (mosaic) 128, 129 Persians 26, 32, 54, 87 Peter, St (icon) 48, 48, 50 Philip of Courtenay 151 Photios, patriarch 43, 58, 90

Poussay, Gospel of: cover 140, 141
Prato, Italy: Santa Maria delle
Carceri (Sangallo) 162, 163
Presentation in the Temple (mosaic) 105, 105-106
Prokonnesos marble 21, 22, 73
Prokopios of Gaza 147
protovestiarios (eunuch) 79

porphyry 23

Psellos, Michael 37

pseudo-Denis 118, 119, 139 pseudo-Oppian: *Kynegetica 88*, 89-90 Pskov, Russia: St Demetrios 155

St Demetrios 155 Transfiguration cathedral of Mirozhski Monastery 109, *109*, 114, 155

Ravenna, Italy 21, 29, 53, 106
S. Apollinare Nuovo (mosaics)
100, 100
S. Vitale 103, 103-105, 104
relief sculpture 15
Blessing Christ (marble) 53, 53
Column of Theodosios 27-28, 28
Emperor John II Komnenos
(marble tondo) 38, 38
Obelisk of Theodosios 26-27, 27

Silivrikapi tomb 77, 77 Renaissance, Italian 12, 114, 137, 152, 157-63 Resurrection, the 119, 126-27 Resurrection (ink drawing) 150, 150 Resurrection (mosaic) 126, 126-27 Roger II, King of Sicily 106, 143 Romanos Lekapenos, Emperor 87 Romanos II, Emperor 35, 91, 139 chalice 130, 130 Romans/Rome 18, 21, 29, 53 agriculture 87 architecture 76-77, 163 iconography 35, 67 portrait painting 48, 50, 52 see also Greco-Roman heritage Russia 44, 45, 137, 152, 155, 157, see also Kiev; Pskov Russian Living Room with an Icon Corner (Vol'skii) 45 Russian Primary Chronicle 98

St Nicholas (icon) 59, 59

St Peter (icon) 48, 48, 50

St Polyeuktos, church of: templon

icons 52-53, 53 St Potentien, shroud of 80, 81 "St Stephen's Crown" 140, 142, 143 saints, images of 114, 116 S. Marco, Venice see under Venice Sangallo, Giuliano da: Santa Maria delle Carceri, Prato 162, 163 sculpture 15 Victory figure 28-29, 29 see also relief sculpture Sens Cathedral, France: shroud 80, 81 Serbia/Serbs 137, 152, 153, 155 see also Sopočani Sicily 143, 150, see also Monreale Cathedral: Palermo signatures, artist's 153 Silivrikapi tomb 77, 77 silks and silk trade 9, 80, 80, 81, 87, 139 Sinai, Mount

Sinai, Mount

see Monastery of St Catherine

Skylitzes, John: Synopsis Historiarum

56, 57, 67, 68

Slavs 15, 32, 90, 137, 139, 155

Sopočani, Serbia:
church 114, 115

Communion of the
Apostles...(fresco) 127, 127, 129

Springtime Activities in the Countryside (manuscript illustration)
frontis., 88, 89

Stephen the Younger, St 55

00198 2647

Stiris, Greece: Katholikon of Hosios Loukas 97, 109, 111 mosaics 128, 129 Suchos and Isis (icon) 46, 46 Symeon 105-106, 124 Symeon the New Theologian 119 Symeon Stylites, St 53 Synopsis Historiarum (Skylitzes) 56, 57, 67, 68 Syria/Syrians 32, 46, 55, 137

Tarasios, patriarch 124 tempera 46, 59 templon (beams) 52, 97, 127 Great Deesis 62, 64, 65 icons 52, 55, 59-62, 61, 62, 106, 114, 119 Tetraevangelion 130-31, 131 textile production 80, 82 see also silks and silk trade Theodora, Empress 56-57, 105 Theodoric the Great 29 Theodosios I, Emperor 26 Column of 27-28, 28, 33 Obelisk of 26-27, 27, 38 Theodosios II, Emperor 7, 18, 28, 50 Theoktiste Instructing her Granddaughters... 56, 57 Theophanes Continuatus (Continuator of Theophanes) 73, 138 Theophanes the Greek 156 Concelebrating Bishop 156, 156 Theophano, Empress 139-40, 140 Theophilos, Emperor 73, 77 Theophilus 157

theosis, doctrine of 119 Thessaloniki 152 Hagia Sophia 8, 9 T'oros Roslin: Nativity and Adoration of the Shepherds 138 Transfiguration, the 122 Transfiguration (mosaic) 113, 114, 122 Tribuno, Doge Peter 148 Triptych of Constantine VII Porphyrogennetos 64, 64-65 Triumph of Basil II over the Bulgarians (manuscript illustration) 36, 37-38 Triumph of Dionysos (mosaic) 76, 76 Triumph of Justinian (ivory) 17, 32, 35 Triumphal Procession of John I Tsimiskes... 67, 68 Turks 7, 17, 40, 41, 151

Valentinian II, Emperor 27
Vandals 29
Venice/Venetians 12, 21, 23, 24, 40-41, 68, 109, 143, 148, 150-51
Constantine's Four Sons 23, 23
Discovery of the Body of St Mark (mosaic) 137
Horses of S. Marco 24, 24, 151
Islamic bowl 95, 95
Mother of God "Nikopoios" 68, 68, 151
Pala d'Oro altarpiece 62, 62, 151
Palazzo Ducale 150, 151
S. Marco 148, 148, 150
Veroli Casket 83, 84, 85

Victory figure (sculpture) 28-29, 29
Virgin and Child with St Dominic and
St Aurea (Duccio) 158, 158-59
Virgin Annunciate (Antonello da
Messina) 160, 161, 162
Visigoths 29
Vladimir, Russia: palace chapel
fresco (Last Judgement) 135, 135
Vladimir, Prince of Kiev 98, 155
Vladimir Mother of God (icon) 68, 70, 70, 126
Vol'skii, Ivan Petrovich: Russian
Living Room with an Icon Corner
45

Washing of the Feet (mosaic) 133, 133, 135, 135
William I, King of Sicily 79, 143
William II, King of Sicily 15, 148
Winchester Bible: Genesis initial 147-48, 148
Wolfenbüttel artist's handbook 150, 150
women, Byzantine 70, 147
and icons 45-46, 56-57
and textile production 80, 82
Women Spinning and Weaving

(manuscript illustration) 80, 81

Washing of the Feet (icon) 61, 61, 62

Yaroslav of Kiev 155

Vsevolod III 135

Zen, Doge Ranieri 151 Zosimos: New History 22